I Just Can't
Make This *Sh!t* Up

I Just Can't Make This *Sh!t* Up

Overcoming Fear &
Accepting My Spiritual Gifts

alejandra g. brady

LIFE. STYLED. BOOKS.

I Just Can't Make This Sh!t Up: Overcoming Fear and Accepting My Spiritual Gifts
Published by Life. Styled. Books.
Tampa, Florida, U.S.A.

Scripture quotation is taken from *THE MESSAGE*, copyright @ 1993, 2002, 2018 by Eugene H. Peterson. Used by permission of NavPress. All rights reserved. Represented by Tyndale House Publishers, Inc.

Library of Congress Control Number: 2022900909

BRADY, ALEJANDRA G., Author
I JUST CAN'T MAKE THIS SH!T UP
ALEJANDRA G. BRADY

ISBN: 978-1-7366856-0-0, 978-1-7366856-2-4 (paperback)
ISBN: 978-1-7366856-3-1 (hardcover)
ISBN: 978-1-7366856-1-7, 978-1-7366856-4-8 (digital)

BODY, MIND & SPIRIT / Inspiration & Personal Growth
FAMILY & RELATIONSHIPS / Family History & Genealogy
BIOGRAPHY & AUTOBIOGRAPHY / Women

Editing: Alexandra O'Connell (alexoconnell.com)
Editing: Jennifer Jas (wordswithjas.com)
Book Design: Michelle M. White (mmwbooks.com)
Artwork & Graphic Design: Rachel Farabaugh (rachelfarabaugh.com)
Publishing Production & Consulting: Susie Schaefer (finishthebookpublishing.com)
Photography: Kenzie Hart (gethartcreative.com)
Hair & Makeup: Nicole Rehak Evans (@believing_in_beauty)

QUANTITY PURCHASES:
Schools, companies, professional groups, clubs, and other organizations
may qualify for special terms when ordering quantities of this title.
For information, email info@lifestyledbooks.com.

Dedication

I dedicate this book to my husband Art,
who has always encouraged me to spread my wings and fly.

To our amazing son Ryan, who gave me
the great honor of being his mom in this lifetime.

To Lydia, whose smile brightens up even the dreariest of days.
I have waited twenty-seven years to have a daughter
and I could not have imagined one as special as you.

From my heart to yours...

As I sit here writing this to you, the reader, the feeling that comes over me is one of amazement and awe. I never set out to write a book. In fact, I fought writing it for quite some time, but in the end, I listened to the messages I was receiving and accepted that I was destined to share my story to help others. My intention for this book is that it serves as a remedy for you and others who are going through a spiritual awakening. At the beginning of mine, I felt so alone. Family and friends, although well-meaning, either didn't believe me or didn't accept what I was saying. There were very few people, one person, to be precise, to whom I could talk about what I was experiencing. My greatest hope is that my story will help you feel less alone.

As you read, you may wonder why the chapter names are all song titles. During one of my visits to Miraval in Tucson, the recurring message from several healers was that my mom, who had passed, was there with me, and she wanted to come through to me more often. She was asking permission. She wanted to communicate through music, and since we all loved music, I said yes. Of course.

I didn't feel my mom's presence right away, but as I wrote the chapters of my book and was remembering details about a certain story or particular person, random songs popped into my head. Some

I had not heard since I was a child, and some I've loved my entire life. Some songs came to me as simply lyrics, which I then had to research to find the title. Inevitably, the song title would make sense with whatever part of my story I was writing. The song titles are my way to honor my mom and thank her for giving me such a creative start to each chapter.

I also felt the need to respect everyone I write about in this book. The healers' names are all real, and they have given their consent to be published. I share them with you in the event you feel called to work with them, so I've included their contact information in the back of the book. Some members of my family and friends also gave their consent to use their real names, which I have honored. For the rest, their names have been changed out of the utmost respect for their privacy.

Thank you for taking the time to read my story. I am extremely grateful.

PROLOGUE

EVIL WOMAN
Electric Light Orchestra

My palms feel clammy as the plane touches down in Dallas. How is she going to react to all this new information about me? I feel like I haven't fully processed what took place. I'm scared I've taken apart the life I knew and am not sure I know how to put this new life together. I have been invited to redefine everything I am doing and everywhere I am going.

My time in the Sonoran Desert was not at all what I expected, and although I feel some clarity, I don't know how I am going to explain my experiences to anyone else, let alone my biological mother, who is an Evangelical Christian.

I see her waiting for me at the American Airlines baggage claim, as she usually does when I visit. We hug, hop in the car, and chitchat on the ride to her house. I am only in town for a couple of days. We spend the rest of the first day seeing family and going out to dinner. The second morning, I smell brewing coffee as I walk downstairs. Sofia is already in the kitchen. I am clutching my journal, still unsure if I am going to discuss what I have been through. She asks, "Would you like some coffee?"

"Yes, please!"

I stand at the kitchen island, holding the warm mug in my hands as I gather up the courage to share. Finally, I say, "I would like to show you my notes from various healing sessions."

"Sure, hon," she says.

She does not seem at all surprised as she reads through them. This startles me, as I am certainly astonished by what I have recently undergone. As she reads my handwritten notes from my session with Mother Emilia, I flip over my hands and show her the *M*'s on my palms.

Sofia puts down my notebook and shows me hers. So apparently, part of my gifts were passed through the bloodline.

Sofia then sighs, gets a serious look on her face, and says, "I want to share a story with you." She starts telling me about an experience she had in the 1970s. "My husband and I went out to dinner and a movie. Everyone was talking about *The Exorcist*, so we chose to go see that." I knew *The Exorcist* was a horror movie based on a real-life exorcism, and I remember my parents going to see the movie and coming home visibly shaken. Sofia continues, "I woke up the next morning, walked into the bathroom to brush my teeth, and when I looked at myself in the mirror, I saw the word *SATAN* spelled out across my forehead from the inside out. The letters were written in red and looked like blood. I ran to the kitchen to find my husband and realized I couldn't speak. No noise came out of my mouth. He immediately put me in the car and drove me to our church. He found the preacher, who prayed and performed something I feel was an exorcism of some kind on me."

I stand there and stare at her, stunned. What a truly horrific story. Sofia then shares that before the incident, she had been told she was a healer, but she had not yet decided what to do with that information. After this horrible experience, she flat-out rejected her gifts.

I had lived through my own frightening experience in Mexico a few years earlier and can certainly understand why she chose to reject her healing gifts. I inform her I have made a different decision. I choose to accept my gifts and release my fears. I choose to be strong

and courageous. I choose to come into my Truth. I will only work with and in the light, for my highest and greatest good, and for the highest and greatest good of those I am here to be of service to.

Her husband walks in while Sofia and I talk, and he quietly listens to our conversation. Abruptly, he excuses himself and leaves the room. A few minutes later, he comes back into the kitchen with a printout. He hands me the sheet of paper, which still feels warm to the touch. He looks at me, says, "Now, let me tell you something ..." and begins reading specific sentences aloud. The information on the sheet claims clairvoyance, clairaudience, and other gifts I just described as mine as being "evil" and "of the Devil."

I look over at Sofia, waiting for her to say a few words to him in my defense. Obviously, neither of them seriously think I am evil, do they? She just stands there, looking down at the kitchen countertop as if the granite pattern were the most interesting piece of artwork she had ever seen. I am now standing in the kitchen, staring at Sofia, completely dumbfounded for the second time in less than half an hour but for a completely different reason.

1

WHAT'S YOUR NAME?

Lynyrd Skynyrd

My first name is Alejandra, which literally translates to "helper of humankind." As a child, I remember my mom telling me this many times. My mom and dad adopted me when I was five weeks old.

I always thought my name was too long and preferred my friends call me Ale (pronounced AH-leh). My mother hated that name. She hated my nickname even more when I went away to college and allowed people to call me Ali. I wanted to blend in, and honestly, most people at Notre Dame had a difficult time pronouncing my name correctly. My mother said, "Your name has power. Never give that away."

She was right.

My first name is also Cassandra. Sofia named me at birth, and Cassandra was my name for the first three days of my life. I learned this during my first phone conversation with Sofia. The thought of having another name had never crossed my mind. Cassandra sounded strange yet somehow resonated with me at a very deep level.

I looked up the name's meaning when we hung up. Cassandra is of Greek origin and means "to excel, to shine." Cassandra also means "the unheeded prophetess." Cassandra, a Trojan princess, was given the gift of prophecy, but her prophecies were not believed. Alejandra (Alexandra) and Cassandra actually derive from the same source.

Since my biological and adoptive families never had any contact, this seemed like much more than a coincidence.

When I really started doing the hard, messy, muddy inner work, I revisited those definitions and marveled at the amazing insights from both mothers and my father to have given me these names. Did they know what was going to happen? Did giving me these names make these events take place? I believe we come here knowing our soul mission since we choose to be here during this time. I could only assume that my names, like everything else in my life, were Divinely chosen.

My story is what I know and believe to be true. I invite you on this journey with me.

2

ON THE FLOOR
Jennifer Lopez

Almost everyone I know has had "the bathroom floor" moment at some point in their life. Elizabeth Gilbert made us all familiar with this type of moment in her book *Eat, Pray, Love*. I had mine, not on the bathroom floor, but in an office building at around 10 a.m., with six other people present.

At the time, I was an interior decorator. I had worked with my client Sadie for close to fifteen years when this incident took place. To be fair, she was not there. Her father was, and as I look back on that horrible day, I now feel absolute gratitude toward him. If he hadn't decided to humiliate and scream at me in front of the contractors present, I would not have gotten off the hamster wheel I was on.

In my time with Sadie, I had completed three homes, five offices, and several remodels. We worked well together; however, every so often, she involved her father on a project, and that was where things always went sideways. I had "quit" once before due to the way he spoke to me, but after a cooling-down period and a meeting with her over coffee at Starbucks, I agreed to come back. We came to an understanding: Her father would not be involved when I was

working on a project. For the most part, we were able to keep our distance and remain civil.

This new project was big and a great opportunity for me. Sadie and her husband had purchased a building that would become their flagship office in a prestigious part of Tampa, where I lived at the time. There would be a lot of foot traffic, and having my name as part of the project would certainly bring me great exposure. The building had housed a law firm and looked every bit of it, down to the dated hunter green marble foyer floor. My client's logo and business colors clashed with this, and I suggested changing out the reception area floors to create a harmonious and cohesive experience for their medical patients as they entered.

The $5,000 cost to replace this area was minimal, considering the purchase price was around $4 million. Sadie, her father, and I met the day before the incident to create a game plan for the space since she was leaving town. Everyone was on the same page, and the new floors were a go. Her father's floor guy would bring samples for me to the new building the next day.

I arrived at the site the following morning a few minutes before the general meeting was set to start. I wanted to look at the floor samples and narrow them down. I found the floor guy and asked to see what he brought. He shrugged his shoulders and said, "I was specifically told not to bring any. The floor is not going to be changed."

I was stunned and looked for my client's father, who was sitting at the large conference table, talking to the other contractors. I walked over and waited for him to finish speaking. I said, "What happened between yesterday afternoon and this morning? Why was he told not to bring samples?"

He turned to me and began yelling at the top of his lungs. "You are not going to touch my building! You are not going to ruin my building with your design! I am not changing the floors!"

I remained as calm as possible, since we were in a professional setting, and reminded him that we, as a consensus, had made a different decision the day before. He continued to scream at me. I stopped listening. I turned around, grabbed my purse and work bag, which were sitting on a bench in the lobby, and walked out of the building. I got in my car, closed the door, and sat there, shaking from head to toe. I called Sadie immediately. She did not pick up. I texted her, letting her know I needed to speak to her right away. Her phone was always with her, so I was well aware she saw my text and didn't want to deal with either me or the situation. I went home and pretty much cried the rest of the afternoon. I was so shaken up by the way this man spoke to me. Never had anyone spewed such anger toward me, let alone in a professional setting. I was there to do a job for my client, and he was not my client!

A week passed. Still no response from Sadie. I know no response is a response, and that put our relationship in perspective for me.

Sadie and I had worked together for many years, but her actions now showed me, in a painfully clear way, she did not value me. If she did, she would have responded. She was in Kentucky, not Kenya. We knew each other well.

She did what she wanted and dealt with the repercussions later. She always said, "Better to ask for forgiveness than permission." She knew even if I got upset, I always came back.

This time was different. I took a step back to clearly assess the situation. The project provided a great opportunity for me both financially and professionally. True. I had never really said no to her before. Also true. I couldn't do this project and look at myself in the mirror. Ding, we have a winner! The time had come to take a leap into the unknown and figure out a new path.

I was a month out from having unexpected cervical spinal fusion, so the timing could only be called serendipitous. I wrapped up as many projects as possible and decided I would no longer work

with my current clients. By the time Sadie chose to reach out to me, I was gone.

I was no longer attracting the right clients, but perhaps before I could, I had to make myself right. And so, the journey to heal myself and make myself whole began ...

THE STREETS OF LAREDO

Johnny Cash

o understand where I wanted to be, I needed to go back to the beginning.

I was adopted from a private Catholic home for unwed mothers in Austin, Texas, at the age of five weeks by two amazing and loving parents, Jose "Pepe" L. and Margarita Verduzco Gonzalez. They raised me in Laredo, Texas. I spoke Spanish before I spoke English, as Laredo bordered Mexico and the culture and society I was raised in mixed the two worlds seamlessly. To this day, the smell of tamales brings back the image of our family at my aunt and uncle's home on Christmas Eve. I order tamales every chance I get, and I still compare them all to my aunt's, who I believe made the best I will ever eat. The masa on her tamales was paper-thin, and they were filled with different kinds of delicious meats. Chicken was my favorite. We all ate until we popped, then headed to midnight mass.

I was well educated in private, Catholic schools. My love of dance started at the age of three with ballet and Spanish dance classes. My parents forced me to recite formal Spanish poetry (which I despised) in middle school as a way to help me get over my shyness and the insecurity of being in a back brace. I had been diagnosed with scoliosis at the age of eleven and spent twenty-three hours a day in the brace

until I turned sixteen. My only respite was dancing. Ballet and Spanish dance classes became the only time I felt "normal."

During these years, Mom and Dad planned summer trips throughout the interior of Mexico to expose my younger sister Andrea (also adopted) and me to as much Mexican culture as possible. I climbed the Pyramid of the Sun and the Pyramid of the Moon in Teotihuacan. I felt a connection there I would not understand until many decades later.

Anything having to do with ancient civilizations had fascinated me for as long as I could remember. I spent hours sitting in my father's study, curled up on his La-Z-Boy recliner, reading about life in bygone times, with Egypt being my favorite. I begged to go to the National Anthropology Museum while we were in Mexico City to see the Aztec Sun Stone. I decided I was going to be an archaeologist.

Then, I became a girl. I discovered nail polish and boys, and my dreams of digs in faraway dusty lands faded into the background.

4

I SEE A GHOST

Concrete Blonde

My parents and I had a huge fight on Sunday, May 7, 1984, because my first boyfriend, Fonso, invited me to go on a day trip with him, and they said no. He was driving to and from San Antonio with his older brother and his girlfriend after packing up his brother's college dorm room.

I was sixteen years old. My orthopedic doctor had reduced my time in the back brace to nighttime use only. Fonso was handsome, junior class president, played football, and was very popular. I was still trying to come out of my shell, literally (the brace) and figuratively. He had a great sense of humor and made me laugh.

I woke up in the middle of the night to see Fonso standing in my room, wearing a pair of jeans and a white button-down shirt. He said goodbye and told me he loved me. His exact words were, "Ale, I love you." I physically saw and heard him speak in his own voice. I told him I loved him, too. Not sure about what had taken place, I eventually fell back asleep and woke up a few hours later, when the alarm went off.

I walked into my parents' bedroom to see my mom holding the almond-colored phone receiver in her hand. I had not heard the phone

ring, but I knew what she was being told. I will never forget the look on my mom's face. Her big brown eyes were red and swollen. Tears were running down her cheeks, and her long lashes were soaking wet. She was crying and looked like she was in shock.

I didn't ask what was wrong. I already knew. I just said, "I don't want to go to school."

She asked me, "Por qué?" which means "why?" in Spanish.

I replied, "Because Fonso died."

We were not allowed to have phones or televisions in our bedrooms, and this was years before cell phones and computers. There was no way for me to have received this information before she did.

My mom looked at me as tears continued to run down her cheeks and asked how I knew, so I told her what had taken place in my bedroom during the night. She didn't really react other than to tell me I could stay home. I went to sit next to her on the edge of her side of the bed, and she told me what happened.

Their pickup had crashed on the highway, and my Fonso's arm was torn off at the shoulder when he went through the passenger window. He bled out on the side of the road. His brother's girlfriend was thrown through the windshield and died instantly. His brother survived; however, he was in a coma until his death in 2003. So, in reality, no one survived. I can't remember the specifics of our fight or why my parents had refused to let me go with him, but obviously, their actions and intuition saved my life.

We went to the funeral, and I grieved as much as any sixteen-year-old could. He had died three days before his seventeenth birthday and five days before our two junior proms. (We went to separate high schools.) My mom had been trying to take me dress shopping for weeks, and I had refused to do so, which was quite unlike me. I have always looked for any excuse, no matter how small, to buy a new dress. I felt my intuitive nature somehow knew, deep down inside, I would not need prom dresses.

On prom day, one of my mother's friends sent me a beautiful bouquet of bright, happy flowers with a note that read: "Prom won't be the same without you." I remember her kindness to this day.

In my senior year of high school, I officially became a debutante. I was presented in the Society of Martha Washington, which meant a year of parties and social events. At the December presentation, I wore a white dress, which, for some reason, had feathers. This was 1984, after all, and we all know the eighties were known for great music and horrible clothes! Laredo has a huge George Washington's Birthday Celebration in February, and during that weekend, I curtsied and waltzed in front of Laredo society in a bead-encrusted colonial ball gown weighing approximately fifty pounds. After the presentation, families, friends, and dignitaries from around the state attended a ball in our honor. We were on parade floats the following morning and then at a cocktail party that evening. The celebration was approximately three days long, but the dress took at least a year to design, plan, and sew.

My parents sacrificed and did the best they could to provide my sister and me with the strongest possible foundation on which to flourish. My father's undergraduate degree was from the University of Notre Dame, so there was really no other option for me once I was accepted than to leave the warmth of South Texas for the freezing winters of South Bend, Indiana. To be honest, I was ready to leave. I actually could not wait to leave. I had never felt at home in Laredo, although the city itself had been good to me. I couldn't explain why, but I felt I was dropped off in the wrong place.

5

YOU'RE THE ONE THAT I WANT

John Travolta / Olivia Newton John

I left for Notre Dame in the fall of 1985, and at the beginning of my sophomore year, I met Art Brady. I first noticed him at my roommate's parents' tailgater for the Notre Dame versus Michigan season opener. He was sitting on top of his Laredo Jeep (yup, can't make this shit up) and wearing only a pair of Notre Dame Lacrosse shorts and a bandanna tied around his upper thigh. I told my roommate, who told her brother, who was Art's good friend, that I thought he was cute. I knew the message would get back to him. He then proceeded to ignore me for three weeks.

One Friday night in early October, my roommate and I were invited to a party in Alumni Hall, where Art and her brother lived across the hall from each other. I walked in to see Art pulling on the back of a beautiful blond girl's jeans. I turned around and started walking out since it was obvious he wasn't the least bit interested in me. To my surprise, he ran out after me and told me that girl was his sister who was visiting for the weekend.

We hung out at the party, danced to "Paradise by the Dashboard Light" by Meat Loaf, and made out and talked for hours. We took a long walk around St. Mary's Lake before he dropped me off at my dorm. We went on our first real date a few days later.

16

Art was a year ahead of me, so he graduated in 1988. He applied and was accepted into an accelerated MBA program at Notre Dame, and we graduated together in 1989. We got engaged in Tampa that September and married on June 1, 1990. We had an amazing, three-day Mexican wedding celebration in Laredo. I took off my wedding dress around 5 a.m., after a night full of dancing, put on my travel dress, and got in the limo for our drive to San Antonio. Laredo's airport was small, so we had to go to a larger airport in order to board an international flight.

We flew to Ireland for a two-week honeymoon. I left home that day and began my new life as a married woman. We flew straight from Dublin to Albany, New York, for another celebration with Art's family and boarded a plane again to start our life together in Tampa. Art had already been in Tampa a year, as he was offered a position with IBM straight out of MBA school.

6

IT'S MY PARTY

Lesley Gore

In March of 1995, I gave birth to our son. My dad and I had made a deal. If it was a boy, my dad wanted us to name the baby Jose, after him, and call him "Pepe." He said, "Pepe Brady would make one hell of a great Notre Dame football player name."

I said, "Absolutely not! But, if our baby is a boy, his middle name can be Joseph, after you. Take it or leave it!" That worked for him, and Ryan Joseph Brady arrived, with the help of forceps, early on March 16.

We had always assumed we would have several children, but after four miscarriages (one ectopic, which resulted in emergency surgery), we accepted our situation, and to this day are deeply grateful for our amazing, healthy son.

Raising Ryan, running the household, and being room mom and later team mom consumed my days. Ryan excelled in sports, so our life revolved around endless soccer and lacrosse tournaments. Years went by. One day in 2004, in the middle of a children's gymnastics class at the local YMCA, a friend of mine who was an interior designer approached me and asked if I would like to go into business with her. She had been to my home many times and felt our styles would complement each other. Ryan was now in fourth grade, and I had more time on my hands.

Art and I discussed the opportunity over dinner that night. Interior design was a passion of mine, but I had never designed professionally. I said yes, and my friend, now business partner, and I opened our interior design showroom and business. Life was great. Life was not so great. Life was life.

In September 2005, I went home to celebrate my thirty-eighth birthday and my twenty-year high school class reunion. My parents had a birthday party for me. My parents' backyard was always beautiful, and the weather was nice enough to eat outside on the patio. There was a horse-shaped piñata for the kids (and the grownups, too, if I am being honest). My uncles, aunts, and cousins came over. Ryan was playing with his baby cousins, Andrea's twins. My dad was on grill duty, making my favorites, *carne asada* and *mollejas*. Mollejas means sweetbreads. This is the meat from the thymus or pancreas and is considered a delicacy in many cultures. I loved them grilled, with a little bit of salsa in a corn tortilla.

Mom walked out onto the patio with a fully lit birthday cake. She always made me my favorite, good old-fashioned Betty Crocker chocolate cake with chocolate frosting. This cake was not my chocolate-on-chocolate cake. "What kind of cake is this?" I asked.

"Tres leches," she said. I don't like tres leches cake. I have never liked tres leches cake. Let's start with the fact that there is no chocolate in this cake. We could end things there, but I can also add that the cake is soaked in three kinds of milk, hence the name *tres leches* (three milks). The soaking gives the cake a wet texture, which doesn't work for me at all.

When I asked why she bought me a cake she knew I didn't like, she replied, "Ay, but I love it!" Well, that was enough to piss me off for the rest of the evening.

I am not good at hiding my feelings, so I am quite sure I let her and everyone else in attendance know how I felt. I blew out the candles

after everyone sang happy birthday, but I wouldn't eat a slice of cake when she handed me a plate.

That was the last birthday I would ever celebrate with my parents. Both my parents were gone by the time I turned thirty-nine.

7

MAMA'S BROKEN HEART

Miranda Lambert

February 9, 2006, changed everything.

February 9 was my grandmother's birthday. When I woke up, I remember thinking I needed to call my mom back. She had called while I was driving home on the Veterans Expressway at rush hour the day before, and I didn't feel like talking. I knew it would be a hard day for her since my grandmother had passed away six years earlier. Then, of course, I got busy and forgot to follow through.

Around 11:00 a.m. or so, my sister, Andrea, called. She was hysterically screaming into the phone, "She's gone. She's gone. I don't know. She's gone."

I couldn't process what she was saying, and I kept asking, "Who is gone? What are you talking about?"

She finally cried out, "Mom!! Mom's gone. The paramedics are working on her."

I was so confused. Was she dead? Hurt? How could she be gone if they were working on her? I understandably couldn't get an answer out of Andrea, as she, herself, was in shock, and the paramedics were working on our mother in front of her. Our conversation seemed to go on forever. In reality, I am sure the phone call lasted about five minutes. When she hung up, I still wasn't sure if my mother was alive

21

or dead. Andrea had to hang up to speak with the paramedics and promised to call back.

I called Art and am sure I sounded just as hysterical to him, sobbing and saying, "I think my mom is dead. Maybe she isn't. I don't know." I was back on the phone with my sister as Art walked through the door.

My parents had gone to San Antonio to help Andrea while she rested after a fertility treatment. She had twin boys who were two and a half at the time. Her husband had businesses in both Laredo and San Antonio, which kept him out of town a lot, and she needed the help. Andrea said, "Mom was in the bedroom with me when she suddenly said she felt queasy. She got up to go to the bathroom. She had a massive heart attack and was dead before she hit the bathroom floor on her way to the toilet."

My sister, the twins, and my dad all watched her fall. They called 911, and that was where the confusion lay. The paramedics were still trying to revive her when Andrea first called me.

My mom was sixty-six years old. She died on her mom's birthday. Her death was completely unexpected.

Art, Ryan, and I caught the first flight to Laredo the next morning and went directly to the funeral home to meet my father and sister. My mother had informed Andrea and me of her wishes years before, but we were shocked to find out she apparently had never voiced them to my father. He was fifteen years her senior, and I guess the assumption was he would be the first one to pass. He disagreed with everything we told him she wanted. Her wish was to be cremated and not have anyone see her. He wanted an open casket and burial. He also wanted my sister and me to do her makeup so she "looked like herself."

My mother was an organ donor, so forty-two of her organs were donated. I still shiver at the thought of feeling the plastic cups under my mother's sewn eyelids (her corneas were donated) as I put eye-shadow on her. My sister and I were left in an impossible position,

but my father received the closure he needed. He had to see her in the casket to make her death real. I, on the other hand, felt so much anger toward her for dying and so much guilt at not being able to fulfill her final wishes. The same issue would resurface when Art's father passed almost a decade later.

The first thing I did when I got back home was to meet with an attorney and have everything put in writing. Ryan has known of our wishes since he was a teenager. I honestly feel that simplifies things tremendously. The "death" conversation is so much easier when death is not imminent.

I stepped out of the limo at the funeral home after her burial and spotted a little dog across the street. The dog sat down on the sidewalk and just looked at me. I walked toward the puppy. I could hear Art saying, "Don't look at the fucking dog; don't touch the fucking dog," so of course, I picked up the fucking dog. I could also hear Ryan's voice. "Get the dog, Mom!" I asked our driver to stop at a veterinarian's office on the way to my parents' house. We were expecting hundreds of people after the funeral, and I couldn't do anything with the puppy at the moment.

We walked in, and I explained the situation to the vet. He listened patiently and asked why I kept calling the dog "he."

"Well," I said, pointing to what I thought was his penis, "because of that."

The vet said, "No, Señora, she is just emaciated."

At that moment, I knew Mom had sent that dog to me, to us. We named her on the spot. Molly was an amazing dog for the eleven years we had her. Her favorite thing to do was go on long runs with Art. She died of a heart condition like my mom, at the same age in dog years as my mom.

The next month was a blur. Art and Ryan flew back after the funeral, and I stayed to help my father. He didn't know how to cook or take care of the household, so I needed to find him help. He was

completely distraught and understandably angry over my mother's death. I was also angry she was gone. Beyond that, I was pissed I had to deal with my father being angry and telling me almost every day he wanted to die to be with her. Molly was the only bright light during that very dark time. After a month, I felt my father was settled enough for Molly and me to fly back to Tampa. Ryan was turning eleven, and I wanted to be there for his birthday.

8

MAMA MIA

Abba

The second or third night I was home, I woke up to see my mother sitting at the foot of my bed. She looked beautiful, just like she always did. She seemed very peaceful and had a small smile. She didn't say anything. I woke up and told Art about my "dream." He didn't say much. He just hugged me.

Mom came back for the next four nights. The pattern was the same. She sat at the end of my side of the bed and gave me that little smile. She said nothing. I knew I wasn't dreaming. She was there. I didn't know what to do. On the fifth morning, I told Art I believed I was going crazy, like, for real crazy, and I needed to seek professional help.

I was trying to figure out what to do or who to call when I decided to check in on my dad. I was hesitant about sharing this information, but a prompting overrode my feelings, and I blurted out, "Mom has been showing up every night. I don't know what to do. I think I need professional help because I think I am going crazy."

His reaction surprised me. He started crying and said, "I have been praying to God for a sign. I wanted to know your mother was okay and in Heaven. You just gave me the answer, *mijita*."

I've never "seen" her again. I feel her around me all the time, but as of now, I've never experienced that type of visitation with her again.

My father passed away almost exactly six months later, on September 8, 2006. He died of a broken heart. In reality, he died of sepsis. He fell and cut his shin on the porch while watering my mom's plants. The small cut became infected. But we all knew he died of a broken heart; the sepsis was just the physical manifestation of his true condition.

I spoke to him a few days before he died, and he pretty much told me he was going to die from that cut. The cut was not a big deal at all, and I said, "Well, that's a cheery thing to say on a Monday morning!" I was being sarcastic, of course, but nine days later, he was gone. He slipped into a coma while I was on a plane en route to Laredo, but Andrea had made sure to let him know I was on my way.

As the oldest, the job of signing end-of-life paperwork fell to me. The decision was made by both of us, of course, but the signature on the orders to disconnect him was mine. I signed, and we went back to Andrea's house to get some rest before returning to the hospital the next day to wish him goodbye. My father's final gift to me was to pass away peacefully on his own during the night so I would not have to carry the burden of that decision for the rest of my life.

I felt so different after his death than how I felt after my mom's. I was so angry at her for dying. This other feeling was unexpected. I was almost happy. I was heartbroken he was gone, but I knew how devastated he was without her, and I knew this was better.

Three weeks later, after going through the funeral and all the necessary arrangements to get the house emptied and sold, I once again flew home to Tampa. A few nights later, I woke up to find my dad at the end of my side of the bed. My bedroom was a busy place! Same protocol as my mom. He didn't say a word. He just looked at me and smiled, and this time, I understood. This message was for us, for Andrea and me. He was good. He was happy, and he was with

Mom. I acknowledged that, thanked him, and have never "seen" him again, either.

By the time I turned thirty-nine, I had buried both my parents and our beloved Yorkie, Lily. She died of an aneurysm at my feet a month before my father passed. Our home was also broken into while I was in New York City on business about a week before my father died, and the majority of my mother's and my jewelry was stolen. What I would have given to be able to sit down and eat a slice of tres leches cake with my parents at that point.

9

MAN IN THE MIRROR

Michael Jackson

/ remained angry (mainly at my mom) for about the next year and a half. I couldn't shake the funk I was in. I look back and see how hard Art tried to cheer me up, and I feel horrible at how awful I was to him during that time.

The cobwebs slowly started clearing as my fortieth birthday drew near, and I was able to stop marking the date every month as to how much time had passed since their deaths. Art, always trying to make me happy, gave me a beautiful two-week birthday trip to the Amalfi Coast, followed by a few days in Paris, France. Four other couples made the incredible gesture of flying to Europe to share this adventure with us. We climbed Mount Vesuvius, hired a driver, and explored all the amazing cities of the coast. We cruised the Mediterranean on a private yacht, toured Pompeii, and walked the streets of Rome. The trip was magical. I chose to make Sorrento our home base, as that had been one of my mother's and my favorite places when we visited Italy in 2004.

The combination of my parents' deaths and turning forty became an invitation for me to deeply reflect and take a clear look at my life. I decided to start making changes in areas that I knew no longer served me. I needed to be brutally honest with myself. Who and what did I

need to let go of? This was years before my "bathroom moment," but these changes gave me the foundation to make the big pivot almost a decade later.

On Valentine's Day in 2008, our two dogs, who sleep with us, got into a fight in the middle of the night for some unknown reason. The room was pitch black, so I put my hands up to try and break them up, and one of their collars ripped off my nail. I jumped out of bed and ran, in the dark, into the bathroom. I could feel blood dripping down my hand. I turned on the light, looked at my finger, and the next thing I remember is Art kneeling over me, asking if I was okay. I had passed out and fallen, face first, on the ice-cold travertine stone floor. I don't know if the sight of blood, the pain, or the adrenaline caused me to faint, but the result was a smashed nose, a split lip, and loose teeth. I couldn't eat solid food, aka my Eggo waffles, for several days. A friend, Amy, came over with fresh ginger and showed me how to make raw smoothies. I did this for five days and was amazed at how good I felt despite my physical appearance at the time.

Almost by accident, my diet ended up first on the list of changes. I had always been able to maintain a decent weight with exercise, but perhaps the time had come for my Diet Coke and Eggo waffle breakfast to go. I knew this breakfast was not a healthy option, but I enjoyed it, just like I enjoyed all the other junk food I ate. This change ended up being more drastic than I initially intended it to be. I thought I would just switch out some of my current choices for healthier options, but then Amy told me about a book she read and what she was doing. She looked amazing, so I ordered the book.

I read the book and immediately decided to embark on a raw vegan lifestyle. I now feel that was Divinely guided as a way to reset my body, but at that time, I just wanted to feel better and lose a few pounds.

Art agreed to try eating raw vegan as well. We lasted about a year and a half, and I can honestly say I never looked or felt better.

However, the raw vegan lifestyle became hard for us to maintain. We were constantly hungry, and forget about going out to dinner with friends or going to parties. I remember being invited for coffee to a friend's house, and the minute I walked in, she said, "Well, I know you don't eat anything, so I don't have anything for you." Friends felt we were difficult to go out with. What is really funny is that now most of my friends are very conscious of what they eat, and some have even more restrictions than I do!

We were also foodies at heart, so eventually, we began to add high-quality animal protein back into our diet. We continued to eat as clean as possible with an occasional dirty martini and skinny fries mixed in for good measure. Life was about balance, after all.

Changing my diet was the first step, but this piqued my interest in all things holistic. I feel my spiritual journey started here, even before I understood that I was on a spiritual journey.

Next on my list was creating a healthier home. I purchased a book that walked me through ways to make better choices about the products I used in my home and on my body. I immediately eliminated all the typical toxic cleaning products in the house. I was shocked to learn how harmful everyday personal products were. I started seeking alternatives and discovered essential oils. I learned to use them in place of chemicals and unsafe personal care products.

As I made these exterior changes, I could feel interior changes screaming to take place as well. The next item on my list I knew had to happen, but I didn't want to deal with it. Removing products you know are dangerous to your health is easy; removing people, not so much. The time had come to part ways with my business partner of almost four years.

I felt tremendous guilt. Elena had taught me how to run an interior design practice. I would never have started my own practice had she not reached out and asked me to partner with her. However, we were no longer in sync. We worked at different paces. Our biggest

client began asking me to show up without her at appointments. The client no longer wanted my partner working on any of her projects because Elena worked at a slower speed than my client liked. Elena and I split all the profits evenly, so this became an insurmountable problem. Something deeper was happening within me, though.

There was an underlying energy I could not explain. I felt my stomach clench every time I pulled up to our showroom and knew I had to interact with her. Despite my guilt, my gut told me to dissolve the partnership. I followed my intuition and ended our business relationship in May of 2008. As expected, I lost her as a friend, but I gained the independence and strength I needed to go out on my own.

10

THE LETTER

Joe Cocker

On August 3, 2008, a letter arrived that would once again change my life. I walked out to the mailbox between rainstorms to get the mail. Inside was a letter with no return address. I felt a strange sensation in my stomach and ripped open the envelope as I stood in front of the mailbox. I knew the moment I read those words that my life would never be the same again.

Thank goodness my parents had always been completely honest about my adoption. I knew from a young age I did not come from "mommy's belly." My parents instead said, "You were chosen and are special."

They told me if I ever wanted to look for my biological parents, they would help. I never felt the need to do so. I know this story can be different for others who have been adopted, and this path can go in a multitude of ways. This was mine.

Over the years, many people made comments like, "Don't you want to know who your real parents are?" My answer was always a resounding "No. I already know my real parents." However, somewhere along the line, I created a caveat. "If she ever found me, I would be open to meeting her because I am grateful for the life she allowed me to have by giving me up." Of course, never in my wildest dreams did I

think a little loophole would come into play. Until the unimaginable happened.

The words on the page stared back at me. I must have read the letter at least five times before the words on the page made sense in my head, and I could move. The letter was from a private investigation agency stating a biological family member was looking for me. I felt a few raindrops and snapped out of my daze. I ran inside, raced past Ryan and his friend who were deep in the middle of a game of Risk, and called Art.

"I am not sure what this is. I think she found me," I told him.

Art felt the letter was a scam. My parents had told me they paid for my adoption records to remain sealed. They did not want me to have to deal with this exact type of situation. That meant this letter couldn't be what I thought it was.

Andrea was my next call. If anyone could understand my emotions at this exact moment, Andrea could. As I read the letter out loud, she kept saying, "Oh my God, no way."

"What do I do?" I asked.

"You have to call back," she said.

I took a deep breath, opened a bottle of organic wine, sat at the kitchen table, and ate some of the all-natural oatmeal raisin cookies that had just come out of the dehydrator for the boys' snack. I thought about how my parents would react. They were my parents, the ones who changed my diapers, dressed me for school, put me through college, and threw me a three-day fairytale wedding. They were the ones there for the birth of our son, his baptism, and his countless soccer, football, and lacrosse games. They were the ones who bought an extra seat on a plane to fly an almost-life-size clown piñata from Laredo to Tampa for Ryan's first birthday party. Memories of my mother and me dancing on the ottoman late into the night at one of our Christmas parties, as my dad came marching down the hallway when the Notre Dame fight song was loaded into the iPod, flooded over me.

How was this new information going to fit into all this? I had buried my parents less than two years ago. I was just coming out of the darkness. I was implementing real changes in my life. I was running my own business and raising a teenager. My in-laws were alive, and our spare time was divided between visiting my sister's ever-growing family in Texas and Art's family in New York. We had wonderful holiday traditions with friends who were like family in Tampa. Did I want to disrupt everything? What did this new family want from me?

I took a large sip (okay, gulp) of wine, looked at the letter again, and dialed the number. Without giving my name, I asked what the company did, in particular, the person who signed my letter. "She deals exclusively with biological parents who are searching for children they gave up for adoption," the person on the other end told me.

I slammed the phone down. I couldn't make this shit up if I tried. I called Art. "She found me, she found me," is all I could say. "What do I do now?" I asked.

"Once you open the door, you can't close it, so be very sure you want to open the door," he said.

That would prove to be the truest advice of all.

Another phone call to my sister. "Andrea, I don't even know what to ask; what if this is a mistake?"

Andrea had attempted a search for her biological parents several years before, which ended unsuccessfully. She was told by a judge the records were sealed, and there was no need to open them as it was not a life-and-death situation.

"Oh my God, that is why they are looking for me. They need something!" I screamed.

Even though she is four years younger than I am, Andrea calmed me down and proceeded to give me the information she had so I would be informed if I decided to call back. She encouraged me to call. More

wine. Another cookie. I picked up the phone and dialed. This time, I asked to speak to the person who sent me the letter.

My first question: "How many females got this letter?"

She answered, "Nine." I felt a sigh of relief wash over me. Maybe this was a big mistake and my life would be back to normal in a minute. Okay, next question.

"What hospital was the person you are looking for born at?"

She answered, "Seton." Oh oh, that matched my information. Not ready to panic yet. I still had a couple more questions.

"Where did the female she was looking for go for her adoption?"

"Home of the Holy Infancy," was the reply.

Shit.

I still had one final question, and this one was a biggie. When I cleaned out my parents' house and went through all their documents, I had found my birth information. I had a page that physically described my birth mother. What did this person looking for me look like?

We matched up line for line: height, eyes, and hair. This was not a coincidence. This was my birth mother.

"So, now what?" I asked.

"I will pass along your phone number so they can call you and have a chat," she said.

"No, they can't call me!" I practically screamed.

"They have been anxiously looking for you for almost twenty years. They are going to want to talk," she explained.

Well, I had only known about them for about thirty minutes. I was nowhere near ready.

"Can they write to you?"

"Yes, they can write," I responded, in what was hopefully a calmer voice. "Do you know what they want? Is there a medical condition? Is there a financial need? I am not sure I want to open this door unless I have more information up front."

She promised to look into my questions and call me back with information before she told them she had found me.

More wine. More memories. My parents had always made me feel extremely special about being chosen. They had doted on my sister and me, and because of that, I never felt the "hole" some adopted children say they feel, hence the fact I never had an interest in finding my birth parents. I knew my biological mother had spent the majority of her pregnancy at the Home of the Holy Infancy in Austin, Texas. I knew she was eighteen and obviously unmarried. I knew her parents sent her there and she gave me up because she was not able to raise me herself. This was 1967. Things were different. My mother and father had always taught me to feel gratitude toward her for carrying me and for giving me a chance at a better life than she would have been able to provide for me at the time. I understood that clearly when I held Ryan in my arms for the first time. Anyone who has had the privilege of carrying and giving birth to a child can relate to how difficult and gut-wrenching a decision she made to let me go.

I knew she thought of me every September 14th. Even if the rest of the year went by without a second thought, I knew on my birthday, she thought of me. That had always been enough for me. Did I really need more now? Suddenly, a conversation I had had with Sadie the previous week came crashing through the wine and cookie haze I now found myself in. She knew I was adopted and had asked me if I had considered looking for my biological mother now that my parents were deceased. I replied as I always did. I was grateful for what my birth mother had done for me, and I would never want to disrupt her life in any way. I was convinced she had moved on, and I did not want to jeopardize anything for her. What if she had never told anyone about me? She did not need me to remind her of her mistake. Blah, blah, blah. I gave my standard speech.

Sadie kept repeating, "I bet you look just like her." *What an odd thing to say*, I remember thinking, but people sometimes didn't know what to say when this subject came up. I changed the topic, and we continued setting up for her mother's sixtieth birthday party.

Those words came flashing back now. Were her words a sign? A warm-up to prepare me for what was about to happen? Did I look like her?

I anxiously awaited the agency's phone call the following day. I found out there was no medical or financial agenda, and the search for me had gone on for almost half my life in one form or another. *Wow.* The agent gave me my biological half sister's information and told me she had been the agency's main contact. The agent then told me she had spoken to Beth, that was her name, and felt I would be hearing from her soon.

Soon came two days later. A FedEx letter arrived around 10:00 a.m. I was working from home and getting ready for a visit from Andrea and her five-year-old twins, John and Emmet. She was coming to spend a week at some beachfront cottages in Sarasota with us before all our kids headed back to school.

I sat in my office and took a deep breath as I slowly opened the envelope with my mom's antique silver letter opener. Inside was a handwritten letter from Beth and two photographs. One was of her, her brother Kyle (my half brother), her dad, and her mother, my birth mother. My birth mother's name was Sofia. A name. I had a name. I had never really thought of her as having a name. She was just "the biological mother." Now here she was, a person with a name, a face, and a family, staring back at me. The other picture was of Beth, her husband (at the time), and their two little girls.

I stared at the photographs for a long time. I had never seen anyone I resembled before. Ryan looked like me, but he also looked a lot like Art.

Sadie's words floated back to me. "I bet you look just like her." Shit, I did look exactly like her. For some reason, I didn't expect that. Our body types were completely different, but our faces were incredibly similar.

Beth's letter was heartfelt, and she repeatedly expressed they had no wish to disrupt my life. She said if I chose not to have further contact, they would respect my decision. Beth said she and her two brothers had known about me since they were teenagers and had wanted to find me for many years. The family would wait until I was ready to respond. She included her email.

I put the letter in my purse and hopped in the car to pick up Andrea and the boys from the airport. I was picking up one sister after reading a letter from another sister I hadn't known existed.

On the ride from the airport to my house, Andrea asked, "Have you heard anything?" I told her about the letter in my purse and that she was welcome to read it. I don't think I had finished the sentence before she was digging through my bag and tearing open the letter.

She read quietly and stared at the pictures. "You look just like her," she said. She picked up her phone and called her husband. "You won't believe what I am looking at. Alejandra got a letter and pictures. This is definitely her birth mother. Alejandra looks like them."

As she spoke, she folded the letter and tucked the envelope back in my purse.

11

MARGARITAVILLE

Jimmy Buffet

We went home, and I cooked while Andrea and the kids unpacked. After dinner, Art asked what he could do to help. We asked him to watch the kids so Andrea and I could go up to my office.

Andrea helped me write an email and choose pictures to send back to Beth. Beth responded almost immediately. She sent more pictures. We spent most of the evening doing this, the sister I grew up with on one end and the biological half sister I had yet to meet on the other. I felt almost guilty as if I were cheating on my family, and I had to keep reminding myself that this family came looking for me. I didn't do anything wrong, but I had "opened the door," as Art said, and I didn't know where it was going to lead me.

The next morning, all of us headed to Sarasota. Andrea and I spent five days walking on the beach and talking about our parents and how complicated mother/daughter relationships are. We were discussing Mom as we walked during low tide one afternoon. I made a comment about how crazy she made me sometimes. I brought up the stupid tres leches cake that she got for me when she knew full well I didn't like that flavor. At that exact moment, a seagull flew by, and I felt something warm hit my chest. I looked down to see bird poop dripping down between my breasts. Andrea looked over at

39

me and then at my chest. She doubled over and almost fell into the sand, laughing as she said, "Well, we know she is watching over us and listening to every word we say!"

No shit.

We stayed up late and talked about the fact that even though our mother always had the best of intentions, the pressure we felt was immense. Andrea and I always had to be "perfect." Perfectly dressed, perfectly behaved. Mom would say, "Someone is always watching, so you have to present the absolute best version of yourself." There was never any downtime. I didn't know at that point that a huge part of my healing would entail me releasing myself from the pressure to be perfect.

I remember thinking it wasn't right to have to get completely dressed up to go to the grocery store, just in case "you run into someone you know." My mom did that. Her mother did that before her. Laredo was a pretty small town at that point, but the fact that someone would care and then talk disparagingly about you if you were wearing less than your best at HEB seemed ridiculous.

That scenario added to my desire to leave Laredo. I knew, from the time I was very young, that somehow I had landed in the wrong spot. I never felt I belonged there, but I could not explain or express why I felt that way. I just knew. I wanted to live in a big city. I wanted to show up at the grocery store after an awesome, sweaty workout with no makeup on, because really, who cared? My sister Andrea and I both chose to live in large cities, and I can almost always be found at the grocery store in workout clothes with little to no makeup.

Andrea and I talked about her adoption. She had wanted to find her biological parents, and my parents had done all they could to help her do so. In her case, the searches all came up empty, and she was not able to get the closure she sought. So interesting how two adopted children, raised in the same home by the same parents, could have such different thoughts, desires, and outcomes.

She and I talked about their respective deaths. Mom's was so un-expected, which led to Dad's becoming imminent. They'd had a great love affair for forty-five years, and he could not bear to be on this planet without her.

Walking on the beach with Andrea finally gave me the closure I had been seeking for almost two years. Our conversations allowed my anger to finally completely dissolve and wash out with the tide. This closure gave me the peace to move forward with the new family that was waiting to meet me. I knew in my heart these people were not only a gift from God/Universe but from my parents as well. I no longer felt I was disrespecting my parents by allowing Sofia and her family into my life. I emailed my phone number to Beth that night.

12

CALL ME

Blondie

Andrea and the boys left on Monday, August 11, one week to the day of the letter arriving. August 11 also happened to be Sofia's fifty-ninth birthday. She had plans that evening, so the first phone call came from Beth and Kyle, Beth's brother and my new half brother. I listened as the voice on the other end of the line tentatively said, "Alejandra?"

"Yes, it's me."

"Wow, I can't believe we are actually speaking to each other," she said.

"I know, this is wild."

We chatted for over two hours. She and Kyle were at a local Mexican restaurant having margaritas as the three of us chatted on speakerphone. Our conversation felt natural and easy. Beth did most of the talking. She started by telling me Sofia's story.

Sofia and Beth were in the car one afternoon when Beth was about fifteen. Sofia pulled over and said, "I have something to tell you. I had a daughter when I was eighteen years old, and my parents forced me to give up the baby for adoption."

Beth told her mother she suspected this news because she had found a letter in the family Bible to "dear baby girl," and what the

42

letter said didn't pertain to Beth. Beth didn't share the details of the letter with me while we were on the phone, and it didn't feel right to ask.

Her mother started driving again, and once home, Sofia and her husband sat at the kitchen table with Beth, Kyle, and their other brother Matt (who passed away before I met him) and told the entire family everything.

The story was the typical high school romance. Sofia found out she was pregnant when she was seventeen. She was understandably scared. Her parents were old-school and very upset and saw the predicament Sofia was in as bringing shame to the family. They forced her to stop seeing her boyfriend, Dick. His family also forbade him to see her. Sofia was sent to "visit an aunt in California." In reality, she was shipped off from Houston to Austin. She spent the last six months of her pregnancy at the Home of the Holy Infancy, a Catholic adoption agency and home for unwed mothers. She called Dick's house to let him know she had given birth to a baby girl. His mother answered the phone. She told Sofia to never contact them again and hung up on her. Many years later, I would find out I was born on that woman's birthday. Not sure how I feel about that to this day.

The nuns took me away from Sofia three days after I was born. They told Sofia my parents had arrived to pick me up and she needed to sign the adoption papers immediately. As Sofia sat across the table from her kids, she explained that signing those papers hurt her heart and was the hardest thing she ever had to do, but without support from Dick, his family, or hers, giving me up for adoption was her only option. She realized adoptive parents could give me the love and life she could not.

I told Beth, "I have pretty much been told a version of that story my entire life. My parents were always upfront with me, and we knew the birth mother had been very young and assumed she did not have much of a choice."

The startling news was about Sofia saying the nuns handed me over to my parents at three days. I knew my parents didn't pick me up from the adoption agency until I was five weeks old. For some reason, we had discussed that detail many times. The same time frame held true for my sister, Andrea, so now the big question was, who had taken care of me in the interim? Beth didn't have an answer. My parents were no longer alive, so I couldn't get an answer from them. That five-week time gap would end up being a major part of the spiritual healing I needed to do. As we wrapped up, I told them I felt nothing but gratitude toward their mother. I understood her unplanned pregnancy took place during a time when people felt shame, embarrassment, and anger about the situation. Few families rallied around a teenager who was expecting. Her difficult and painful decision led to my amazing parents and life.

Sofia and I spoke on the phone the following day. She had a very distinct Texas drawl, just like Beth and Kyle had. I sat, looking out my dining room window and watching people drive home from work and going about their daily lives as I embarked on a monumental new chapter of my own life. She retold me some details Beth had described the night before. She asked a lot of questions about my family and my life in Tampa. She also said, "We are happy to find your biological father if you want. I feel strongly you should have complete medical records."

"Thank you," I said, "but I am not able to even think about finding him at the moment. This situation is overwhelming enough for the time being."

I told her I knew none of this would have taken place if my parents were still alive. "I truly felt this would have been brutal on my mom, even though she offered support my entire life. Honestly, I am more open to exploring a relationship with you and your family since they are both gone."

13

DALLAS
The Flatlanders

About a month after we started communicating, Sofia and I decided to make plans to meet in person. I agreed to stay in Sofia's home so we would have more time together. I flew to Dallas alone because I didn't want to expose Ryan, who was only thirteen at the time, to them if we met and I then felt the relationship had no future.

As soon as the plane touched down, I got off and ran to the closest bathroom. My hands were shaking, and my stomach was in knots. I took so long to compose myself that by the time I walked into baggage claim, my bag was the only one left on the belt. Sofia and her husband were standing there looking anxiously at the door. I felt a twinge of guilt, knowing I had kept them waiting so long.

Seeing someone I looked like for the first time was bizarre. She's five foot one and has a totally different body type, but our faces left no doubt we were related. They hugged me. Her husband graciously grabbed my suitcase, and we headed to the car. They asked if I was hungry, and I honestly can't remember if I was or not, but we stopped at one of their favorite casual restaurants and had a light lunch before heading to their house to meet Beth and Kyle.

In hindsight, staying in their home was a huge mistake. This is one of the best lessons I learned and can share with anyone who may

45

be going through a similar situation. I own my part in all of this by saying I did not do my research beforehand. I was not prepared to mindfully navigate a situation of this magnitude. My advice would be to stay in a hotel or any other place where you are able to extract yourself from these new people for a good amount of time each day. Give yourself time to decompress. The reality is that these people are strangers! They are only family at this point because of shared DNA. I don't mean this to be harsh, but this is the truth, and I was completely unprepared.

Even though everyone was very welcoming and had the best of intentions, the experience was utterly overwhelming. I felt thrilled and sick to my stomach at the same time. I had no time to process anything. People kept coming over to meet me. There were nieces and nephews, sisters-in-law and brothers-in-law, neighbors and friends. Her husband was intent on finding qualities or interests Sofia and I had in common and saying things like "blood is thicker than water." Of course, this did not sit well with me since "water" in this circumstance referred to the people who raised me, when the "blood" gave me away. Still, I tried to be respectful, as I knew he was desperately trying to find similarities in order to make us all feel closer. Beth, Kyle, and I kept staring at each other in search of physical similarities. We realized she and I had the same hands, and Kyle and I had the same lips. I had never had anyone to compare physical traits with, and seeing the similarities did at least create some sort of connection.

The next three days were a whirlwind. The night of our last dinner, my head started to hurt. I dismissed this as a tension headache. Although I don't suffer from headaches, getting one seemed pretty natural, given the situation. I ordered a glass of red wine to help me relax and had chocolate cake for dessert. I would later come to find these were major triggers for what I was actually experiencing. By the time we returned to Sofia's house, I was having a hard time seeing, and light began to bother me. I was sitting in the family room with

everyone when I jumped up and ran to the bathroom to avoid throwing up directly on the coffee table. I was mortified and apologized as I came back into the room.

Beth looked closely at me and said, "She's having a migraine!"

My flight had to be canceled, and I was in bed for two days before I was well enough to fly home. I don't know if I would have been spared the three-day migraine had I stayed in a hotel, but I certainly felt I could have helped myself by having time to decompress and not feel "on" for the entire visit. Even though our first meeting in person had unfolded in the best possible way, I was not prepared for the flood of roller coaster emotions I would experience while there ... and in the months to come.

14

PARTY OUT OF BOUNDS

The B-52's

I wish I could say having my birth mother and her family find me was the fairytale ending to my story, but that would be a lie. I will always be truly grateful they found me. Having them come into my life would be the catalyst to the most important lesson for my spiritual growth, and Sofia would be my greatest teacher, but the journey was difficult, even harsh at times. A lot of people were involved. Art, Ryan, and my sister, Andrea. Even though she encouraged me to go through with meeting the biological family, things changed after Sofia came into my life. I tried to combine families for a few events in San Antonio, but the situations always felt forced, and I felt Andrea start to pull away. Our phone calls and visits became less frequent.

Sofia invited the three of us to join them on their annual summer family vacation in South Padre Island, and we accepted. I was really looking forward to introducing Ryan and Art to the family and enjoying a fun-filled, relaxing week at the beach with Sofia, her husband, Beth, Kyle, and their spouses and children.

The trip started off well enough. Ryan loved playing with the other five children, even though they were much younger. Art and I spent time trying to get to know everyone better, but eventually, the

cracks started to show. Everyone was making an effort, except Beth. She seemed to distance herself from me and acted mad if other people were spending time with me.

Even though Beth had been instrumental in finding me and claimed she wanted a sister, her actions began reflecting the opposite. My parents had taught me that actions speak louder than words and paying attention to how people treat you is the key to how they really feel, regardless of what they say. This, of course, worked the other way as well. My parents' teaching was mainly to show me how to treat others, but I could hear their words swirling around in my head, and this time, they were meant for me.

Art and I were making smoothies at the time, and we offered to make them for anyone who wanted one. Almost every morning, our condo was filled with the smell of coffee and suntan lotion, the whir of the blender, and lots of chatter and laughter as people popped in for breakfast. One morning, Beth opened the door, stood in the doorway, didn't say anything to any of us, and stuck her hand in as if she was holding an imaginary cup. Her husband asked if that meant she wanted a smoothie. She made some sort of grunt that he took as a yes. Art and I just looked at each other, not sure if we were supposed to respond.

Beth and I had had an argument over an issue the night before. I honestly can't remember why at this point, which means the reason was probably trivial. I shrugged, and Art poured a smoothie in a to-go cup since she was clearly not coming inside. Her husband walked the cup over to her.

I began to notice there always seemed to be a problem or drama when Beth was around. People appeared to walk on eggshells around her and did everything she wanted all the time. I didn't understand why. Even though the rest of us had a great time together and there had been good vibes up to that point, after smoothie-gate, the trip became uncomfortable for everyone. Beth either walked away when

I approached a conversation or group of people or grunted and was dismissive when I made any sort of comment.

Pretty much every member of my birth family pulled me aside individually to give me advice about Beth the next day. They all explained this was her normal way of operating and I should just ignore her. There seemed to be more they were not saying, but I could not figure out what that was. I, for one, found her difficult to ignore and was now upset for putting my family and myself in such a vulnerable position with these people. South Padre Island, one of my favorite vacation spots, had now become more prison than paradise.

Here's the thing I now realize. You have to be prepared. I was not. I went into this situation with my heart open and my eyes closed. I didn't do any research on how to navigate this scenario of traveling with a new family, and I really should have. I thought because my parents had always told me the truth about my adoption that I was emotionally prepared to deal with this new family. In all honesty, the expectations and assumptions on both sides were probably too much for all involved to handle well. The concept of an instant family is impossible. We had only been around each other for a few days in Dallas, and everyone had been on their best behavior. We had experienced a honeymoon phase where everything seemed shiny and new, but eventually that faded, and people showed who they truly were and how they truly felt, and reality set in.

I feel we all do this more than we realize—going in with our heart open and our eyes closed. As human beings, we want to trust and usually expect we will receive the love we happily give. That will not always be the case. Sometimes people are not capable or have different intentions. We may not know what is going on in their lives to cause this; all we feel is the sting of their rejection. We don't need to become untrustworthy and closed off, but we do need to be careful who we open ourselves up to fully. In this case, Beth liked the idea

of me, of having a sister, but she lacked the maturity to handle the reality of me.

My parents expected a lot out of me, and I grew up continuing to expect a lot out of myself. I pushed myself to achieve the life I wanted. I worked hard to get into and graduate from the University of Notre Dame. I pushed Art to travel internationally as much as possible. I learned a third language, Italian, just to be able to chat with the locals when we traveled there. We were successful and self-sufficient. I was happy with the life I had based on my hard work and my choices.

Beth was quite private and chose not to share her true circumstances with me, but her behavior and her words showed she obviously was not happy with her life or the choices she had made, and she projected her unhappiness and anger onto me over and over again. When I chose to accept my gifts, I would understand why I could so clearly feel her disgust toward me.

One afternoon, about four days into the trip, Sofia asked me if I wanted to go for a drive. I said yes, and when we got back, she parked the car but did not get out. Sofia turned off the ignition. She said she wanted to talk for a minute. She told me she had been working up the courage to do so the entire trip, but circumstances with Beth had made having this conversation more difficult.

Sofia said, "You don't have to speak or even try with Beth anymore during the trip. Beth's issues are her own to deal with, and you should not take them personally."

Easier said than done! Beth's seemingly permanent negativity and demeanor made me feel that so much was not being said or shared with me. I had come into this situation fully open and ready to embrace them as family and was starting to feel they were not responding to me in the same manner.

Sofia then said she loved me. Her words seemed heartfelt, and I could see she was torn between the daughter she had raised and myself. I thanked her and told her I felt the same about her and felt bad

things were not working out with Beth as I had hoped they would, although I wasn't quite sure why.

I spent the next few days focusing on and getting to know the rest of the family and honestly, avoiding Beth as much as possible. Dinners at the beach were a big deal since we were a large group. We went out a couple of nights and then each individual family took turns cooking for everyone. We ate outside overlooking the ocean. The dinners were a blast, and we shared recipes. To this day, one of Ryan's favorite meals is my sister-in-law's chicken marsala. After dinner, the adults would hang out and sip wine while the kids ran around. When our turn came, Art and I made a big Mexican dinner, complete with his killer organic margaritas and my homemade chips and salsa. Everyone had wonderful things to say about our food. Beth was the only one who didn't cook, so that became one more thing she held against me.

15

COLD AS ICE

Foreigner

After the beach trip, I chose not to communicate with Beth. I would later learn, during my healing process, that this behavior on my part was how I dealt with deep-seated rejection and abandonment issues. Subconsciously, my go-to behavior was basically, "I am going to leave you before you have a chance to leave me."

However, the rest of the family and I spoke regularly. One afternoon, several months later, I received an email from Sofia, inviting me to a mother-daughter trip to New York City. She wanted a chance for Beth and me to spend time together so we could get to know each other away from everyone else. I thought the trip was a great idea. Since I traveled there often and was most familiar with the restaurants and theatre scene, Sofia asked me to create our itinerary.

I put a lot of time and effort into our plans to show them the best time possible. I was well aware of their religious beliefs and always did my best to respect them. Sofia had shared her religious history with me early on. She and her husband were both raised Catholic, as I was, but they had left the Catholic Church at some point and became Evangelical Christians. Beth's husband was a pastor, and they all attended his church. I wanted to make sure the Broadway show I

selected was in no way offensive to them. *Wicked* was running at the time. The show was a family musical based on *The Wizard of Oz*.

I had seen *Wicked* on Broadway and taken Ryan to see the musical when the show ran in Tampa and felt that was a good choice. I emailed Sofia and asked her to read about the show to make sure she and Beth agreed before I purchased the tickets. Sofia replied after she said she read about the show and told me to go ahead with the tickets. As far as I was concerned, everything was settled.

But a few days later, I received an unexpected email from Sofia. She stated, "As for me and my family, we will not expose ourselves to evil."

When I emailed back and asked her what in the world that meant, she said she was referencing the play, *Wicked*. I asked, "What happened? You said you were fine with the show and had done the research." I also said, "If you feel the musical is somehow exposing you and your family to evil, perhaps New York is not the right venue, since you are probably going to see much more you may find offensive just walking down the street!"

In hindsight, maybe I shouldn't have added that part, but really? I was trying to be light-hearted; however, this may not have been my strongest attempt.

Sofia emailed back without answering my question, probably annoyed by my comment, and said the trip was a mistake and was now off. She reimbursed me for the show tickets, and that was that, or so I thought.

A few weeks later, while having lunch in South Tampa, I received a text from one of my closest friends, Grace. The text said, "I thought your mother/daughter trip to NYC was called off."

"Yes," I replied, "Sofia canceled the trip."

Grace told me to look at Beth's Facebook. Beth had posted she was "on the best NYC mother/daughter trip ever!" There were pictures of her and Sofia at several of the places on the itinerary I created for our trip.

I felt the air leave my lungs. My friends at lunch asked what had happened. They assumed there had been a tragedy by the look on my face. I showed them the text and the Facebook posts. I was simultaneously angry and disappointed in myself for allowing Sofia and Beth to make me feel like this. I had not protected myself enough. I had allowed myself to feel like a member of the family, and clearly, I was not. I emailed Sofia that night and let her know I had seen Beth's photos on Facebook and that I was no longer interested in having any kind of relationship with either of them. We did not speak for the next six months.

Kyle was the only person I was in contact with during those six months. He and I got along from day one and had always had an easygoing banter. He called me one night while I was in Atlanta on business and pleaded with me to talk to Sofia again. He said she was incredibly sorry and very remorseful. I asked Kyle to let me think about the situation for a while.

I have always been able to understand Sofia's first "rejection" of me. She was a teenager in trouble, and according to her, she did what her parents forced her to do. This time, as an adult and a mother, the choice was solely hers to make, and instead of embracing me, she purposefully chose to reject me. She chose to take one daughter to New York City and leave one daughter behind, all because I pointed out what she was saying was simply not true—if that was the real reason for uninviting me. Disagreements are fine. Disrespect is not.

Sofia's rejection cut deeply, and as much as the thought of "letting go" sounded wonderful to me, I found myself coming back to the pain her rejection caused when I least expected it.

I will never know what really transpired, as I only have Sofia's emails to go by. Many months later, after I chose to forgive and allow her back into my life, she told me a friend of hers (also an Evangelical Christian) went to see the play. Of course, she told Sofia the show was exactly what I had described. Had Sofia opted to trust and have

faith in me in the first place, the trip could have been the bonding experience Beth and I so desperately needed.

A few years later, Beth started divorce proceedings against her husband. She and the family finally shared a bit more information that helped me better understand some, although not all, of her behavior. Again, though, I was obviously not really part of the family. They constantly used the word *family*, but their actions of withholding "inner circle" information showed I was still considered outside the immediate group. I had come to them with my heart open, without secrets, and very willing to embrace them as part of my family. They did not come into the relationship with the same intentions, and my eyes were closed to that. I am sure they had their reasons, although since I wasn't asking for anything from them, I was not sure what those reasons were. I can understand if I was asking for money, to be made part of the family business, or to insert myself in holidays or other special occasions, but none of that happened or would happen. Had even one of them chosen to be honest and open in the first place, our relationships could have been very different.

16

LIFE GOES ON

The Kinks

eventually allowed Sofia back into my life for a couple of reasons.

I thought of what my parents would have wanted. I feel strongly they had a hand in bringing us together and would want me to fight for the relationship. I thought about taking away Ryan's new grandmother so soon after he had lost his grandparents. Even though Sofia and I had a completely different dynamic, I thought about myself and how nice it was having a "mother figure" again. She did not have any direct say in how I lived my life, but still, some sort of maternal relationship was nice. After multiple conversations with Kyle, telling me how sorry she was, and my considering things for several months, I agreed to talk. Sofia apologized, and we began the process of rebuilding our relationship once again.

At the beginning, Sofia made an effort. She and her husband came for Grandparent's Day at Ryan's school, Jesuit High. They came to lacrosse games. They came for Ryan's high school graduation. Our relationships seemed good. Over the following few years, we had a couple more trips to South Padre Island with the family, but the relationship between Beth and me remained extremely strained. Between that and the fact that Art, Ryan, and I were busy with full-blown travel lacrosse, we gradually let the yearly beach trip fade out.

So, Sofia and I were in a good place in 2014, for which I was grateful, as in general, that year sucked.

In February, Ryan was halfway through his freshman year at Washington and Lee University, and his first college lacrosse season was about to start. I, on the other hand, was in the hospital, having just had a full radical hysterectomy for a grapefruit-sized fibroid that had tilted my uterus. The fibroid was extremely painful. Since I needed this surgery, I found a specialist who combined hysterectomies with bladder tightening. Anyone who has given birth knows why. Leaking while laughing, exercising, or doing just about anything is far from fun and not sexy in the least.

My surgeon explained about 25 percent of the bladder tightening procedures had serious complications. I signed the paperwork in his office, feeling confident I would not fall into that category. Unfortunately, I did. So, as I tried to recover from the invasive hysterectomy, I was also attached to a catheter. I was attached to the fucking catheter for four weeks for twenty-four hours a day. My family and friends took turns driving me to my surgeon's office once a week to see if I could pee on my own. When I couldn't, no matter how much water I chugged, the catheter would be reinserted for another week. This broke me. I had been able to handle a lot of physical pain in my life, but being attached to a catheter that shot sharp pain deep into my belly any time I moved was just too much, and that wasn't even counting the pain of the actual hysterectomy.

Still, there was no way around the issue and no end in sight. The doctor informed me I would have to wait six months before he could operate again and loosen the bladder enough for me to pee like a normal human being. I had two options. I could continue the current plan of action, or I could learn to insert and remove the catheter myself every time I had to go to the bathroom. Neither were solutions I wanted, but I agreed to learn and lived that way (catheterizing myself at least six times a day) for another six weeks. At that point, I was

finally able to pee by myself enough until the six months were up and I could undergo the second surgery.

The hysterectomy was the catalyst for what I hoped would end up being a true mother/daughter relationship.

I had not really opened back up to Sofia after the New York trip rejection. We talked on the phone, but I kept the conversation superficial. When I told Sofia I was having this surgery, she immediately offered to fly in and help me for the first week. She had also had a hysterectomy and knew how hard the recovery was. I accepted because I knew I needed the help. I remembered Mom's hysterectomy. I was about eleven, and we all moved into my grandmother's house for several weeks so she could recover.

Art moved into one of our other bedrooms so he could sleep at night and function at work. The catheter was painful and made me so uncomfortable I was awake a lot and had the television on most of the night. Sofia was an excellent caregiver. She would get up to make toast or bring me crackers so that I could take my pain medicine every four hours. I was not supposed to take the medicine on an empty stomach. My friends brought over food, but if something needed to be made, Sofia cooked. She was a great cook. She took the dogs out while Art was at work and basically made sure our home ran seamlessly so I could rest and heal.

Before Sofia left, she said something I will never forget. I thanked her profusely for all her help, and she turned to me and said, "Thank you for letting me be a mother to you." Now, I certainly would not have chosen to go through all that pain just to get our relationship back on track, but I was grateful it seemed to be better. For the first time since we met, I needed help. Because I did, I once again put myself in a vulnerable position physically, emotionally, and mentally and allowed her in. I couldn't recover alone, so I relinquished control and let her be a mother to me. The time together was a turning point for both of us, at least for a while. My sister, Andrea, was sweet

enough to leave six kids, fly in, and take over for the next few days after Sofia left.

My second bladder surgery, in August, was successful. I was anxious to get back to a normal schedule. In October, however, my recurring back pain from childhood scoliosis got to a point where a doctor visit was in order. I had had a laminectomy when I was thirty-three. A laminectomy is a surgery that enlarges the spinal canal to relieve the pressure of sciatica or any other nerve condition along the spine. The doctors said that surgery would only buy me time. I would undoubtedly end up needing fusion. The pain had held at a tolerable level, with incidents every so often, but had been building back up over the last few years. I needed to see what was going on.

This time, the conversation with my surgeon was serious. The time had come for fusion, a two-level spinal fusion, to be exact, which meant three of the discs in my lower lumbar area would be fused together. So, on December 30, for the third time in ten months, I was back in the hospital for another major surgery. Sofia flew back to Tampa and once again took care of me in much the same way as she had for my hysterectomy. I was only attached to a catheter for a week this time, so I was more mobile. Friends came by to visit, and Sofia was able to spend quality time getting to know my close friends as well. She made sure my flower bouquets were all watered and dead-headed. She cooked. Having her around started to feel nice and natural.

17

THE STRANGER

Billy Joel

I spent most of 2015 recovering, getting stronger, and making as many trips as possible to watch Ryan play lacrosse. I felt good enough to enjoy a beautiful two-week trip to Europe with Art for our twenty-fifth anniversary. Our first stop was London, where we visited Ryan, who was interning there at the time. We took a day trip to Stonehenge, which I had felt strangely drawn to for a long time. The energy there overwhelmed me, and I felt like I was some-how home. We hopped the train from London to Amsterdam for several days and then spent a week in Belgium and France. We had an amazing trip but were exhausted when we returned to the States in early August.

Beth was divorced by the time we returned from our trip. She and I had been slowly texting and trying to build a relationship of some sort again. She wanted us to meet her new boyfriend and asked if they could visit and stay with us. Art and I said, "Yes, of course," since Beth now seemed more open and willing to have an honest relationship. Kyle and his wife wanted to come as well. We had two guest rooms, so there was plenty of room for the two couples. I gave her dates that worked best for us, but they didn't work on their end since our

dates coincided with the start of their children's new school year. In the end, we agreed to their dates, even though we knew we would be completely jet-lagged. I had high hopes for the weekend. After all the ups and downs Beth and I had been through, being able to get together and have fun would be a huge accomplishment.

The sun was shining, so we hung out by our pool, relaxed, and talked. Art and I made a big Mexican meal one night. On Sunday afternoon, while Beth packed, her boyfriend hung out at the patio bar with Art and me. I was sipping chilled pinot grigio, feeling happy and quite relaxed as I sat cross-legged on the bar countertop. I told him I was thrilled to see how far Beth and I had come. I said, "She was such a bitch to me at the beginning, and now look at us. We are able to be together and have fun all weekend without a single issue!"

He said, "That's great!"

Little did I know what was coming after that comment.

Beth came downstairs, and we said our goodbyes as everyone left for the airport. A few days later, I sent an email to Beth and Kyle, reminding them to look at their calendars. We had made a group decision to go to Cancun together in November to celebrate Art's fiftieth birthday. The big day was just a few months away, and we needed to finalize plans. I was completely astonished when Beth responded she and her boyfriend would no longer go because I had "called her out of her name to a stranger."

Her email went on to say, "You had no right to say anything about me to a stranger." That word stood out vividly, as I found it utterly ridiculous. The "stranger" she kept referring to was the boyfriend she specifically asked to bring into our home! They slept in our guest room, ate our food, and drank our liquor, and after three days of hosting them, suddenly he was a "stranger"?

For the life of me, I could not figure out what I could have said to him to get her to say they would not come to Cancun. Then I had a flashback to my conversation with him at the bar. Was that why?

My first question was to ask what "calling her out of her name" meant, as I had never heard that phrase before. I also asked her if my conversation with him at the bar was what she was referring to. Beth refused to give me a direct answer, much like Sofia had refused to do when I asked her why she was canceling New York. I guess like mother, like daughter. Her follow-up emails simply kept repeating that I called her out of her name and I had no right to tell a "stranger" anything about her. Since she would not tell me what it meant, I looked it up on Urban Dictionary and found that the term refers to using an insult in place of a person's name, most commonly "bitch." Okay then, fair enough. I didn't call her a bitch; rather, I referred to her behavior—"she was such a bitch"—but I could see where she could have taken that either way.

However, what I could not get past was her telling me what I could and couldn't say to her boyfriend. That did not sit well with me at all. In fact, her words irritated me tremendously. She *had* been a complete bitch to me for years, and everyone in the family saw it, and therefore, I had every right to say it. I think I was actually angrier at myself than at Beth. I felt stupid for once again opening myself and my home up and letting anyone in that family in. When was I going to learn? Once again, I went into the weekend with my heart open and my eyes closed. I let my guard down and allowed myself to feel like part of the family.

I sat at my desk, fuming, and responded tersely. I informed her I actually had every right to tell anyone I wanted anything about myself, and that is what I had done. Her behavior and her actions were toward me; therefore, I could say whatever I chose to.

I didn't say anything that wasn't true. Perhaps she was embarrassed and didn't want to be held accountable for her previous behavior toward me and had not shared any of that with the "stranger." I didn't know then and don't know now. What I do know is that what was obviously lost when "the stranger" decided to share my comments

with Beth was the tone in which I made them. The point I was making was how far we had come and what a great weekend we had just spent together. Whether he conveyed the conversation incorrectly or she chose to ignore the main point, her emails and trip cancellation led to us not speaking or seeing each other in person until almost three years later.

18

DOWN IN MEXICO

The Coasters

Life, of course, continued to be busier and busier. I was working more, and there was no time to slow down and pay attention to what the Universe was trying to tell me. Looking back now, I see the Universe had been whispering to me for a while, but I was not ready to listen.

We did celebrate Art's fiftieth birthday in Cancun. Kyle had also canceled, without any real explanation, but when we'd planned the trip with Beth and Kyle, we had also included Art's brother and his wife. She was turning fifty a week before Art. So now there were four. We had a fabulous time. On October 31st (Halloween in the USA), the resort had a moonlit beach party. A live band played under market lights strewn from palm tree to palm tree. The setting was magical! We all danced barefoot in the sand into the early hours of the morning. Art and I finally dragged ourselves to our oceanfront suite around 1:00 a.m.

At about 3:00 a.m., I woke up because I couldn't breathe.

I opened my eyes to see a little girl, around six or seven years old, sitting on my chest. She was very dark, with the rounded facial features of the indigenous Mayan people in the area. Her large, saucer-like brown eyes were piercing right through me. I didn't know what to do. I felt a scream rise up in my throat, but no noise came out.

Art was sound asleep right next to me, and I was unable to move or make a noise that would wake him up. The only idea that flashed into my mind was to start reciting The Lord's Prayer. I closed my eyes and prayed. At the end of my prayer, I opened my eyes. She was still there, still staring into my soul.

I whispered, "There is nothing here for you. I wish you peace. You need to move on." Nothing changed. I still couldn't breathe as she sat, staring at me through her thick bangs.

Suddenly, her face morphed into that of a small creature. The closest animal I can think of to describe the creature's face would be a black Frenchie bulldog. The faces themselves were not frightening, but watching the little girl turn into the creature and then back into a little girl scared the shit out of me.

She slowly turned her head to the right in the direction of where Art was sleeping, and the situation went from scary to truly terrifying. My eyes followed hers, and I saw a thick black fog creeping toward our bed. The fog was about a foot away from Art's feet. I knew, without a shred of doubt, I was looking at a dark, evil entity. In that instant, I screamed again, and this time, my vocal cords worked. Art leaped out of bed as I kept screaming, "Something is in the room!"

He ran around the room, turning on all the lights, ripping open the closet doors, and doing his best to calm me down, saying, "You just had a bad dream." I, of course, knew what I had just experienced was not a dream. I made him leave the lights on as we laid back down. I did not close my eyes the rest of the night.

At breakfast, as I downed coffee after coffee, I couldn't shake the memory of what I had been through. I was anxious and had chills even though the temperature was close to ninety degrees outside. We were heading out on Art's birthday catamaran cruise, and all I wanted to do was curl up in a ball somewhere and rest. But even if I wanted to, I knew I wouldn't sleep.

I had a thought as the waiter refilled my coffee cup for the fourth time. I asked him when Day of the Dead was in Mexico.

Even though I was raised in the Mexican culture, this day was not one my family celebrated, so I didn't know much about the tradition. He looked at me and said, "Señora, today is Day of the Dead, but only for children."

That, of course, made every hair on my body stand up, and my chills turned into the biggest goose bumps I had ever had. The little girl! A child! What did all this mean?

On our way back to our room, I noticed a small plaque on the grounds that I had not noticed before, even though I had walked by this spot several times a day to get to the resort's main restaurant. I bent down to read the plaque, and the words, once again, left me unable to utter a sound. The spot I was standing on and a large portion of the resort had been built on an ancient Mayan burial ground! Seriously? Needless to say, I made Art leave the lights on every night and hardly slept the rest of the trip.

As soon as we were back in Tampa, I reached out to my dear friend Heather. Heather and I had been friends for several years at this point. We officially met through our hairdresser Nestor on a Tuesday afternoon. When I was walked back to my station, I was seated next to this beautiful blonde. Nestor said, "Heather, meet Ali. Ali, this is Heather." We both smiled and said hello and started chatting while he worked on hair. As we did, we realized we had been circling each other for years. I had been going to the spa she owned until the day the business closed. We were both sports moms at Jesuit. We knew a lot of the same people. Fifteen minutes into our conversation, we felt like we had known each other for years and couldn't believe we had never met.

Suddenly, Heather asked me the strangest question. "Can I muscle test you?"

My face must have answered her question even before words came out of my mouth. "It's okay," she said, "muscle testing doesn't hurt. You look like you have been through a lot."

She was right, of course. My hair had been the first appointment I scheduled once I could drive after my hysterectomy.

I said, "Okay," and we have been friends since that day. She would be the first, but not the last, to tell me my adrenals were shot and I had something called leaky gut. Heather told me she was a board-certified holistic health practitioner, gave me the names of some supplements she felt would help, and told me to go home and look up what she had told me.

What I read made total sense. Adrenal fatigue is when your adrenal glands are not working properly. I could check off most of the symptoms, like weight gain, hair loss, trouble sleeping, and more. I almost started crying when I did my research on leaky gut. When someone has leaky gut, the gut lining is not functioning correctly. The list of symptoms was long, and again, I could relate to most of them. Heather and I had exchanged numbers, so I reached out to her, and she answered all of my follow-up questions.

A few weeks later, she reached out to me again. She and her husband had sold their current home and were moving to a new one. She wanted to work with me. We agreed to meet for lunch the next day and started working on her home a few weeks after that.

One day, we were out shopping for her home, and there was a room in a store I could not set foot in.

Heather looked and me and asked the strangest question yet. "Do you feel a male or a female energy in there?"

"What? What are you talking about?" I responded.

"You don't want to walk into that room because you feel an energy you don't like."

I honestly had no idea what she meant at the time, but this small interaction opened the door to much larger conversations. Heather is

now one of my closest friends and confidants. I feel she came into my life exactly when she was supposed to.

After my experience in Mexico, I asked Heather if she would meet me for lunch. This was not the kind of story you shared in a text. We met at Hyde Park Village, and I shared the details with her over tacos and guacamole at Bartaco. After lunch, we walked around and I told her I felt like a dark presence was after me, and I was worried this darkness somehow came home with me.

I knew I could feel things; I somehow knew events were happening before they actually took place, and occasionally I saw people. However, up until the little girl in Mexico, the only people I could remember "seeing" were people I loved, so that didn't seem as strange or frightening to me. This event changed how I felt about my gifts. I was scared. I didn't think I wanted to have "gifts." Heather didn't feel I was ever in any danger, but I was so shaken by the encounter my entire body physically shook as I recounted the events to her.

Heather was the first person who told me I had "gifts," and she had been guiding me into this world for a few months now. She and I had many discussions about energy and intuition, but I still didn't really understand what all of this meant. I did notice I was suddenly attracted to crystals, and things that I thought about seemed to happen within days of my thinking of them.

We stopped in front of Pottery Barn, and Heather said, "I am going to reach out to my mentor, Dr. Diane," and immediately dialed her number. Heather said hello and told Dr. Diane she was with a friend who needed her advice, then she passed the phone to me.

Dr. Diane had me tell her everything, and at the end, she said I was actually there to help the little girl.

What? How?

Dr. Diane explained that Art and I were never in any harm, and I was a "light" the little girl was coming to for help. I helped her get away from the evil entity that was after her, not us.

Wow. Okay. That was *a lot* to take in. I thanked her for her time and passed the phone back to Heather so they could say their goodbyes. I knew I would see that little girl's face for a long time, but I gratefully accepted Dr. Diane and Heather's interpretation of the frightening events. Heather and I walked around a little longer and then said our own goodbyes.

The experience in Mexico was just too much for me. I strongly feel I subconsciously shut down my clairvoyance that day. As of writing this book, I have never "seen" someone in that way again. I really didn't want any more encounters like that, and I did anything and everything I could to deny thoughts and reject feelings that could possibly lead down that kind of path ... at least for a while.

19

UNDER PRESSURE

Queen / David Bowie

In the fall of 2016, life started to unravel at home. Art had worked for a startup company for almost two decades, and even though we were always told there were "good things on the horizon," the brutal truth was that he was working for two-thirds of his salary pretty much every year. No bonuses, no retirement, nothing. That was causing an incredible amount of stress at home. Still, we knew we would have limited time with Ryan after graduation, and we wanted one last family trip, just the three of us. We decided on two weeks in Germany and Switzerland before the start of Ryan's senior year.

We came home from the trip to find water pooling in the corners of the wall between our laundry and dining rooms. I called our insurance agent, who had a leak-detection company come out to the house. The inspector found a slow leak in the wall from a condensation pipe and upon further inspection, found mold throughout parts of the house. I did my best to hold back tears as the inspector said, "You have mold." This was going to be a huge problem since the leak had been active for a while, perhaps years.

"How long will all of this take?" I asked.

"At least six weeks, if not more," he replied. "Your entire first floor will have to be torn out, all leaks fixed and mold remediated, and

then the new floors, kitchen island, and interior/exterior walls have to be rebuilt."

Overnight, we had to find and move into a place that was furnished and took three dogs. There were few choices. I was miserable.

I had been sick on and off with bronchitis and lung issues for years, and the mold turned out to be the reason. I stopped by to check on the project the day the kitchen island was being removed and watched as the entire island fell apart. The interior of the island was completely covered in mold. This time I couldn't hold back, and I burst into tears in front of the construction crew. I had been buying organic food and using only nontoxic products, and the reality was I had been breathing in mold for hours a day the entire time. I felt like I was taking one step forward and five steps back.

On top of everything, the holidays were upon us, and work-wise, this was my busiest time of the year. One morning, I was scheduled to drive to Sarasota to work on a client's home, and my car got towed because the stupid apartment complex tag was in the middle console instead of being on the dash. The tag was still clearly visible, so the tow was overkill. Then between Thanksgiving and Christmas, our beloved Molly died. Nothing seemed to be going our way. My life felt like I was smashing into obstacles in every direction. I had a full-blown anxiety attack in the apartment bathroom one afternoon, complete with hysterical screaming and crying. I yelled at Art mercilessly. I was like a champagne bottle whose cork popped after being shaken. After my outburst, I crawled into bed and slept for about twelve hours. I told my clients I needed a mental health day and took the next day off. That small self-care decision was the best choice I could make for myself at the time.

On December 22, we flew to Albany, New York, to spend Christmas with Art's family, as we did every year. Art's dad had been in declining health for a few years, but nothing led us to believe he was close to the end. Art and I went to visit him at the nursing home, and

I barely got through the visit. For the first time, fully conscious of my awareness, I knew he was going to die within days. I carried on as best I could, and when we got into the car, I burst into tears.

Art just stared at me as I told him his dad was dying, not in the "we are all dying" way but in the "everyone needs to come see him in the next day or two" way. He said, "You're being dramatic. I don't want you to walk into the house and alarm everyone. Keep this to yourself."

I profoundly disagreed and deeply felt it was my duty to let the family know. We pulled into the garage, and I hopped out of the car, walked in, and found his brother. After I spoke to his brother, I pulled Ryan aside and told him I wanted him to go visit that afternoon. "What's the worst that can happen?" I said. "You get one more visit in, as opposed to the alternative of having the time, not going, and feeling horrible if something happens."

Art's mom walked into the mudroom while Ryan and I were talking and asked to speak with me privately. She looked me in the eyes and asked, "What do you know?" I told her what I felt to be the truth, and she simply said, "Thank you."

During the next two days, everyone enjoyed nice long visits with Dad. We spent Christmas Day in the hospital as a family. Art's father passed away on the 28th of December, five days after I cried in the nursing home parking lot.

In early spring of 2017, construction and mold remediation were completed, and we were able to move back home. We often traveled to see Ryan play his final college lacrosse season and for his college graduation. We moved him into his new apartment in Chicago's Lincoln Park over Labor Day weekend. Art and I then settled into life as true empty nesters.

I celebrated my fiftieth birthday with trips to both coasts. We had a beautiful trip to Napa Valley, hosted by amazing friends we made at Washington and Lee. Our boys were teammates and fraternity

brothers. The joke amongst our kids is that we traveled back to the campus more often to see each other than to see them! Art also surprised me with a trip to New York City to the Food Network's annual Wine and Food Festival. We had tickets to all the fun events, and we had the opportunity to meet the chefs I loved to watch on television. I started to feel like the clouds were lifting.

A month later, my world was rocked again. In September, I started experiencing strange symptoms. I was dropping things constantly, as I suddenly had little control over my grip. I also began suffering from migraines, which were not normal for me, and experienced several episodes of vertigo. Not sure what was going on, I made an appointment to see my spinal surgeon, hoping whatever was happening was minor. On a sunny October afternoon, my surgeon calmly looked over my MRIs and informed me I needed yet another spinal fusion, cervical this time, and if I didn't get the surgery soon, there was a high probability I could end up paralyzed. I felt like someone had punched me in the gut. "Cervical fusion?" I asked, in a shaky voice. "I don't have problems in that area of my spine. My issues have always revolved around my lower back. What do you mean I need cervical spine fusion?"

I had just finished healing and getting back into shape from the last fusion! We finally had time to travel, and now I was headed back into another major surgery with a recovery that included six weeks in a neck brace and at least a year of healing. "THIS IS NOT FUCKING FAIR!" I screamed as I sat in my car after walking out of his office. I called Art and Ryan, screaming and bawling on the phone like a baby.

I now look back on that day as one of the best days of my life. I had heard the saying many times that the Universe whispered and if you didn't listen, it would eventually scream. Well, I was not sure who was screaming louder at the moment, but I finally decided to stop long enough to listen to the Universe.

I knew my neck couldn't handle doing the holiday decorating. I had actually come to dread doing this part of my job as the years went by, but my clients had come to rely on me. The people-pleaser in me had a hard time saying no. It was time to make yet another change. I closed my business.

As I was trying to sort out my life and plan my recovery, Heather told me she had hired a feng shui consultant named Karen Rauch Carter to come do a home consultation. Karen lived in Naples, Florida, at the time and would not charge us travel expenses if we both hired her. Heather wanted to know if I would be interested in a consultation.

The session was expensive, and Art and I were already stressed about finances with everything going on, but I needed something to give at that point and felt strongly, from deep down inside, that this could help. I said yes. I was excited, intrigued, curious, and above all, desperate for change, so therefore, I was *open*. I had reached the point where I became more committed to change than to my comfort zone.

20

A CHANGE WOULD DO YOU GOOD

Sheryl Crow

Karen came to my house in the fall of 2017, and life has never been the same. During the first ten minutes of my consultation, she told me I would be a feng shui consultant, and I thought, *Yeah right. Let's move this along, and just tell me what I need to do!*

I didn't know what to expect. I had already been reading about feng shui online, and I was successfully using crystals in the garden, but I was not sure what she would do other than perhaps move furniture around. Heather and I were good enough friends that we decided to go to each other's consultations. The plan was to excuse ourselves and hang out in a different part of the house if a sensitive topic came up and then rejoin when asked.

I told Art I would love for him to be home when Karen was there but would understand if he didn't want to. He said he would work from his home office that day. His office was across from our master bedroom, and I knew he could hear us discussing the major changes that needed to take place in the bedroom. Every so often, he would throw in a comment from his office but would not come into the room.

Life was definitely tense between Art and me at that point in our relationship, and I really wanted to fix the problem. However, in his

mind, this was just another way for me to spend money we didn't need to spend.

Karen immediately commented on the massive size of the bedroom furniture. In 1999, Art and his partners sold a company, and everyone made out really well. We decided to move to a much larger house in one of Tampa's most elite neighborhoods. We bought the house, and I started the process of completely gutting and making this house our dream home. I flew to the furniture market in North Carolina and bought all-new, high-end furniture for the entire house. Then the tech bubble crashed, and Art made the painful decision for us to sell the house, which led to years of resentment from me. I am obviously not proud of my behavior toward him, but I have to own and be accountable for my actions. He made the right decision for us, and even though we bought the house with cash, keeping the house would have been a huge mistake in the long run. He had the balls to make the call, knowing full well he would face my wrath, but he did what was right anyway. Years passed before I understood and gave him the apology he so richly deserved.

We never moved in, but I had spent an enormous amount of money on furniture. We offered the furniture to the new buyers, but they had their own and were not interested. I was forced to move this hugely out-of-scale furniture into our current bedroom. For almost eighteen years, the pieces served as negative reminders of the dream home I lost. No surprise our bedroom didn't feel light, sexy, and romantic!

I also had a huge floor-length mirror that faced the bed on my side. I could see myself almost all the time. Karen explained that mirrors serve as portals for some people, and for others who are not as highly sensitive, they can simply disrupt sleep. I had two mirrors on my side of the room. She asked how I slept, and I told her I had to take Xanax if I wanted any shot at a full night of sleep.

We came to the realization that I needed to get rid of everything in the bedroom. I could literally feel Art seething in his office.

In his mind, of course, all this meant was spending more money. Karen walked across the hall to his office and asked permission to enter. I was still pretty new to this whole energy vibe thing, but even I could feel the invisible wall he had erected, even though the door was open. Still, he politely said yes, and we walked in. Heather must have been able to feel his energy as well, and she chose to go downstairs during this part of the consultation.

Art was respectful and listened to Karen's suggestions for his office. The changes in there were free. We simply needed to move his desk into the Command position and rearrange his degrees. I think that allowed his wall to come down just the slightest bit. Karen then asked Art what three things he would change if he could. He wanted:

1. Peace when he walked in the door.
2. Positive energy between us.
3. Harmony between us.

Art got a call, and Karen and I left to continue the consultation.

Karen and Heather left, and I started dinner. After dinner, Art and I chatted over glasses of wine. I think he appreciated being heard, even though he really didn't say that directly. He did agree to let me completely redo our master bedroom, so I took that as a sign he had opened up just a bit. Even the thinnest sliver lets light in!

I called Heather, told her about my chat, and made plans to go shopping the following day. I was not about to give Art time to change his mind! As we walked into the furniture store, Heather said, "I expect miracles today." Okay by me! We walked in and looked around. Within ten minutes, I found all the pieces I wanted. Everything was in stock and available for delivery within a week. I am in this business, and let me just say that is almost unheard of. I texted Art pictures of the furniture, and he liked all my choices. When the

salesperson handed me the paid invoice, I couldn't help but laugh out loud. The name of our new bed was, wait for it, HARMONY! I had not noticed that on the sales floor. We were off to a good start, as I had just crossed off number three on Art's list.

Within a month of working on the changes Karen suggested, the energy in our home and our bedroom was completely different, and Art was now on board for me to continue to make any changes I felt were necessary. He helped me move his office around. I was able to get off Xanax. As I cleared our home of things that no longer served me (and the guilt attached to them), we were able to make room for all the amazing new things that were happening.

I read both of Karen's books, which I bought directly from her while she was at my house. I had no idea when she came that she was a bestselling author whose feng shui books had been published in multiple languages. I just went with my intuition and said yes to the consultation.

I read everything I could and listened to feng shui podcasts, and that is how I found Amanda Gates. I was in line at the bank drive-through when Amanda mentioned her teacher "Karen" on a podcast. I immediately felt goose bumps all over my body. Was this my Karen? I sat at the bottom of my staircase and texted Karen as soon as I got home. Her reply changed the trajectory of my life. Yes, indeed, Amanda had been one of her students. Everything instantly made sense. I was supposed to do this. I *had* to do this.

Karen said she would take me as a student. I burst into tears as I sat on the bottom stair with my phone in my hand. The tuition wasn't cheap, and we had just been through so many major expenses. I also had a surgery coming up, which meant no income for the foreseeable future from me. How could I ask Art to do this? I felt guilty.

I picked up the phone to call him. He had flown to Albany that morning, as his mom had fallen during the night and had to be

hospitalized. I once again knew she was not coming out of the hospital and had told him he needed to get on a plane as soon as possible.

I remember saying I was sorry to be bothering him with this information, considering the circumstances he was dealing with, but that I had to tell him. I had to become a feng shui consultant and work with energy. He was so sweet, loving, and supportive and said we would talk about it as soon as he could, but the doctor had just walked into the room. He flew back the next day, and we sat outside at the patio bar, having glasses of wine and catching up. He pulled a wad of cash out of his pocket and handed the cash to me. He said simply, "Your feng shui tuition."

21

CHANGES

David Bowie

A few days later, the day before Thanksgiving, Art's mom passed away. We flew up for the funeral and for the holidays and then began preparing for my cervical fusion in January. We had been working energetically on the house since October, and I felt as prepared as possible going into surgery. Sofia once again flew in to help me for a few days. She knew firsthand what I was about to go through. In the summer of 2016, Sofia had undergone the exact same fusion surgeries. Mine were four years apart, while hers were six months apart.

I was in a neck brace for the first six weeks and spent most of that time with family and friends. As soon as I was off all pain medicine and felt coherent, I began my feng shui training. The training was a full-time job, and I dove into my coursework with all I had. I read until my head hurt. I started a small crystal healing certification course as well, simply because I loved crystals and wanted to learn how to properly use them in clients' homes. I kept chipping away at our house. We ended up redoing most of the house, as a lot of the furniture was stuff I had purchased for the other home.

Every time we felt the shift in energy come in, we eagerly moved on to the next room. I have no doubt this also helped my recovery. The doctor allowed me to take off the brace in six weeks without any

issue. In full disclosure, we were able to do such a massive overhaul in such a short period of time due partially to an inheritance we received from Art's parents. I will always wonder at the timing of these events. We so badly needed our situation to change, and we were given the funds with which to adjust our circumstances within a month of us making a conscious decision to do so. Whatever the timing, I am forever grateful to Art's parents for the beautiful gift they gave us.

We either gave away or donated all our existing furniture, regardless of how expensive the item had been. We were ready to let go. The more we gave away, the lighter we felt. I finally detached myself from my "stories" of what could have been and where the item was "supposed" to have gone in the other house. Changes manifested in us physically as well. My recovery was seamless. Art decided to buy a Peloton, and after several years of not having a set exercise regimen, he got on the bike. Within a couple of months, he was down close to twenty pounds. He was happier and more confident. He even gave acupuncture a try. We started doing different activities on the weekend. We found festivals and markets, and in general, just branched out of our comfort zone. We were having fun together again. A palpable, fresh energy was in our home and in our relationship. Number two crossed off Art's list!

Of course, all of this energy work had a ripple effect. If we were harmonious and having fun, there would most likely be peace when he walked through the door, and there was. Awesome, list complete!

22

IF YOU LOVE SOMEBODY
SET THEM FREE

Sting

With the house coming together nicely and spring around the corner, I decided to apply my BTB feng shui training (the style of feng shui I trained in) to the exterior of our home.

I ordered a new front door as I learned in training the main door is considered the mouth of chi in feng shui and is where energy enters the home. I added a water feature to the front yard because moving water directly across from your entry is considered auspicious. I moved my herbs to a more auspicious area of the garden, hung a wind chime, and so on. The results were amazing. The energy outside now matched the energy inside. All the while, I was hard at work on my feng shui certification.

My training involved a series of modules with assignments and presentations. My next module was on clutter. How to deal with clutter and what clutter really meant to a home and a person. This topic is a big part of feng shui training. There is no way for new energy to enter a space if the space is full of old, stagnant energy and items.

The topic fascinated me. My sister and I had had no idea how out of control our mother's "collecting" had gotten until she died. She had every gown my grandmother wore in the nursing home,

along with her hospital bed sheets—gross and grosser, considering my grandmother had been paralyzed by a massive stroke and did not get out of bed for the last five years of her life. Every closet was completely filled from top to bottom. Three other buildings were on my parents' property, and all of them were filled with multiple copies of old newspapers and empty soap boxes from hotels they had stayed in. The situation had gotten so out of control my parents no longer had use of their master shower. My mother had installed a rod to hang old clothes no one wore. None of this made sense to us. We asked our father about this after she died, and he simply shrugged. When we came to visit, we rarely went upstairs. We would see some small piles lying around but nothing that prepared us for the reality of what was happening in their home and therefore, in their minds.

My teacher Karen described clutter as "a series of unmade decisions." She emphasized the importance of being in control of one's environment so the environment could be supportive and nurturing to the person living there. Once my father passed, Andrea and I had to sift through all their belongings. I felt such frustration and anger as I went through their things and saw how they had closed themselves in and how their environment had strangled them.

I thought a lot about this while studying. There was a link between decluttering a home and a mind. I had been physically decluttering for a while, but I knew I had work to do on mentally decluttering my life. The physical was the easiest place to begin. I got into every single closet, cabinet, and drawer. I released the guilt associated with any item I had kept out of obligation. The process was extremely cathartic, to say the least. By the end, I felt lighter and the house felt completely different.

I decided to use myself for part of my assignment. Karen liked my paper on clutter so much that she asked if she could publish the article. My homework became the topic of her April newsletter.

"Part of what my job evolved into was clutter-clearing for clients, especially their closets, and I thought I had a pretty good handle on my closets as well. Since I have been applying feng shui to my own home, I have been amazed at how much clutter I still really, truly had. All my closets were organized, but they were filled with items that no longer served me or my husband and the life we were looking to lead. I thought about how much space those items were taking up and decided to release them and any guilt associated with them. We donated our wedding china, which had not seen the light of day in many, many years! I think we used those dishes a total of five times in twenty-eight years, but china is something you are supposed to keep forever and ever and ever—or so we are told!

The process got a little harder when the time came to get rid of things I inherited from my parents, but that, too, slowly got easier, and now I have a few very meaningful things instead of so many things I kept out of guilt even though they didn't work with my house.

Then, I hit my purses! I admit, I am a collector of expensive handbags and had at least thirty high-end designer purses in my closet. There is probably a support group I should join, but that is a discussion for another day. I have always preferred one nice gift versus several smaller ones, so this collection represented many years of Christmas, birthday, Mother's Day, and anniversary gifts. The thing is, since I had the cervical fusion, I found I could no longer handle the weight of my large and fabulous handbags. So, I dove in and started weeding through my Louis Vuitton, Gucci, Prada, etc. ...

I was able to gift my niece with my first Gucci. That was pretty easy and felt great! I also had several less expensive bags, which were donated to raise money for a food bank. That was also pretty easy. Then came the hard part. I moved the rest of the bags from my closet to a guest

room for a few days and just stared at the empty shelves. I kept reminding myself (and hearing Karen's voice) that space equals opportunity, and if I wanted new bags that would work for me now, having my shelves overstuffed with the old ones was not going to help or even allow that to happen.

Next step was to move them into a box. However, I was scared to let them go for fear I would not have the funds to replace them all since they only keep getting more expensive! I actually had anxiety and a pit in my stomach over purses. Really, this happened.

Still, I moved forward and sent most of them to a luxury consignment store. I told Art what I was doing and that I was afraid he would not let me replace them because he has never seen the value in them anyway. His response was quite amazing. He asked what handbag I still "coveted" but didn't own that would fit in with my new "normal." I told him I would love an Hermès crossbody, thinking he would laugh and walk out of the room. What can I say, my tastes have only become more refined over the years. Instead, he pulled out his computer and told me to order the bag. Just like that, a bag I dreamed of owning was coming my way!

The following day, a dear friend I hosted a baby shower for dropped by to bring me a thank-you gift, a fifteen hundred dollar Neiman Marcus gift card—insane! That quickly turned into a lovely gold Valentino bag. So, by decluttering physically and mentally and allowing what no longer served me to go, energetic space opened up for new prized possessions to appear.

I hope to be able to use my little story to help clients who are stuck and are having a hard time with whatever items they have that no longer serve them but that they still feel they can't let go of. Price is not really a factor. What is a factor is what those items mean to them

and the space those items take up, both physically and mentally. I let go and allowed space for a new collection to be created. Mentally, I feel great walking into my closet now and seeing a few new, beautiful pieces that work for me instead of the overstuffed shelves that held very little I actually used. Of course, I have left some empty shelves for future treasures to be housed. Like I said, there is probably a support group out there for me :)

My next assignment was to go into the field and do this for a client. This would be fun. I asked Heather if she would volunteer to be my guinea pig. She said her pantry needed some help. I was able to help her organize, donate the majority of her cookbooks (she now got most of her recipes online anyway), and move her pet's ashes to an area of the garden. I spoke to her the following week to see if there had been any major shifts since I was there. She said she was cooking fresher food now that she could see where everything was, and she found herself walking in there over and over just to look at the space because the uncluttered pantry brought her joy. She sent me a beautiful bouquet of flowers for my help. This was my first paying feng shui gig!

23

IN THE CLOSET

Michael Jackson

Ten days later, I walked into our master closet and was hit with a blast of cold air, which felt really strange. I don't know how else to describe the feeling other than I felt energy from someone other than myself or Art in there. I turned around and walked out and went about my day.

Each time I walked into my closet during the day, I felt I was not alone. I almost didn't want to walk in, but I needed clothes! I didn't sleep well that night. I thought about telling Art what I was feeling but decided he had already heard enough of my "crazy" stories for a while. I got up, said goodbye to him as he left for work, and sat down to meditate. Meditation was new to me. I had just begun to incorporate it into my morning routine but was not yet trained in a certain technique or style. After fifteen minutes or so, I got up and decided to take the dogs for a walk. During the walk, I prayed and asked God for a sign or guidance as to what was happening in my closet.

A female cardinal flew right in front of me within seconds of my asking, and the answer came to me. I had read somewhere it is said cardinals appear when loved ones who have passed are close by. The presence in my closet was Art's mom. I realized this would be the first Mother's Day weekend without her.

I got home, walked into the closet, and sat on the floor with my legs crisscrossed on the carpet. I looked over to my right and realized the only full-length mirror left was now in here. I couldn't have the mirror in my bedroom since mirrors were portals for me. After Karen had explained that possibility to me, I had gone back and thought about the layout of the rooms in which my visitations had taken place. All of them had mirrors facing the bed, so I had taken them all out of my current bedroom.

Mom Brady's energy coming through in here now made sense. I could not see her, but I felt her. I pulled out my beautiful silver and crystal quartz pendulum, which is a tool I used for healing and inner growth, said a prayer, and asked for only the highest and greatest good outcome and that answers come from Source and not from me. I asked if the presence was Mom Brady, and the pendulum swung to "yes." Then I sat quietly and listened for messages. The message that came through for me was that she wanted Art to know she was happy and in a good place. Most specifically, she was with Art's dad. This took place on Friday afternoon of Mother's Day weekend.

I shared the message with Art when he got home from work. He was still pretty skeptical of my "gifts," but he listened and thanked me for sharing.

On Monday morning, I received an email from the company we hired to make and install the cemetery headstones for both of Art's parents. The email included a picture of her headstone lying next to his. I didn't understand what I was looking at. The company was supposed to inform us before installing her headstone, and the first available install date we had been given was at the end of June, which was almost two months away. But of course, her message in the closet now made perfect sense. She was indeed with Art's dad. The marker had been installed Friday morning, the same day and time when I had received the message.

On May 1, I decided to commit to a daily meditation practice but didn't know how or where to begin. I had listened to guided meditations from time to time, but I wanted to learn to meditate and be able to do so anywhere, anytime.

As I ran errands while listening to another Amanda Gates podcast, I got my answer. Amanda was interviewing Emily Fletcher, and I felt her course, ZivaOnline, might be a great place to start. When I came home, I researched the course, which felt like the right fit. I downloaded and signed the agreement and committed to cultivating a daily meditation practice.

THIS MUST BE THE PLACE

Talking Heads

Art was scheduled to go on a three-week business trip at the end of May and asked if I wanted to join him for part of the trip. I had gone on the same trip the year before with Grace, and we'd had a blast. I was excited about going again. However, a few weeks before the trip, Grace and I were walking, and she told me she was no longer going, which meant I would not be going. Her bowing out meant the trip would no longer be a spouse event.

I was understandably upset that circumstances that had nothing to do with me would lead to a trip being taken away from me. Art felt terrible about the situation and suggested I go do something for myself since he was going to be gone for so long.

I finished my meditation, which had now become a daily practice, and I still didn't know what to do. I hadn't really traveled by myself except to go to the Atlanta Market's gift show for work a few times, and even then, I preferred to take someone with me. I went online and started looking at destination spas.

I had never been to one, so I was not sure what to look for. I wanted to find a spa that included interesting activities. I already had great providers in Tampa for manicures, massages, and facials, so that was not what I was searching for. I wanted something different, even

though I didn't know what that meant. Since I was going to be a feng shui consultant, and feng shui is all about working with the energy in your space, I thought looking into and learning about other healing and energy modalities made sense. I had never experienced crystal healing, shamanic journeys, sound baths, or anything even close to that. I was pretty sure my feng shui clients would be more educated than I was in these areas, so this was a perfect time to open myself up and try something new.

About ten minutes into my research, the name Miraval popped up. I didn't know where this spa was or anything about the property, but I felt led to keep researching. The spa was in Arizona. I had never been to Arizona. Miraval picked you up and dropped you off at the airport. Nice and easy. The services offered looked interesting. I chose my dates and immediately picked up the phone to book my travel and schedule appointments. The woman on the phone, Angela, was helpful and guided me to the sessions she felt would be best for me based on the information I gave her. I told her I was particularly interested in working with Dr. Tim Frank and experiencing his Shamanic Healing ceremony. She said he was not available on the days I selected, so I changed my dates in order to work with him and his wife, Pam Lancaster.

I literally could not wait to get there. I felt I was supposed to be there but was not sure why the pull was so strong. I read Miraval's suggestions for "what to pack," pulled out my suitcases, and laid out my clothes in the guest bedroom a week before leaving.

As promised, a driver was waiting for me upon landing. As the shuttle pulled up past a beautiful water feature to the front entrance, I exhaled, and a wonderful sense of peace washed over me. The property was spectacular. Across from the main entrance was the largest gong I had ever seen in person. The desert landscape was immaculate. There were saguaros, prickly pear cactus, ocotillos, and even a totem pole!

The greeters came out to meet us with non-alcoholic drinks in pretty glasses. I was able to check and leave my bags to be taken to my room just in time to join Dr. Tim Frank and Pam Lancaster's talk Calm the Mind—Open the Heart. I sat on the floor next to a couple I had shared the shuttle with during our forty-five-minute ride into the desert.

Dr. Tim asked us to "turn to your neighbor and share why you are here." I looked over and said, "I turned fifty this year, and I am trying to figure out what the next step in my spiritual journey is."

After we all shared, Dr. Tim and Pam took out Tibetan singing bowls and used them on us. When Dr. Tim put one on my head, he asked me, "Why are you here?" What came out of my mouth was quite a surprise to me. "I am open and ready to do the work."

He smiled and went on to the next person. I thought, *What work? What was I talking about?* In my mind, I was there for a week of cool sessions, yoga, spa food, desert hikes, and hanging by the pool. But before I could think more about this, the talk was over and I had to get to the next session.

I grabbed a smoothie and two slices of zucchini bread at the to-go counter and went on to a half-hour workout called "set your shoulders free." The class sounded perfect for me. I had been experiencing a lot of shoulder pain since my cervical fusion. The pain was a surgical side effect called a frozen right shoulder, which could last for an indeterminate amount of time. The class definitely helped loosen up my shoulders and neck. I then headed to my room, which was now ready, to unpack. I had worn workout clothes on the flight, knowing my room might not be available when I landed, and I didn't want to miss a thing!

I went to my room to unpack before my early evening session on making Malas. Malas are necklaces or bracelets with 108 beads that first originated in India over three thousand years ago. *Mala* is a Sanskrit word that means "garland." They are also known as yoga

beads or meditation beads. They aid in mindfulness and meditation because they give you something to focus on. I had never made one and was looking forward to creating my own and then adding it to my meditation practice. The class took place in one of the activity rooms. We all got to select the stones that called to us the most. I was drawn to the dendritic agate, which is a stone for inner growth and wisdom gained through inner work.

Little did I realize that would be the theme for the week! I sat next to a cool woman from New York City named Diane, and we chatted as we created our Malas. The Heart Calming Mantra, "Gate Gate Para Gate Para Sam Gate Bodhi Swaha," Karen taught us to recite before walking into a consultation was playing on a CD player, and I felt I was destined to be there. I loved the mantra, as it helped set in the highest intentions for whatever I was doing.

When we were done, my new friend invited me to dinner, but I passed. Arizona was three hours behind Florida. I was exhausted from a long travel day, and all I wanted was a shower and bed.

25

LET IT GO

Idina Menzel

The next morning, I woke up in time to do my meditation before the two-hour sunrise desert hike I had signed up for.

I had never been in a desert. There were two guides and about twenty of us. The guides pointed out free-roaming desert cows and jackrabbits. I got up close and personal with a saguaro cactus. The minute my sneaker hit the desert floor, I felt something shift way down deep inside me. I belonged there, in the desert. Everything felt right. The land had called me back, and I almost burst out crying at the start of the hike. I had never experienced such a visceral reaction to a location in my life. The feeling was one of coming home. Laredo's climate was dry and desert-like, but nothing like this, so this feeling was not nostalgia. I was feeling a deep, deep remembrance of the land bubbling to the surface.

My first private session this second day was Tibetan Chakra Balancing with Pam Lancaster. I had no idea what to expect. The session consisted of being surrounded by healing sounds and vibrations of Tibetan bowls and gongs to cleanse and help reconnect with one's true nature. I walked into the room and almost burst into tears again the minute I said hello. I had absolutely no idea why.

Pam was beautiful. She had long dark hair and piercing blue eyes that felt like she was looking directly at my soul. She was dressed in all white. She smiled, and we sat down to talk. I could barely contain myself. Pam told me I was coming face to face with the obstacle in front of me—fear of the unknown—and I had to let that go in order to move forward.

She had me lie down to start the balancing ceremony and suddenly asked me if I could see what she saw because she knew I could "see." I said I wasn't "seeing" anything in particular at the moment.

Pam then said, "I see Jesus blowing white light into the top of your head and holding his hand to your heart." She told me a white beam of light was coming straight from above and going directly into the crown of my head. Well, that was interesting. I wasn't sure how to respond to this strange (at the time) information, so I just said, "That's cool."

After the session, we talked a bit more and Pam asked what my goal for my time at Miraval was. "Clarity," I responded, again a bit confused at what came out of my mouth. She smiled, gave me some suggestions to help me sleep with less fear, and reinforced how important it was to protect myself at all times.

"What does that mean?" I asked.

Pam explained I was "open," and I needed to learn how to close myself to things that were not in my highest and greatest good. At that point, I decided to share my experience in Mexico with her. Pam listened and confirmed I was, indeed, there to help the little Mayan girl and was never in any danger. She also said my being open was why the visitations I had had since childhood had taken place.

She used the term "lightworker" in reference to me for the first time. A lightworker is a person who is here to help raise humanity's consciousness and be of help to humankind. The first thought I had was, *Woah, my name literally means helper of humankind, and here is someone telling me that is my purpose here on Earth.* I started to feel a little dizzy. This was a lot of information to process.

Pam went on to teach me that because I am a lightworker, all entities, both light and dark, would be attracted to me. What I needed to learn was to let go of my fear and learn how to ground and protect myself so I only allowed in the light.

So many new words and a new terminology. I was overwhelmed, and it was only day two! I wrote down her earlier recommendations, which included burning mugwort and taking St. John's Wort to help me sleep, and said goodbye.

I was excited to work with as many practitioners and teachers as possible and wanted to make every second of my time there count. During my short break between private sessions, I sat down to enjoy Miraval's lunch buffet. The options were all healthy and delicious. I ordered prickly pear iced tea for the first time. I had decided I was not going to drink alcohol during this trip, not sure why, but drinking just didn't feel right to me. I wanted to be very "present" and not miss a thing.

My next private session was with Dr. Tim Frank. He remembered me from his talk the day before and asked how many times I had been to Miraval as we walked from the spa lobby to the outdoor New Life Village healing room where my session would take place. "This is my first time," I replied.

He looked stunned and said, "And you booked an appointment with me?"

I told him his session was a very big factor in my coming. I had read his bio on the website, which, in part, stated he was a godson to a Cherokee medicine man and apprenticed with a Native American Shaman. I had never been exposed to or worked with anyone like him, and I was here to experience new modalities. I had changed my original dates in order to work with him and with Pam. He seemed very surprised by my answer.

Dr. Tim escorted me into the healing hut. We sat down to chat a few moments before my Samadi Healing Ceremony began. This was

a shamanic ceremony of purification and healing meant to pull out negative energies and entities that had bound themselves to a person. I lay on the table as he chanted, smudged me, and put acupuncture needles in place. As he took the needles out and began praying and speaking in light language, I started crying again! *Where were all the tears coming from?* I was two for two today. He told me to let go and allow the much-needed release to take place.

After the ceremony, we sat down facing each other on chairs, and he said, "You are ready and things will be happening very fast." *What things?* This was going down a totally different path than I had anticipated.

I chose to also share my visitations with him, and Dr. Tim told me I needed to create boundaries. No longer were "they" allowed to come in the middle of the night and frighten me by sitting at the end of my bed or on my chest. This was a big part of why I had so much fear of the unknown. It was time to let the fear go, and setting clear boundaries would help my fear subside. We chatted for a few more minutes as my session wrapped up, and then he walked me back to the spa lobby. On our short walk, Dr. Tim suggested I work with a Catholic healer named Mother Emilia. I said I would look into booking a session. Emotionally, I had been wrung out. I was in bed before 8:00 p.m.

I woke up bright and early the next morning to meditate and hike through the Sonoran Desert. Today was June 1st, my twenty-eighth wedding anniversary. Another day of feeling so connected to the land I was walking on.

I came back, chatted with Art for a few minutes, and quickly grabbed a cup of coffee before my first session of the day. I decided I was not going to let him know about all the emotions I was experiencing until we had a chance to sit and talk in person.

I was going to do the Himalayan Sound Bath session at one of the heated salt pools. This was one of the activities I had really wanted to do when I booked, but the activity had been sold out. Of course,

a slot had opened up. This was the case the entire week I was there. The healers were, once again, Dr. Tim Frank and Pam Lancaster. They were a powerful team. The aquatic session was unlike anything I had ever experienced. I thought, *This must be what being in the womb feels like.* The saltwater was warm as we floated, our bodies being held up by pool noodles. Sound bowls were placed on our stomachs and, at times, around our heads, and the music they made was peaceful and healing. At the end of the session, the group of ten sat in a circle, and we were each asked to answer the following questions: What do you choose to release, and what do you choose to accept?

"I choose to release the fear of the unknown, and I choose to accept my gifts along with the clarity and wisdom as to how to best use them to serve the world," I responded. The words felt truthful, although I still didn't really know what my "gifts" were.

As we got out of the pool and gathered our tote bags to head off to our next appointments, Pam pulled me aside and once again told me to let go and release emotions, as that would be the only way to move forward. I thought back to what I was learning as I continued my feng shui training. Part of my job as a certified feng shui consultant, and something I was already doing for years as an interior decorator, was to advise clients to release physical stuff that no longer served them. This would then make room for new items that would help support the life they wanted to lead. The same could be said for emotional "stuff." I needed to be my own client and release feelings that no longer served me in order to make space for my gifts to make themselves known.

That afternoon, I enjoyed a lecture on Transforming Pain through Conscious Attention and Love. I learned that my emotional status would affect my pain level, and there is less pain when I choose to be present versus letting my mind wander.

I followed that by focusing on my physical body for a while. I did a breathwork class in which I learned about the Joy salutation, and I

stayed for a yoga class. At the end of class as we lay in Savasana, and even though my eyes were closed, I saw the words "I am AWAKE." I was not sure what the words meant at the time, but the message made enough of an impact for me to write them in my journal the way I saw them—all in caps.

My final lecture for the day was Master Your Mind—Heal Your Body. Brent Baum was speaking. One main point I took away was that the body kept score, whether or not you wanted the body to do so. That rang so true to me. My body had been trying to get my attention for so long and took quite dramatic measures to get me to stop and pay attention. Well, I was paying attention now; that much was certain! By doing so, I felt my body was responding in kind. My shoulder had not bothered me once since the class I did on the first day.

26

HOME SWEET HOME

Mötley Crüe

The following morning, on the hike, I had the same reaction. *I was home.* Going back to Florida would be hard. I almost couldn't imagine starting my day without a desert hike.

I gave myself time to read afterward. I had brought my childhood friend Alexa Person's book *The Zero Point* with me. I was surprised by how many similarities I found to my life, which we'd absolutely never discussed with each other. She was a bridesmaid in my wedding, and I didn't know any of this stuff! I went back to my room and sent Grace a text. I wanted her to know how grateful I was to her for what happened. If she had not canceled, I would not be at Miraval, and I was absolutely, without a shadow of a doubt, supposed to be here.

My next private session was with Mother Emilia, who was a faith healer, Reiki practitioner, and minister. She was a sweet, middle-aged Mexican woman with short brown hair and warm brown eyes. We connected instantly and spoke Spanish on the way to the treatment room.

As she performed Reiki over me, she told me God was with me and I should no longer be afraid. She was the first one who explained to me that I needed to let go of the subconscious fear of abandonment

and rejection I had carried around with me my entire life. Mother Emilia also said I walked with a beam of light over my head.

That was the second time someone had said that to me in the past twenty-four hours.

I would be channeling in the future. God listened when I talked to Him. I needed to focus on protection. She said my husband would hurt my heart. He would have a difficult time accepting my gifts and would criticize me for them. When I shared I was worried our relationship would not survive this, she replied, "God says all will be well."

Mother Emilia also said I needed to forgive my biological mother. We worked on that for the remainder of the session. This was not fun. I am going to be honest here and repeat: this was not fun. I found it difficult to forgive someone who, I felt at the time, willingly chose to hurt me and cast me aside more than once. Sofia and I were in a good place, and I was headed to Dallas directly from my stay at Miraval, but my relationship with her still didn't feel completely "safe" after the NYC incident. I knew, even if I would not admit it out loud, that I certainly continued to harbor anger and resentment toward her. However, by the end of the session, I felt a piece of my heart soften toward Sofia. I was pretty certain I wasn't done, but I was on my way and looking forward to spending time with her in Dallas and perhaps even sharing some of this information with her.

Lunch was next, followed by an anti-inflammatory diet workshop. I loved that I was getting to experience such a variety of offerings.

I had a private astrology session in the afternoon—again, something I had never experienced before. My practitioner created my natal chart, and we went through the chart together. This would be the year of becoming who I really was. My life would have a lot of expansion. She also could see there would be difficulties with Art in the fall, but they would work themselves out. She asked if I was moving. I told her we had no plans to move. She saw travel and work in another location. This was also happening in the fall. Some kind of move was

definitely involved. December and the holidays would bring difficulties. By January, I would be in my true power and really good things would start from March on. I needed to focus on protection and the color green, which symbolized expansion, growth, finances, and the heart chakra.

The sessions I had selected were forcing me to branch out. The next was a private reading from Intuitive Kristin Reece. The session was called Journey to a Higher Power. Being raised Catholic, receiving a spiritual reading where one connects with people who have passed was not in line with what I had been taught, but I felt those old ties starting to unravel. Something greater was out there to be learned. I also felt to my core this didn't conflict with true spiritual beliefs but instead was a way of getting closer to God/Universe/Higher Power.

Kristin met me in the lobby. She had long, flowing blond hair and literally glowed from the inside. She was beautiful and very friendly. We had an instant bond. She hugged me and told me we would do the session outside, as connecting in nature was much more powerful. We sat by the stream, which meandered throughout the property, and the reading began.

She told me I had major psychic abilities. My clairvoyance, claircognizance, clairaudience, and clairsentience were all very strong. I had a past life in Medieval England and was a white light witch/sorceress. I had been hung to death. That life was now present in this one as the scar on my throat. I had past lives in Egypt as well. I was royalty there. She felt she and I shared many lifetimes together.

Woah ...

She asked about a daughter. I told her I didn't have one. I had a son and four miscarriages. She would be the first, but not the last, to tell me how strong my daughter's presence was around me and that she was always with me.

The issue of protecting myself came up again. This seemed to be one of the major themes for me here. I obviously needed to pay

attention to this. Kristin said, "You need to protect yourself morning and night and bring in light and love. Doing so will allow you to do your lightwork and keep your intentions for the highest good. You need to encase yourself, but not build a wall, so you can still receive and be the messenger and teacher you are here to be."

We hugged goodbye, and I asked if she worked remotely. She said yes, and I promised to be in touch. She is now a dear friend and one of my most cherished mentors.

I arrived at the spa for my next session, and by now, you can guess, the Universe had its own plans for me. I heard a familiar voice call my name as I waited. When I looked up, there was Mother Emilia again. I told her I was there for crystal healing, and she just smiled and said God had other plans for me.

I followed her into the treatment room and lay down on the warm massage table. She began with, "All is well. The time to accept your gifts has arrived. In order to do this, you still need to forgive, in this order, the following people: yourself, Beth, Andrea, and Art." She didn't bring up Sofia, which was interesting. Perhaps I had made more progress than I thought in yesterday's session. She then said, "You will be speaking at conferences all over the world." That was surprising. I didn't know what I would be doing that would lead to me speaking at conferences worldwide. Mother Emilia assured me the details would be revealed to me in Divine Timing.

Mother Emilia asked to see my hands. I lifted them up, and she flipped them over to see my palms. She traced her finger on each palm and told me to research why I had *M*'s on my hands.

At the end of the session, I heard a voice, which was not Mother Emilia's, say, "It is over." Strangely enough, the voice didn't frighten me. I couldn't place if the voice were male or female, but that didn't seem to matter. Perhaps this was because I was in a safe place or perhaps because my eyes were being opened to my gifts. I wasn't sure, but I accepted, just like in the closet with Art's mom, that I would be

receiving communications I couldn't explain, and for the first time, I was comfortable with that knowledge.

I walked over to the main restaurant and had lunch with a woman I had met earlier. She asked about my sessions, and I shared some of what had transpired. I said, "I am an Intuitive," out loud for the first time and could feel a wave of anxiety flood my body as I said the words. Then, just as quickly, the anxiety was replaced by a wave of relief. The words felt authentic, and saying them out loud to another person was the first step in truly accepting my gifts.

27

TRAIN IN VAIN (STAND BY ME)

The Clash

My week at Miraval in Tucson had been transformative, to say the least, and I was equally excited and nervous about sharing my experiences with Sofia and her family. I was in no way, however, prepared to be called "evil" and "of the Devil." Her husband's words shook me to my core.

I stared at the sheet of paper lying on the kitchen island in front of me and tried to remain calm as he spoke. Sofia simply stood there, staring blankly into space. She didn't try to defend or stand up for me in any way. In fact, she didn't say a word. She may as well have been bewitched all over again. He continued reading through the list, starting almost every sentence with, "Now let me tell you something ..." and then inserting whatever the list said next, for example, clairvoyance and why clairvoyance was "evil" and "of the Devil." I attempted to keep my composure by tuning him out and found my mind wandering to something else he had said to me, many times, in fact. He often said his daughter Beth possessed the gift of "great discernment." He finally finished going through the list. I attempted to recover from what I am sure was quite a fucked-up look on my face and calmly asked what he felt the definition of Beth's gifts were, in comparison to mine.

He gave the exact same definition of someone who is claircognizant, one of my gifts. Someone who is claircognizant knows shit without knowing why or how we know it. We just do. So ... Beth had a gift, and I was "of the Devil." I just can't make this shit up.

Obviously, we both had the same gifts. They were bloodline gifts, and we shared the same biological mother. This pissed me off even more, and I am quite sure my face now showed how angry and upset I was. I tried my best to be cordial and said goodbye as he left for work. I went upstairs to gather my things. As Sofia drove me to the airport, you could have cut the tension in the car with a knife. I tried to have a discussion with her, but she still had nothing to say. I knew then and there things would change between us.

While I waited for my flight to Tampa, I followed through on part of my conversation with Mother Emilia. She had told me to research the meaning of *M*'s in both a person's palms. I read that all of the Apostles possessed this mark. People with the double *M*'s on their palms also possessed the following qualities: healing abilities, ability to see through lies and deceit, blessed with good fortune, highly intuitive, advocates of the truth, possessed a sixth sense, and were leaders and teachers. They had to learn to balance both giving and receiving love. People who had lived lives on Lemuria were said to have the *M*'s as a way for them to recognize each other in this lifetime.

I did a quick Google search to find out what Lemuria was, since I had never heard of this place before. There was a lot on the internet, and the information was conflicting, to say the least. Lemuria, in some articles, is said to be the cradle of civilization, a lost continent, an ancient sunken city somewhere in the Indian Ocean. In others, Lemuria is said to be a completely fictional place. I was not sure what to believe at the moment. My brain was already on overload. I would circle back to ponder Lemuria another day.

I tried to sleep on the flight but was still so incredibly upset I couldn't rest. I landed, got out of my Uber, and walked into my empty

house around 9:00 p.m. Art was still on his business trip. I decided not to unpack. The day had been long and emotionally charged, and I was not up to going through almost two weeks' worth of clothes. I grabbed a nightgown out of my dresser and crawled into bed.

The next morning, when I walked into my master closet, I felt the same cold air as when I had had the spiritual visitation from Art's mom. I grabbed my pendulum and inquired if she was there, and my pendulum swung to the "no" position. That freaked me out. I called Heather, and thankfully, she came right over. She is a Flower Essence Alchemist, so she brought me a custom-blended flower essence for protection.

We went upstairs. Heather stood at the closet door and said she could feel the cold and the strange energy. She said, "There is definitely a presence in here."

We walked in and sat cross-legged on the floor, facing each other while I did a salt burn. A salt burn is a space-clearing ritual I learned during my feng shui certification. The objective is to transform any negative energy into positive energy for the home and the home's inhabitants. If that is not possible, then you invoke the negative energy to leave the space.

As the salt burned, I "heard" the name "Timothy" and immediately knew who the presence was. This spirit was my ex-brother-in-law, who had been married to Art's sister. While I was at Miraval, he died of complications due to many years of alcoholism. His body wasn't found until several days after his death. His addiction had caused severe pain for the entire family, and the situation was heartbreaking. Timothy was now desperately trying to get through. I pulled out my pendulum and began asking questions. He confirmed he was there. His first message was for Art. Timothy and Art were very close for many years. Art referred to him as a "brother" and was heartbroken to find out from his sister, Fiona, what had really been going on. The message was, "I am deeply sorry."

Heather added a few drops of the Bach flower essence Walnut to the salt burn to help him transition. While doing this, she received two additional messages from him, which followed the messages he gave to me.

The first message was to "Check his jacket pocket. Someone needs to look inside his jacket pocket. There is something important there." She said he was very insistent, almost shouting this to her. The second message was simply the words "yellow flowers." Heather asked if either message meant anything to me.

I said, "No, I have absolutely no idea what either of those mean." We said a prayer, promised him we would convey his messages, and encouraged him to complete his transition and be in peace. The salt finished burning, the closet temperature normalized, and Heather went home.

I called Art. I gave him the messages and asked if he thought I should call his sister. "Yes," he said. If I am being totally honest, his answer surprised me a bit. Perhaps the amount of otherwise inexplicable events in my life lately had caused him to be a little less skeptical. I picked up my cell phone, found Fiona's contact, and pressed the button.

Fiona and I had never been particularly close, and I had no idea how she would react. I was honestly a little apprehensive, but I was starting to understand having these gifts meant I needed to deliver the messages, regardless of whether or not they made sense to me or how I felt about the situation.

I told Fiona about the jacket and the yellow flowers. She said, "I can't look in his jacket pocket. His family went through his belongings and apartment. No one has said anything to me."

I asked, "Do you remember someone who perhaps sent yellow flowers to the funeral? Somehow, yellow flowers were very important."

Fiona said, "That is not what Timothy meant. I know what he is talking about." Her voice quivered as she explained, "They (he and

their son) would pick all the little yellow flowers that had sprouted from the grass before he mowed the lawn. That was their thing." I got goose bumps all over as she spoke.

She thanked me for sharing the information but said little else and has never brought up the subject again.

I fell asleep, happy Heather and I were able to be of service, only to be woken up by a terrible dream of a strange-looking boy with sharp teeth and red eyes. I started praying and realized I had forgotten to protect myself. That was one of the core teachings for me as a lightworker when I was at Miraval. Lightworkers are light, as Pam, Dr. Tim, and every other teacher I worked with had taught me. Everything comes to us. We have to constantly protect ourselves and allow only the light in.

I eventually fell asleep and felt a "download" of some sort take place. I saw symbols, hieroglyphics, and sacred geometry.

Ryan and I had a chance to talk on the phone the next day. We went through everything that happened at Miraval and in Dallas and talked about his uncle's death. Ryan was taking Timothy's death pretty hard. Ryan was the oldest of all the nieces and nephews and had spent a lot of time being doted on by his aunt and uncle when he was young. He adored them. Ryan asked questions, and I did my best to answer.

Before we hung up, I asked him to look at his palms. He had two *M*'s. The bloodline continues.

28

SHE TALKS TO ANGELS

The Black Crowes

I was in a horrible mood. I had waited over two hours for my six-month cervical fusion checkup. The only thing that kept me sane in the freezing examination room was reading Oprah Winfrey's book *The Wisdom of Sundays*. I got home, turned on some Vivaldi, and decided to arrange fresh flowers before sitting down to meditate. I again asked for clarity and further guidance on what my true purpose here on Earth was. This time, I received my answer.

I sat in stillness and clearly heard a voice behind my right ear. Somehow, I knew the voice belonged to Archangel Michael. He said, "You are going to write a book." I accepted this information, finished meditating, thanked my guides and angels, and reached for my journal.

Now, this didn't mean I was totally on board with writing a book. The thought of writing a book had never crossed my mind. What did I have to say that other people needed or wanted to hear? What could be so important? Those would be questions for another day. That day, June 11, 2018, I had asked for and received an answer. I would have to be satisfied with that.

A few days later, I saw an outline of a figure in our dining room window, and again, I knew the figure was Archangel Michael.

I reached out to Kristin Reece, and we had our first phone session on June 27th. I wanted to be energetically clear for the call, so I decided to take an Epsom salt and frankincense essential oil bath. While I soaked, I listened to environmental artist Tobacco Brown's TED Talk. Her words resonated deeply. "When the caterpillar transforms into a chrysalis, it involves some struggle but it's a challenge with a purpose. Without this painful fight to break free from the cocoon, the newly formed butterfly can't strengthen its wings. Without the battle, the butterfly dies without ever taking flight."

Kristin guided me through a visualization where I saw the color pink, which symbolizes love, and a butterfly, the symbol of transformation to many. I was starting to notice synchronicities, and this felt like one. We worked on colors and what they meant to me. She had me write down the feeling I received from each color as she said them. This list would be part of the toolkit I used to expand my light. The colors would also help me interpret messages that came through.

After the call, I had to run to my first physical therapy appointment. I had been cleared by my surgeon to begin therapy.

My therapist said my neck and arms were weak. I needed to work on regaining strength. The butterfly metaphor again came up. I had been in a cocoon, not only since surgery, but for many years prior. I was just now starting the hard work of gaining strength and breaking free to become who I truly was. I flashed back to what I had said to Dr. Tim Frank a few weeks before, "I am ready to do the work." The work would challenge me physically, mentally, and spiritually, but I was indeed *ready*.

The following day, I received more messages from Archangel Michael during meditation. He told me Archangel Gabriel was also with me. I noticed I got very hot, almost like a hot flash (which, thanks to bio-identical hormones, I no longer had), when they made themselves known. The dogs were barking during this, and I asked the archangels

to quiet the dogs so I could listen and absorb what they were trying to convey to me. The dogs stopped barking immediately.

The message was, "You will be writing a book and traveling the world helping millions of people. You will be very financially successful and be able to do much good in the world while also leading an amazing life."

I asked three times if this was really Archangel Michael and not just me talking to myself. I was assured what I was being told was true. Sometimes knowing the difference was difficult. However, I chose to trust that what I was experiencing was real and that accepting this was in my highest and greatest good and for the highest and greatest good of the people I was here to be of service to.

I didn't have the first clue as to how to write a book, and I have had stage fright since I was a kid, so I wasn't sure how I was going to pull all this off. All I knew was that I took a leap of faith and said *yes*.

29

GREEN EYES, RED HAIR

Gaelic Storm

By this time, I was "seeing" and hearing the word "Sedona" at night in my head. Then, walking through Hyde Park Village in June of 2018, I ran into an old friend, Amber, whom I hadn't seen in at least ten years. After saying hello, the first thing she asked me was, "Have you been to Sedona? I just got back. You have to go."

I didn't want to tell her I had been hearing the word and had basically been ignoring it, so I asked her, "Where exactly is Sedona?"

"Arizona," she replied. "It's magical."

We said our goodbyes, and I remember thinking what a random encounter that had been.

A few weeks later, in early July, Art and I spent a long weekend with Ryan in Chicago. During Sunday brunch, I casually mentioned if they would consider a desert house instead of a beach house for our second home. We had been looking for a beach house for close to two years and had not found anything that felt right. I told them I had this strange pull to go to someplace called Sedona, Arizona. In all honesty, I fully expected them to disagree since a beach house made much more sense. Ryan asked, "Is there good golf there?"

"I have no idea," I said, "but I can find out."

We flew back that evening, and I woke up at 3:00 a.m. The dogs also woke up and needed to go out, so I was fully awake by the time Art and the pups were back in bed. I closed my eyes and started working on the *I am*. I am grateful. I am healthy. I am happy. I am sleepy! Suddenly, I was soaring over a green meadow at the edge of an ancient cliff. I had a bird's-eye view. I heard myself asking, "Where am I?" I felt weightless. A male voice answered, "Atlantis." At that moment, a red-headed warrior with green eyes dressed in ancient armor showed himself to me. "Who are you?" I asked, and he responded, "Your Spirit Guide." I thanked him for allowing me to see him, and as I did, he was gone.

I woke up the following morning wanting to go straight into a Spirit Guide meditation and hoping to connect with him again. The feeling had been magical, but sadly, I had a house full of workers, as I was redoing our master bath. Connecting with him again would have to wait.

Four days later, my computer dinged as an email from Ryan with a Zillow listing for a home in Sedona arrived. I had not thought of Sedona since we flew home. Our conversation was just that, a casual conversation over brunch. I was surprised at how eagerly I looked at the listing and couldn't wait for Art to get home so we could discuss this as a real possibility. We both liked the house and decided to contact our Tampa realtor to see if he could put us in touch with a realtor in Sedona.

We had a realtor by Friday night, but by then, the house also had a pending offer.

Over coffee on Saturday morning, Art and I decided to fly to Sedona. We figured we actually needed to see the place before buying a house. We were not normally this impulsive, so clearly, we were being Divinely guided. We purchased tickets. I was elated and went off to do my meditation.

The meditation was one of the most powerful yet. I kept hearing, "I am going home" and was crying tears of joy throughout most of my time on the cushion. Dr. Tim Frank's words popped into my head. "You

115

have all the right answers inside you. You should only listen to what is inside."

The day before flying out, I went for a cupping and acupuncture session with Dr. Sandi Carter. Dr. Sandi said I needed to go to Sedona. There it was again, Sedona. WTF? I had not told her what my plans were.

She said my Mom was present in the room and emphasized I had to continue to work on my fear of the unknown. Then Dr. Sandi said, "There is a red-haired, green-eyed man in the room, too. He is your protector. You were together in previous lifetimes. He was not able to protect you then, but he is around you and will be throughout this lifetime. He knows you can protect yourself and won't be killed for speaking your truth as you were in the life you shared together."

I couldn't believe what Dr. Sandi was saying to me. I shared with her I had "seen" him for the first time a few nights before.

I prepared for the trip as much as possible. I scheduled another call with Kristin. I didn't share what had happened earlier in the week. I wanted her reading to be pure and not muddled with what I had heard or seen. She immediately brought up the presence of the green-eyed, red-haired man. He was definitely making himself known these days! He was a protector *with* me. She emphasized the "with" because I had the power to protect myself in this lifetime.

"Your souls have an energetic connection, and you can call on him when you need him. He has been waiting a long time. I see him cliffside in some beautiful ancient land. Dragons. I see dragons. More dragons are coming. You need to pay attention to dragons and dragonflies," Kristin said.

What Kristin saw expanded upon the information Dr. Sandi and I had already received. I couldn't make this shit up if I tried! That night, I woke up at 3:00 a.m., clearly saw the warrior's face, and felt our souls connect. I asked him what his name was, but he was gone before I received an answer.

30

SEDONA SUNRISE

Aerosmith

Thursday, exactly one week after Ryan sent the Zillow listing, we landed in Phoenix, grabbed a rental car, and made the two-hour drive through the desert to Sedona. During the ride, I shared with Art what I had learned about the Sonoran Desert while at Miraval. I passed the time by pointing out the different cacti. My favorite was the saguaro. Their majesty was unrivaled. They felt like the ancients of the desert. I also told Art about the red-headed warrior and my session with Kristin. He listened attentively but didn't have much of a reaction. Perhaps he was getting used to my "unusual" stories!

About twenty minutes outside of Sedona, the scenery began to dramatically change from the typical desert landscape of the area, and the red rocks suddenly appeared. We both gasped at the majesty before us, and I immediately pulled out my cellphone to video record what I was looking at because I knew my description was not going to do the rocks justice. I wish I had better words, but magical is the only word that came, and still comes, to mind. The red rocks that jut out of the earth here are totally unique. It feels like you are driving into a different world. Ryan had traveled to Iceland as part of his graduation trip, and I remember him trying to describe the landscape there. He said it was moonlike, unlike any other place he had ever been, and

that it felt magical. That is what we felt now. Both of us knew right then and there we would be buying a home on this trip. We wanted to be part of this magical, moonlike landscape.

Our first stop was the Church of the Holy Cross. We parked at the bottom of the hillside and climbed to the sanctuary. I started crying, feeling overwhelming gratitude to be standing on such sacred ground. We got back in our car and headed to our uptown hotel. We settled in and watched the sun set behind Snoopy Rock over dinner and cocktails.

I had a vision during the night. I was walking down a street in Sedona, turned left, and ran into a body of water. I also saw the name *Zoey*.

We woke up before dawn since we were still on East Coast time. We decided to go for a sunrise walk and check out our surroundings. I told Art about my vision as we walked. I asked him to turn left when we got to a certain spot. It looked like the spot in my vision. We did, and at the bottom of the street, we ran into a creek, the water I had "seen." I took a photo. I had never been here; I simply followed what I saw in my vision. Nothing showed up pertaining to the name Zoey, though.

Our realtor met us, and we spent all day Friday learning the area and looking at homes. I felt all my feng shui knowledge bubble to the surface. The more homes I saw, the quicker I was in picking up on problems and energy. Sometimes, we would pull up to one, and I wouldn't even get out of the car. Sedona was progressive energy-healing-wise, but even my realtor was giving me sideways glances. No matter, I was not going to go into this if the house was not the perfect house for us. One of my favorite "needs some energy work" houses had an outdoor stairway that led to a hidden front door with a ceramic cobra in attack position and a ceramic monkey crouching next to the snake. Not surprisingly, they had gone through many price reductions and the house was still on the market, despite being in a highly desirable area. I suggested he contact that realtor and help

those people out by telling them to remove those items. At the beginning, I knew he thought I was nuts, but in the end, he actually offered me a job.

We looked at everything within the price range we had specified and didn't find anything. As I sipped a dirty martini at our hotel bar on Saturday evening, I said, "Well, maybe I was just supposed to come to Sedona, not have a house here. Looking for a house got us to come, so now we know we like the town and will come back."

Art said, "Let's bump up the budget and see if there is anything else to look at before we leave tomorrow. I think we should have a house here."

I opened my iPad, and we found two more properties that looked promising. We called our realtor.

Art and I woke up to do a sunrise hike at Bell Rock before looking at the last two properties. As we walked past the hotel's front door, we came upon an A-frame chalkboard with the words "Welcome, Zoey!" Our hotel was a dog-friendly hotel, and apparently Zoey was checking in. All I can say is, the look on Art's face was priceless!

We drove out to Bell Rock as the sun started peeking over the red rocks. We didn't really know where to go. Out of nowhere, a man walked up to us. He didn't ask if we were lost, he just told us where to go and what to do. He was explicit about where to sit. We followed his instructions.

About half an hour into our hike, I told Art I wanted to meditate for a few minutes by myself. I now loved meditating and was excited to practice in such a powerful setting. I sat facing Courthouse Butte, as the man instructed. That meditation was, to this day, one of the most powerful meditation sessions I have ever experienced. Tears of joy, prayer, and gratitude dripped down my face as I sat in perfect stillness and was PRESENT. I felt such appreciation for being able to be in that space at that moment. I thought my heart would explode from happiness. I was completely overtaken with emotion and could

feel Mother Earth's vibrations coming up through my chakras as I sat there deeply rooted to Her.

Art went to explore while I meditated. About fifteen minutes later, he walked over to check in. He held out his phone to show me something. When I leaned in to look at the photo, I gasped. The picture was of me, or rather, the back of my head while I was meditating and praying. There were rays of multicolored light all around me and a white beam of light shooting directly from the heavens into the top of my head! Oh my God, this was what the healers at Miraval said they saw when they met me.

During a previous meditation, Archangel Michael had told me Archangel Gabriel would also be around me. I had shared this information with Art, and understandably, he didn't believe me. Hell, I wasn't sure I believed me. Now, Art himself took the photo that held the proof. I would know when I saw "a beam of light." As Princess Buttercup said in *The Princess Bride* (my favorite movie of all time), "I will never doubt again."

We drove back to the hotel to pack up, change, and meet with our realtor to see the last two homes. I was in and out of the first in less than five minutes. The last house on the list sat on a lovely piece of property. Overgrown wilderness made the front door invisible from the street. As soon as we walked in, however, I whispered to Art, "Hope you have your checkbook." That was the house! There were issues, of course, as no house was perfect, but the issues were all things I could cure through my design and feng shui training. We met the elderly owner and walked through. I took a video, and then we had to say goodbye. We had a flight to catch in Phoenix.

We talked about the house the entire trip home. Art kept saying he could not believe how different and special Sedona was. Monday morning, we submitted an offer. I meditated and asked that our offer be accepted if owning a home in Sedona was in our highest and greatest good. Tuesday, our offer was accepted. That was that. We were

now homeowners in Sedona. The time frame was pretty incredible. Exactly ten days from the day Ryan sent us a Zillow listing to the day our offer was accepted. If that was not meant to be, I didn't know what was.

31

KNOW MY NAME

Goo Goo Dolls

woke up around 4:00 a.m. on July 20, 2018, to a voice telling me to look up the meaning of my name. I remember having a conversation (in my head, since Art and the dogs were asleep next to me), saying, "I already know what my name means. Alejandra means 'helper of humankind.'"

"No," I was told, "look up the meaning of your other name."

This took a minute to register, and then I said, "Cassandra?"

"Yes," the voice said.

I had a long to-do list for the day, but I listened and took ten minutes to look up the meaning of the name Cassandra. I found this information online at sheknows.com:

> Cassandra was a Trojan prophetess, daughter of King Priam. Her mother was Hecuba of Troy and she had the gift of prophecy but the curse that her prophecies would never be believed. The name was popular in Medieval Britain. People with this name have a deep desire to create and express themselves, often in public speaking, acting, writing or singing. They also yearn to have beauty around them in their home and work environment.

I JUST CAN'T MAKE THIS *Shit* UP

Hmm ... interesting. I identified with some of the descriptions, but I certainly had never had a deep desire to speak in public, act, write, or sing. I felt this was a breadcrumb to a bigger idea that had not yet revealed itself to me.

For the second night in a row, I woke up, this time with a visual of the number eight. The next morning, I sipped my coffee and looked up the spiritual meaning of the number. From astrovera.com: "The number 8 in the Bible signifies resurrection and regeneration. It is the number of a new beginning. 8 is 7 + 1 and since it comes after 7, which itself signifies an end to something, so 8 is also associated with the beginning of a new era or that of a new order." I certainly felt like a lot of things were shifting for me as old patterns and ways of thinking were ending, so this made perfect sense. Our house number in Sedona added up to an eight, and that was certainly a new beginning for us.

Art came home from work with flowers for me for no reason that evening. I felt all the energetic shifts I was making were positively impacting him as well.

32

FATHER OF MINE

Everclear

On the morning of July 25, around two weeks after buying the Sedona house, I woke up to an email from ancestry.com. I had decided to find out "what" I was a few weeks earlier, meaning I knew I identified as a Mexican American since I was raised in that culture, but I was curious to know what my actual DNA was. The site showed a match to a potential relative, and someone was trying to contact me. I scanned the request and raised my finger to hit the delete key, as I had done to several before. After all the issues with Sofia and her family, the last thing in the world I wanted at this point was more new family members. I just wanted my DNA results. I glanced at the sender's name as my finger touched the key and saw the last name: Williams. Shit.

Only a few days had passed since I was "told" to look up my name, so my name was still very fresh on my mind—Cassandra Williams. I knew from Sofia that Williams was my biological father's last name. I pulled my finger off the key and read the email.

"Alejandra, my name is Kay Williams Turner & u r a DNA match to me. Ancestry shows us as cousins but I suspect we may b closer than that. Could u contact me? Are u by any chance adopted?"

Double shit.

I ran into our master bath where Art was showering (too much information, I know), and I shouted, "They found me! They fucking found me!"

You can imagine the look on his face, considering what he was in the middle of. He asked, "Who found you? What are you talking about?"

I shoved the phone up against the glass shower wall. "The biological father and his family!"

He rinsed off and sat next to me on the edge of our bed. We looked at the email again, and he once again reminded me of what opening this door meant. Ugh, I didn't think I could go through this again. I left the room to meditate, but my meditation was half-assed at best. I was too distracted. I got up and called Ryan. Both Art and Ryan said they would support whatever decision I made. I had been asking for clarity as far as direction for the book. Could this be the answer? How many people have both sides of their biological families find them when they don't care in the least to be found? Perhaps this was part of the story I was here to share ...

I decided to take this email as a sign, and I responded a few hours later.

"Hi Kay—Yes, I was adopted in 1967. My biological mother's name is Sofia. I have a relationship with her. She found me when I was forty. She told me my biological father's name is Richard Williams. I am guessing he is closely related to you since you know about the adoption?"

I had a response almost immediately.

"Alejandra, you are my niece!!! My brother, Dick Williams (Charles Richard Williams), was your father. Unfortunately, he died almost 4 years ago. You have a half brother, Todd Williams, who is 45. You also have aunts. I don't know how to navigate all this but I know I want to meet you. I live in Dallas, Tx. The others are in Houston, Todd is in Plano. Here is my phone number."

A lifetime of information in a few short sentences. I didn't know how to process the loss of someone I never thought of or cared to find. Surprisingly, I found myself feeling quite sorrowful. I sat down for a little while to absorb the information and gather my thoughts before responding.

I wrote back, "Kay, let me discuss all this with my family and I will be in touch. I have never had any inclination to look for either biological parent as I had amazing adoptive parents who gave me an incredible life. I always said if they found me, however, I would be open to having a conversation. As you can imagine, this is a lot to process, so please be patient and I will get back to you."

She replied instantly. "Alejandra, I completely understand. More than you know. I am so glad you have a loving family. If all you want is info (medical) and perhaps pics, I will respect that. I did not know of your existence until about 18 years ago. Your biological father was one of five kids."

I needed to talk to Sofia before going any further. The only information I had on my biological father's side was what Sofia shared with me, and since she was not treated very nicely by either Dick or his family, I felt my loyalty at this point was to her. I texted her and asked to talk. I responded to Kay a few days later, after having a phone conversation with Sofia.

"Kay, I am very sorry for the loss of your brother. I talked to Sofia today and she was sad to hear the news as well. I live in Tampa, and my maternal biological family lives in Dallas and Plano. My husband and I will discuss things further, but I am okay talking to you at some point and I would like the medical information—always good to have that. A few pics would be nice. Sofia has always said Ryan looked like him. I am on Facebook if you would like to connect that way and we can go from there. Does Todd know about me? If he wants to reach out as well, that is okay with me. This is a lot for everyone to process

in the beginning. Know going forward, even when it's all good, it's not all good."

Again, Kay responded almost immediately. She didn't know if Todd knew, so she had reached out to his mother, Dick's ex-wife. His mother always felt telling Todd had been Dick's place, and he had chosen not to, although Dick had shared the information with her due to the possibility I could surface at some point. So Todd didn't know.

I waited for Art to come home to decide how to move forward. We talked, and I sat down and responded after dinner.

"Kay—After discussing the situation with my family, I believe there are only two ways to move forward. If Todd does not know about me and is not going to be told, then we will leave things as they are. I appreciate any medical information you feel could be useful to me and you are welcome to send me pictures if you like. I am not going to have a relationship with part of the family and be a secret to others. If you intend to inform him, then at some point I would be willing to come to Dallas and meet you all as long as Sofia comes with me. My half sister Beth already told me you all have five mutual friends on FB, so one way or another, this is going to affect a lot of people."

Beth and I still didn't have a close connection, but I had reached out to her and Sofia so they knew what was happening. Sofia had said she would be there for whatever I needed and decided. I had a feeling the situation could get messy since everyone was in the same zip code!

33

DIRTY LITTLE SECRET
The All-American Rejects

received another long email from Kay the following day. She let me know Todd's mom had driven to Dallas from Houston to tell him in person. Obviously, he was very surprised to know of my existence. He didn't want to be intrusive but did want to know more about me. He would send me a FB friend request, and we would go from there. She went on to describe Dick's medical conditions in depth. He had passed away from cancer. She also shared with me why she was on ancestry.com.

A few years earlier, her mother passed and Kay found personal papers that led her to question the paternity of her biological father. Ancestry proved the man who raised her was not her biological father, and even though this revelation came in her seventies, the news was still shocking.

The hypocrisy of this situation from my perspective is that the woman who called Sofia names, told her she would never ruin her son's life and to never contact the family again, had absolutely no moral ground to stand on herself. She had gotten pregnant and passed off her oldest child (Kay) as her husband's. That was the person I shared a birthday with.

I replied to Kay's email that evening, and we began to get to know each other. I filled her in on parts of my life and encouraged her to share the emails with her siblings and Todd. I was not ready to share my spiritual journey or gifts with them yet, seeing how the last time I shared that kind of information with my biological family, I was called "evil" and "of the Devil."

Through Facebook, Sofia found out her granddaughter and Kay's grandson were in the same class at school, so Kay and Sofia were grandparents at the same school at the same time. The reason this is so insane is that both Sofia's family and Dick's family grew up in Houston, and now, fifty years later, they are all living within twenty minutes of each other in Dallas.

I received my first email from Kelley, Dick's youngest sister, a few days later. She was five when I was born and said she remembers how pretty Sofia was. She also hadn't known of my existence. Kelley told me about her family and how she and her husband spent their time. She also told me Ryan looked similar to Dick when Dick was the same age. She said, "His hair is very similar as is his nose." She hoped Todd could send me some pictures, as she didn't have any. She wanted to know when I was going to Dallas so we could meet.

I responded that a trip to Dallas was premature at the moment. I had rushed into the in-person meeting with the other family, and I would not make that mistake again. The mere fact I was having this type of conversation for the second time was mind-blowing enough.

Emails and phone conversations would be best for the time being and would give everyone involved, especially Todd, time to process before the added pressure of meeting took place. I asked how she found out about me. In her email, Kelley stated that she'd found out about me as an adult. I was curious as to how this information came to light.

Kelley shared with me that Margaret (Todd's mom and Dick's first wife) had a "Kelley, I think it's time you knew this" kind of

conversation with her in her kitchen one day. Kelley never discussed me directly with Dick. Dick was apparently a very private person, and once he divorced Margaret, got remarried, and moved to Georgia, there was not a lot of communication.

Kelley told me she wanted to share some of his positive qualities (as few had surfaced yet). "He was very handsome. That is a strange first 'quality' but that is what most people would say about him, especially when he was young. Sadly, from a young age, that was his identity. He was athletic and a very good cook. He was a big supporter of the Georgia Bulldogs and traveled to their games. He was very organized and liked everything to be neat and orderly. He also had a lot of friends and was very outgoing ... Dick didn't share his emotions, but he was very kind and friendly to many people."

She told me a bit about her mom as well. I shared what I knew of the conversation her mother had had with Sofia the day I was born, and she sadly agreed that was something she could hear her mother saying. She acknowledged her mother had "a lot of wonderful qualities, but she had a very quick temper and could be very harsh. I'm afraid Dick inherited those qualities from her as well. I can not (nor will I try) to justify what my mother said but I want you to know ... and Please tell Sofia ... how deeply sorry I am!!!"

Kelley went on to say, "Again, please know those horrid, negative words don't represent the rest of our family. Alejandra, thank you for your honesty. I hope I will have the opportunity to meet you one day but I will leave the timing up to you. I try to be a very open person so if you have any further questions or concerns that I could be helpful with please don't hesitate to contact me and I know Kay feels the same."

I shared what Kelley said with Sofia, who understandably didn't have much to say.

The emails flew back and forth for almost a week. I finally sent an email to both Kay and Kelley to wrap things up for a while. I needed

time to process without constant communication and information. "Wow, again, lots to process. Thank you both for being honest and giving me real answers to my questions. I do want to clear one thing up though. I don't have conscious anger towards Dick or your mother. I have always felt very grateful I was given the parents I had. They went out of their way to make me feel special and chosen until the day they died. I asked the question because I only know Sofia's version of events and I feel if we were all going to move forward, everyone needs to know what I was told.

"I have been working with master healers who told me I have very old, deep-seated fears of abandonment and rejection in my subconscious. I have been doing a lot of work on this in the last two months and have been able to release fears and forgive all involved. I do not hold anyone else in your family responsible for either Dick or your mom's actions, so there is no need to apologize to me. I look forward to getting to know both of you and I am glad you understand why things need to be taken slow. Todd, most of all, needs time to come to terms with this, process, and have a say in how things move forward. There will be a trip in the future and we will have moved past all the secrets and lies and can at that point, just enjoy each other."

34

UNKNOWN BROTHER

The Black Keys

knew having this family come into my life at this point in time was no coincidence. They were part of my healing. Perhaps they were part of my releasing my fears of abandonment and rejection. I was cautiously optimistic at best, however, based on my last experience with biological families.

I had a call scheduled with Kristin that afternoon. I hoped I could handle doing energy work after how emotionally drained I felt. I lit a candle and misted myself with the beautiful Practitioner's Potion that Heather had created for me and waited for the phone to ring.

Surprisingly, my session left me energized instead of further drained. I was so happy I didn't cancel. The main message Kristin channeled for me was "not to absorb anyone else's journey." Yes, this seemed right on point based on the events that had just taken place. Everyone involved had their own agenda and their own version of how they wanted me to see things, and I couldn't take that on. Information overload was coming at me from all sides: the Williams family, Sofia, her family, Andrea, myself, and my own family. I needed to rely on my intuition and not feed into the frenzy.

The next morning, July 31, I received a Facebook message from my new half brother, Todd. He shared the emotions he had been

going through since receiving the news. He had, after all, lived the first forty-five years of his life as an only child. Finding out he had a sibling was quite overwhelming. His father had chosen to keep this information from him, and he said that stung the most.

Todd told me about himself, where he grew up, and when he met his lovely wife, Nancy. As we found our paths continuing to intersect, he told me he lived in Chicago for several years and even went to Notre Dame football games! They had a son named Jacob, who was their miracle baby as Ryan was ours. The synchronicities continued as he informed me he lived in Plano, about fifteen minutes away from Sofia's house.

He shared he had had a good relationship with Dick for the most part, saying when Dick left his mom and moved to Georgia, "his leaving really hurt and I carried a grudge for a while. Over time, those wounds healed and we got along fine, but between the distance geographically and living two completely different lives at the time, I did not see or talk to him often. He was a good man. He was in failing health when Jacob was born and passed away just three months later. The good news is he was aware of him and knew he was a grandfather before he passed away, which meant the world to him."

Todd offered to send pictures of Dick. Art, Ryan, and I were floored when we saw them. Ryan did look just like him. I wonder what he would have felt like knowing he had another grandson who was so physically similar to him.

Todd agreed with me on taking this process slow. He, unlike me, had done some online research. I shared the story of my previous experience and the waves of emotions that take place in the first few months after getting the news. We shared phone numbers, photos, and emails and slowly began the process of getting to know each other.

35

LEARN TO LISTEN

Ramones

A few days later, I took a much-needed day off from biological families and feng shui studies and had an acupuncture session with Dr. Sandi. My final exam consultation was in a few days, and I wanted to be at my best. She said the message "they" wanted to get across to me was to be obedient.

The exam consisted of a full in-home feng shui consultation. Heather had introduced me to a colleague of hers who was willing to let me use her home. I was at the house for a little over two hours and felt great about the suggestions and advice I was able to impart. The next step would be to write up a paper with the challenges the client faced and the solutions I provided, and turn it in. I left the consultation in a great mood and called Art to let him know I was on my way home.

About five minutes into the drive, a little voice told me to go to the crystal store. The closest crystal store was Serenity Now, the first crystal store I had ever been to. I plugged the address into Waze at a stoplight, but as I drove, I changed my mind. I started driving home again. I knew if I walked into the crystal store, I would not come out empty-handed!

The voice got a little louder and once again said, "Crystal store." I remembered the takeaway from Dr. Sandi the day before to be obedient, so I changed direction again.

When I walked in, the first thing I noticed was the exotic smell of some sort of incense or spray. Then I saw the crystals—so many beautiful specimens! Brooke smiled warmly at me from behind the counter and asked, "What are you looking for today?"

"I have absolutely no idea," I answered honestly. "I was just told to come here."

Brooke, who the first time I walked in had also told me I had a beam of light over my head, grabbed some sprays and said, "Let's start by clearing you and see if that opens you up." She started spraying. There was the smell I noticed when I first walked in.

"What is that?"

Brooke said it was a Smudge Spray blend to clear negative energy. She followed the Smudge Spray with a misting of Rose, which is said to bring in loving vibrations. Then she handed me a necklace with two crystals and said, "Wear this for a few minutes."

Almost immediately, I felt something radiate from my throat, ears, and up through the crown of my head. There was so much energy moving up through my crown I got a little dizzy and lightheaded and grabbed the edge of the countertop. I knew how powerful crystals were, but this was the first time I had experienced such a visceral reaction when wearing one.

I could see another lady toward the back of the store as I leaned on the counter, and I asked who she was. This turned out to be Dr. Marcella Zinner, an intuitive and a psychic. I asked Brooke if Dr. Zinner had time for a reading, and of course, someone had just canceled.

I left the necklace on during the thirty-minute reading, during which I felt waves of energy pass through me. Dr. Zinner told me I was very intuitive and empathic and had a very expansive aura. She

"saw" me up on stage, "speaking to many, many people on a large scale." Then she asked me, "Do you like to write?" I just looked at her. "You are going to write a book. Have you started the book yet?" I can't make this shit up, people!

"Did you have a daughter at one time?" Dr. Zinner continued. "She is now one of your Spirit Guides."

This lined up perfectly with the information Kristin saw at Miraval. Dr. Zinner told me I was a healer who would be helping many learn to navigate their own gifts from events that occurred to me. I was speechless as she spoke.

After the reading, I told her that at Miraval, I had already heard many of the things she said. She said her words were a confirmation those situations would indeed take place. She asked who I worked with, and of course, she either knew them or knew of them. Dr. Zinner said I had worked with the "top" people. So, so much confirmation that I was on the right path.

I felt such gratitude for listening and allowing the "voice" to be my guide. Of course, I bought some of the yummy spray mists too.

36

SYNCHRONICITY

The Police

*D*uring meditation one afternoon in early August, I received a message from our daughter, asking to be properly named.

We didn't know the sex of the babies I miscarried, and to be honest, I chose not to dwell over them. The losses themselves were painful enough. We had chosen not to find out the sex with our first pregnancy, so we already had boy and girl names picked out from that time.

I talked to Art when he got home from work, and he was on board. We officially named her Hannah Catherine Brady.

That night, around 3:00 a.m., I felt a male energy envelop me from behind. The energy breathed heavily into my right ear, which woke me up. When I got up the next morning, I had terrible vertigo and had to cancel all plans. The following day, I still felt dizzy and called Heather. We both felt the energy was Dick's, I can't tell you why, but that is what we felt. This is how claircognizance works—you know shit because you just know shit! Heather suggested I do a meditation to leave Dick on an island. I hung up and immediately lay back down on my bed and did exactly as Heather recommended. I felt lighter, and the dizziness went away.

A few days later, Karen Rauch Carter arrived. This time, she was at my house for a visit and to hand me my feng shui certification in person. As we moved around the house for her to see the changes Art and I had implemented, I shared my nighttime experience with her. As I spoke, my right earring suddenly fell out of my ear. I reached down and popped the earring back on. I continued my story, and the earring fell out again. This happened three times. Once while we were standing in the kitchen, once when we were in our bedroom, and once when we were sitting in the family room. Even she seemed surprised, and she had seen a lot of stuff go down!

Later that afternoon, I found out I was a blood relative of General Robert E. Lee. Kay had emailed me historical information and a family tree. Apparently, through General Lee, I was also related (by marriage somehow) to Martha Washington. Who would have thought when I was a senior in high school and a debutante in the Society of Martha Washington, I would somehow come to be distantly related? And Ryan had chosen to attend Washington and Lee University, where Lee is buried in the chapel on campus, although it wasn't a family school. I sat in my office looking at my computer, reading Kay's email over and over again, making sure I understood what she was saying. Honestly, if someone had asked me to write down a story, I couldn't have come up with this.

A week later, I went to get a facial from a provider I had not gone to in a year. David's facials were amazing, but between the treatment and traffic, I needed about four hours. While he was working on me, he received a "message." He said his deceased grandmother Mimi wanted me to know something. Her message to me was, "You are on the right path, but 'they' know you need more confirmation and reassurance."

David stopped working on me and excused himself because he was "told" to go write the rest of the message down immediately. He left the room for a few moments while I lay with an organic mask on

my face. As we hugged goodbye, he handed me a yellow, lined sticky Post-it note. The handwritten message said:

"How to heal from within: Living a life of knowing the Power exists but never developing or accepting it is a crime against your own Power and happiness. Tell the reader the time is NOW to develop YOU. Touch briefly to not lose their interest on your life journey and how you got to this place."

I walked out of his office in a daze with the note in my hand and looked at my car across the street. A sign caught the left corner of my eye. I was across from an arcade on Central Avenue in St. Petersburg, Florida, at the end of which was a little shop I loved. The owner, Alex, had had a heart transplant and was extremely spiritual. He also had a beautiful daughter with special needs. You could see she was an angel here on Earth. The shop had authentic Himalayan sound bowls. Instead of going home, I walked over to the shop.

Alex looked at me as soon as I walked in, and he said, "You need this one."

I asked, "Why this one?" as I had not said anything other than hello. I felt the way I felt at the crystal shop a few weeks before. I was being led and had no conscious agenda. I was simply following the inner voice and guidance.

He said, "This bowl is an A note and is for the throat chakra. You will need the bowl for your job moving forward because you will need to communicate with many, many people." Once again, I was speechless.

As I drove home across the Sunshine Skyway bridge with my beautiful antique Tibetan sound bowl in the seat next to me, I remembered a bird I had seen on my early morning walk. In over twenty-nine years of living in Tampa, I had never seen a spoonbill in the wild, let alone in Carrollwood Village along Ehrlich Road. Based on the events of the last few days, I decided to look up the pink bird's spiritual meaning and see if it held a message for me. When I did,

I read that a "Spoonbill would teach you how to scoop up and use whatever information came your way."

I had certainly been receiving an astounding amount of information lately, and "the spoonbill would teach you to be open to the possibilities and gobble up the lessons thrown at you in life." Seemed pretty perfect.

The following morning, I was back at Dr. Sandi's for acupuncture and cupping to help with the ongoing frozen shoulder. I knew a session would be beneficial before my long flight to Sedona the following day to close on the new house. As I lay facedown on her table, she asked me, "Who is Robert?"

I knew enough now to know she wasn't referring to anyone living but to someone around me as I lay there. I couldn't think of anyone except my mom's brother, whose name was Roberto. I had never met him. He was a pilot and had died in a plane crash years before I was born.

Then all of a sudden, a thought hit me. "Could this be Robert E. Lee?" I asked.

Dr. Sandi gasped and said, "All the lights in the room turned off." (My head was in the massage table face cradle, and my back was covered in needles and cups, so I couldn't see.) All the other electronics in the room remained on. She had me say his name again, and the lights came back on. We did this several times, and every time, the lights either flickered or turned on or off!

In all honesty, I was a bit shaken as I was checking out. I noticed her assistant's name tag. Her last name was Lee. I literally blurted out, "Are you related to Robert E. Lee?"

"Yes," she said, "on my father's side. How did you guess that?"

Dr. Sandi walked over, and when we realized two descendants were in the building at one time, his showing up made sense.

I sat in my car and was about to call Art and Ryan to share this, but Instagram sidetracked me. As I scrolled, I saw a quote from @spirit&bone: "The past holds a key to the present. Today extends an invitation for you to celebrate where you come from so you can inform where you are going."

37

MY LITTLE BROTHER

Art Brut

rt and I flew to Sedona, only to find problems that delayed our closing. Todd, my newly discovered biological half brother, and his wife, Nancy, were coming to visit us in Tampa, so we had to fly back to our home in Tampa before everything could be addressed in Arizona. This would be Todd's and my first in-person meeting.

I picked them up at the airport and headed to lunch at Steelbach, which was in the newly remodeled Armature Works by the Tampa River. I wanted them to see how beautiful Tampa was. I felt such déjà vu as Todd and I sat across from each other and tried to find physical similarities while making small talk. My surprise this time was that I could not see any real resemblance between Todd and myself. However, I could see several between Todd and Ryan. The mystery to Ryan's hairline and nose was finally solved!

After a nice lunch, we drove around Tampa for a little while, and then we headed home to meet up with Art. We had a relaxed dinner at our house. Todd brought photos. The correlations between my biological father and Ryan were even stronger, which shook me a bit. From everything I had heard up until this point, Dick was not a very nice person, and having Ryan be so similar physically to him left me a bit uneasy. I decided I really wanted to know about him and have a

better understanding of who he was as a person, not just as a sperm donor, so we talked a lot about Todd's father—our father.

After dinner, Todd and Nancy took an Uber back to their hotel. I had suggested staying at a hotel after my first visit to Dallas. I knew from experience it would be best for both of us to have time to decompress without each other around.

Todd was also a craft beer lover, so Art and I picked them up the next morning, and we headed to downtown St. Petersburg to tour some of Art's favorite breweries. The weather was gorgeous, so we walked along the water and had a great time. We had a wonderful visit, but of course, a lot of processing still needed to take place. Todd had been an only child for forty-five years at this point and now, seemingly out of the blue, he had a big sister. I knew from my first time in Dallas how much of an emotional toll the weekend would take on all of us.

We said goodbye on Sunday afternoon, and by Sunday night, I was physically and emotionally spent. I was getting ready for bed when I received an unexpected call from Beth, informing us her ex-husband had just been put on life support. He and my other ex-brother-in-law, Timothy, suffered from similar issues, and unfortunately, both would die of similar causes.

The week had been difficult, and I was looking forward to my monthly session with Kristin the next day. Our session started with her asking me, "Who is Charles?"

"My biological father," I told her. Kristin said he put his hand over his heart, said "thank you," and was very happy. He was proud as a father that Todd and I were able to accomplish what he wasn't able to do in his lifetime. Kristin said, "He watched over you during your weekend together and was content." I don't know why, but that made me happy.

I asked about Beth's ex. "He needs permission. He is in a gray area, and he doesn't think he can make the necessary changes needed in order to come back," Kristin said.

As soon as Kristin and I hung up, I prayed he would find peace.

I woke up early to meditate the next morning. We were remodeling and updating our master bathroom, and meditation had been a challenge with workers around. I felt frazzled and ungrounded. I was starting to see how different my days were when I was able to make time for meditation versus when I didn't.

We finally closed on the Sedona house, albeit almost a month late. Before I left for my month-long install trip, I reached out to Deana Lee, a world-renowned intuitive, healer, and teacher who has over forty years of experience with Akashic Records. The Akashic Records are said to hold the collective consciousness of all beings who have ever lived on the Earth, across all time, and some believe the answers to all questions can be found in the Akashic Records.

While we spoke, Deana said, "Spirit has already given me a page of notes on you. I am very impressed with the growth you have shown in such a short period of time. Write down things that come to your mind because Spirit will be giving you hints on things you need to know or heal from."

I did as Deana suggested. I couldn't wait to meet her in person and have my session. I hoped my time with her would answer the sea of unanswered questions I now saw staring back at me from my journal.

38

JET AIRLINER
Steve Miller Band

October 22nd was the day. I had been prepping for this flight and this trip for almost a month.

The plan: I would fly five hours, land in Phoenix, rent a car (something I had never done, even as a fifty-one-year-old woman, so I already had some apprehension there), and then drive two hours through the desert to Sedona. Appointments were set up at the house with movers, designers, my assistant, the painter, and the landscape contractor.

The reality: after boarding and sitting on the plane for over an hour, the pilot announced our flight was canceled. His exact words were, "We will not be going to Phoenix on this plane today." I deplaned and headed straight to the Admirals Club to rebook my flight. Within fifteen minutes, I was rebooked on the same flight the following morning. Baggage was called to pull my bags so I could go home. I went down to baggage to claim my luggage, and then the real fun began. No one took accountability for the bags, and they had me wait, and wait, and wait.

While I waited, I started working on all the logistics, which were now a complete mess.

Sedona was three hours behind, and the current time in Tampa was 9:00 a.m. I worked on the rental car first. I had booked through Priceline, so I called them. They told me to call the rental car company, Fox, directly, as they couldn't help me. So I did. After being on hold for thirty-five minutes, the rental car representative answered the phone and informed me he couldn't do anything, and I needed to call Priceline back. I calmly explained I had just done that, and he still said no. I called Priceline back, and they told me I needed to call Fox directly. I was not so calm anymore, and I'm sure the tone of my voice gave me away. I was finally transferred to someone who informed me she would call the rental car company while she put me on hold. Thirty-eight minutes later, she told me she couldn't do anything, and the reservation had to be canceled and rebooked.

The company was now out of cars, and they couldn't hold the car they had for me for twenty-four hours, even though I offered to pay for the day. So, after over an hour, nothing was accomplished. Meanwhile, no luggage ...

I started the rebooking process, and now for one day less of rental, the total went up over $250. Not happy. Next on the list: the hotel. Again, I had booked through Priceline (a mistake I wouldn't repeat), and we went through the entire scenario a second time. The outcome was a bit better, as the hotel agreed to change my days and make life simple for everyone. Still no luggage ...

I continued canceling lunch platters, my assistant, and all other contractors except the movers, who were unloading furniture at my house at that very moment. I had hired a local design firm to receive items I ordered and purchased. I was talking them through what room to place what item in as best as possible from baggage claim.

Finally, after sitting in one spot for almost three hours, I was informed they had "good news and bad news." I was not feeling any zen Sedona vibes at the moment. The good news was one of my bags (the bag with all the cold-weather clothes) was available, and they would

deliver the bag shortly. The bad news was the other bag (the one with all my everyday items) flew to Phoenix ... on the plane! I asked, "How is that possible? We were told the plane was not flyable." The attendants' response was that the flight was just really, really delayed. I felt a blood vessel pop somewhere inside my head. Seriously, we were not given any option other than to deplane and rebook. I did not understand.

I grabbed my one suitcase, jumped in an Uber, and fumed all the way home. About twenty minutes later, a friend called me and let me vent. "Well, you certainly were not meant to be on that flight or in that rental car today, that's for sure." That sentence stopped my rant, and I thought about her words for a minute.

We hung up, and I sat down to do what ended up being a pretty sloppy meditation. I was still aggravated, and I asked my Spirit Guides to explain this one to me. I received a message there would have been an accident between my rental car and a motorcycle. Well, I had ended up with a different rental car company, and the flight eventually left without me, so ... maybe?

My mood immediately shifted from annoyance to gratitude. I was being protected. Getting told no or having plans fall apart was also a way the Universe took care of you. Sometimes the true guidance is in the "no." Thank you, Universe ... still wished I had my makeup, though!

My eventual arrival in Sedona felt like Groundhog Day, except the second time around, everything went smoothly, and upon landing, my missing bag was located right away. As I pulled into our new driveway, a bobcat sat on our sidewalk steps. We made eye contact. I said hello. He turned around and sauntered away.

39

WALK LIKE AN EGYPTIAN

The Bangles

The next few days were a blur of activity as I worked to get the house up and running. I took a break for my appointment with Deana Lee, though. I had never been under hypnosis before and was not sure how I felt about the entire appointment. I was so tired, I almost canceled, but the little voice told me not to.

Deana's cozy office was full of beautiful crystals. She immediately hugged me. We sat down at her desk and began my session by reviewing the two printed versions of my personal Merlin report.

The Merlin report is an interpretation of a person's birth chart. The cover of one report had the name Cassandra, and the other had the name Alejandra. I have to admit, a lot of stuff hit close to home. "You expect much from yourself and may not give yourself enough room to experiment and make mistakes." Yup. "You are careful and cautious in your approach to life, realistic, practical, and disinclined to gamble. You analyze before you act. You are too serious sometimes. Allowing yourself to play and to make mistakes would be healthy for you. Family ties and attachments are not as important to you as they are to most people, and you often consider your friends closer to you than your blood relatives." Um, hello? Absolutely true.

We moved from her desk area to her treatment room, and I lay down on the warm massage table.

Deana said, "Spirit asked if you would like your hands activated."

"Sure!"

She explained, "You need to be perfectly clear on what this means. Having your hands activated is a gift. If you say yes, when Spirit asks you to touch someone, you are agreeing to do so."

I agreed to the terms. The next step was to energetically clear and decalcify my pineal gland. I could feel a finger pushing into the space between my eyebrows, although no one was physically touching me. The Akashic Records session began. I closed my eyes and let Deana guide me through my spiritual journey.

All I remember is feeling light and at peace, asleep but not really asleep. Our session was being recorded so I could go home and listen to it later, since more than likely, I would not completely remember what took place. When the session ended, we hugged goodbye. As we hugged, Deana encouraged me to go to the Boynton Canyon Vortex.

Sedona is known for four energy vortices, and people travel from all over to experience them. The Boynton Canyon Vortex is described as a site of balanced energy (the others are said to have either masculine or feminine energies, but Boynton Canyon has both). I got in my rental car, took a deep breath, and headed to the Canyon. I had been there several times, and this vortex was one of my favorites. The hike to the top was an easy fifteen minutes. Deana wanted me to decompress and process all my session information.

I parked, saw the trailhead sign, and started walking up the familiar red dirt trail that led to the vortex. Suddenly, I found myself lost. I looked up and saw the back of a woman about eight feet ahead of me, and at that moment, I heard Spirit speak. "Go touch her."

Seriously? I thought, *I got this gift, what, an hour ago, and now I am supposed to go up to a random woman on a mountain and come up with a*

way to touch her? Spirit sure has an interesting initiation process. But I did as asked. I walked up to her, tapped her (counts as touching in my book) on her right shoulder and asked for directions to the vortex.

She smiled and showed me the path that was now right in front of me. I thanked her, made the quick climb to the top, and sat at the base of one of the twisted juniper trees in the center of the swirling, twisting energy. There was so much to process, and I was exhausted. I closed my eyes and allowed Nature to ground me.

After about twenty minutes, I got up, thanked Mother Earth, and prepared to head home. I didn't want to be up there alone after dark, and sunset was quickly approaching. As I walked down, a man came up to me and handed me a heart-shaped red rock. He simply said, "You need this rock." I was a little taken aback, but the day had already been a strange one, and I was in Sedona, after all. I thanked him and made my way to the car.

After dinner, I lit a candle and curled up with a cozy blanket on our sectional to listen to the recording of my session with Deana. During the session, she opened my personal Akashic Records to see what they revealed. She said, "If Spirit wants to share information with you, that information will be revealed."

Spirit and the Akashic Records had so many messages for me. A Spirit Guide would come and help guide the writing of the book. The guide would help me sort out what was helpful and healing for those who read the book. All I needed to do was ask for help. I was to start the book *now*! The bobcat showed up because he was our new home's protector.

How many lives have I lived? "At least nine."

Which was most significant? "One of your lives was in Egypt. You were a Pharoah, King Tutankhamen."

I heard myself laughing and then remembered Deana laying her finger in the middle of my forehead and saying in a serious voice, "Stop. Never laugh when Spirit is sharing a message."

What were other significant lives? "You were a light sorceress in Medieval England, and you were Athena, the goddess, in Greece."

Did I have my names in previous lifetimes? "Yes, you have been both Cassandra and Alejandra many times."

What is the name of my red-haired warrior Spirit Guide? "Rufus." (I would later be told this name literally means "red" or "reddish"!) "You will see dragons when he is around."

What is my main spirit animal? "The owl." (I have had an extensive owl collection for over a decade. I find them on my travels, and my collection includes ceramic, wood, and stone statues as well as original watercolor paintings.)

Why did I choose Sofia as my biological mother? "You needed her lineage and bloodline. She comes from a long line of both light and dark sorceresses."

Other information from Spirit came through.

"Your friendships with some close friends will fade. You are in a massive period of transition. You need to relax. Camilla will bring you the material necessary for the book. Your strongest gift is clair-cognizance—knowing. Continue to use and develop your gifts. You will be able to see and communicate with more Spirit Guides moving forward, and your intuition will only get stronger."

Spirit's last message: "Start the book now!"

I sat up after hearing the recording and still found the information on Tutankhamen hardest to absorb. The words had come out of my mouth under hypnosis when she asked who I had been in Egypt.

I made some chamomile tea, sat back down on the sectional, and began to do some research. As a young child, I had been obsessed with Egypt and spent hours in my father's study, reading the Encyclopedia Britannica and *National Geographic*. Still, there was so much I no longer remembered. I had also flown to New York when King Tutankhamen's exhibit was at the Metropolitan Museum of Art. I remember walking through the exhibit and feeling such a connection

to the items, mummies, and columns full of hieroglyphics. That memory triggered another memory: my experience at the National Anthropology Museum in Mexico. I felt the same way when I saw the carvings on the basalt Aztec Sun Stone. I sipped my tea and continued to read. Two thoughts immediately jumped out at me. Tutankhamen had also had scoliosis as a child, and when his tomb was opened, his heart was missing.

I looked over at the coffee table where I had placed the red rock heart. Just a few hours ago, the man on the mountain said I needed that heart. Was that confirmation? At this point, I was on information overload and decided to go to bed. I took a warm bath with Epsom salts and lavender oil and crawled under the covers. This was the first time, but not the last, I was told I had been King Tutankhamen.

40

KING FOR A DAY

Thompson Twins

I continued working on the Sedona house, creating my own little routine. I would wake up and have coffee while checking emails and watching the quail, other birds, and javelina come in and out of our backyard. Living on a game trail certainly had its advantages. There was so much to see that I rarely turned on the television. After coffee and a banana or avo toast, I either walked or did some sort of online yoga video. The rest of my day was usually filled with contractors, furniture and accessory shopping, and getting the house organized and fully stocked. This was a very different install, as we didn't bring anything from our other home. I was starting completely from scratch, which sounds fun but isn't when you don't even have a spoon in the house!

I made time for my monthly session with Kristin. The messages coming through for me were to own my "royalty" and step into my bloodline. (I had not discussed the Deana session with her.)

I needed to get ready to be on my "throne," which equaled being on stage. The stage would feel good. My higher self came through and said, "I belong up here."

Then the messages suddenly switched and went in a completely different direction. Kristin asked about my stomach and said I needed

153

to pay attention to what I was eating. I had to bring awareness to what went in. My body needed help. I needed to focus on my physical body. I was to immediately remove dairy and bring in foods that were replenishing and nourishing. What? This seemed so strange to me. I led a healthy lifestyle, so I wasn't sure why there was so much emphasis on what I was eating. The messages would make perfect sense soon enough, however.

That night I woke up at 3:33 a.m. and "heard" I had to ask for a somatic massage to work on my shoulder and reproductive area. When I woke up, I reached out to a practitioner and made a 10:00 a.m. appointment for the following day. The therapist used several modalities on me, including myofascial release, visceral manual therapy, and cranial sacral therapy. These were all new to me, and I was fascinated by how much she was able to tell me about my own body after having just met me.

Once again, the issue of early childhood trauma came up. The trauma my body held all went back to my not feeling safe on this Earth, which, in turn, went back to the adoption.

Sofia was obviously not in a happy place while she was pregnant with me. Her family had sent her away in shame. Her boyfriend deserted her. She had shared all of this information with me when we met. All her anxiety and fears were probably transferred to me while in utero. The mystery of who took care of me for those five unaccounted weeks still remained. There was no safety or stability for the first few weeks of my life. I did not bond with anyone.

The therapist released the left side of my groin, explaining, "This area is completely blocked. By releasing your groin, I released your digestive organs, which will improve your neck and shoulder." My homework was to go home and rest, relax, and watch the birds while I sipped a concoction of aloe vera juice, grated ginger, lemon, and water. The drink was not my favorite by any means, but I drank every last drop.

I went back for a second session a few days later. She unearthed the main problems and core issues. Seven years in the back brace had literally glued my organs together, and I had not been able to expand physically. This led to a lot of the physical pain I felt. She worked on releasing my spine and ribs. She said she saw a bright light going in from the top of my head and down through my spine. The light needed to radiate outward, like the sun, and by opening up physically, I would be able to do what I was supposed to do. My Spirit was open, but my body was closed. This was the truth and why I was called to Sedona. I realized at that moment that true healing had begun.

After the session, I ran to Whole Foods to pick up some groceries. I got home, put the food away, ate a chicken teriyaki bowl, and filled the tea kettle. Once the water was ready, I made some prickly pear tea and sat down to begin a writing session. As I sat down, a blue jay flew up to the window and wouldn't leave. I walked outside to talk to him. He sat on the rail with his head cocked to one side and looked at me. When Art and Ryan had been in town recently, we had seen blue jays all weekend. They would fly a little ahead of us and then stop until we caught up and then fly ahead of us again. This happened in the car, while we were hiking, and literally everywhere we were.

I said goodbye to my blue visitor and walked inside to look up the spiritual meaning of the blue jay in my favorite animal reference book, *Animal Speak* by Ted Andrews. "If the jay has flown into your life, it indicates that you are moving in a time where you can begin to develop the innate royalty *(really, again?)* that is within you, or simply be a pretender to the throne. It all depends on you." *Whoa.*

That afternoon, Amanda, my sweet assistant in Sedona, asked if she could stop by and drop off a gift for me. She had been such a help during the move, and I was happy to spend a little non-working time with her. Amanda had mentioned she liked my essential oil diffuser, so I had ordered one for her and the diffuser had just arrived, so the timing was, of course, perfect.

Her gift was a crystal hanging from a leather strap. The crystal was wrapped in copper wire. Amanda told me she mined the stone herself in a nearby forest. The stone was called an angel quartz or Payson diamond. She told me I needed to look up the quartz's meaning after she left.

The weekend came and went. I was busy with house matters, as this was my last weekend before flying back to Tampa for Thanksgiving.

On Monday morning, Amanda showed up for work and asked if I had looked up the stone's meaning. When I told her I had not, she flipped back her long red hair and looked at me very seriously with her bright blue eyes and told me I had to do so. I promised I would read about the Payson diamond before I went to bed.

That evening, I sat down with a cup of chamomile tea. What I read blew my mind! This stone was also called a Lemurian diamond. Tears rolled down my cheeks. These stones were purportedly left for those of us who had learned we lived in Lemuria during one of our lifetimes. They were for us to find. The stones held ancient information, and those of us who were lightworkers could access that information by wearing and using the crystal.

I honestly could not remember if I had told Amanda about the double M's on my palms, so I texted her and asked. Her response was, "No, you didn't share that information, but something inside me told me to give you this very powerful stone because you touched my heart."

I was overcome with incredible feelings of gratitude. I could not thank the Universe enough for the magic I now experienced on a daily basis.

41

SYNCHRONICITY II

The Police

My plane touched down in Tampa, and I found myself being pulled into old patterns and habits. I only meditated two of the ten days I was home, and the difference was evident. The old anxiety and stress once again reared their ugly head. I honestly could not wait to get back to Sedona, even with all the work I had waiting for me there.

I flew back the Monday after Thanksgiving. On my two-hour drive from the airport, I listened to several episodes of Oprah's *Super Soul Conversations* podcast. Her guests included Sue Monk Kidd and Anne Lamott. Despite all the messages I'd been getting about writing a book, I had been procrastinating in writing anything because I felt immense pressure to write prolific chapters every time I sat down. One podcast guest said exactly what I needed to hear in that moment. "Write one sentence every day." A lightbulb went off. I could do that, and today was the day I would start.

However, the exhaustion of my ten-hour journey had set in. I was still on East Coast time, and after two trips to the grocery store, unpacking, and arranging flowers, I asked out loud, "Can this sentence wait until tomorrow? I am so tired."

I heard, "No. Sit down and write one sentence."

"Fine." I opened a shiny new journal, took out my black felt-tip pen, and proceeded to write one sentence. Three pages later, I finally stopped. These were the easiest pages I had ever written. I listened, I acknowledged, and took action on the guidance I was given, and I was rewarded with material for the book. Now I really was ready for a shower, cozy pajamas, and a bowl of Whole Food's organic turkey and rice soup. I could not wait to see what tomorrow's one sentence would bring!

As I walked down the hallway and into the family room the following morning, I was startled by a large ten-point mule deer looking right through the family room window at me. Our eyes locked, and I said hello. I asked him if I could take a picture so I could send the photo to my family. He stood perfectly still as I got even closer. I thanked him when I was done, and he immediately turned and jumped over the manzanita bushes and headed down the animal trail in our backyard. His photograph now graces the entryway of our home. I love to look at him every time I open the front door and always show him to everyone who visits. Most people describe him as magical, and I couldn't agree more.

I grabbed a coffee cup, made a Nespresso, sat at the kitchen table, and reached for my *Animals Speak* book. I was having so many interesting animal encounters that the book was now permanently placed on the kitchen table. "The deer is a central religious image for Buddhism," I read. "Buddha is often pictured with a deer."

While I am not Buddhist, I had recently been drawn to placing Buddhas in both my homes. The Buddha for Sedona had been delivered the day before, and the deer appeared this morning. Can't beat everyday magic.

As always, I had many appointments scheduled, and as always, the reality was quite different. The glass company was late, and when they did show up, the mirror had been incorrectly cut so they were not able to install it, which meant the electrician had to be canceled.

Another contractor showed up an hour and a half late and then was unable to work as he forgot his tools at home. Amanda didn't show up due to car problems. Painters couldn't paint because the back patio didn't get finished. The problems and excuses went on and on. I kept my cool and didn't freak out. In the end, the glass company made a second trip, and the electrician came back, and projects were completed. I could once again not control the situation, but this time, I chose to step back and control how I responded to the situation. That small shift in consciousness felt like real growth.

A few days later, my landscape architect picked me up. I needed to select plants for the meditation garden. As we chatted on the way to the nursery, he shared with me that he was an intuitive. As he drove, he looked over at me and said, "I feel you lived in Greece at one time and were perhaps an oracle." *What?* I had no idea what an oracle was. He said, "An oracle is a prophetess." I thought of the meaning of the name *Cassandra*.

Since he had brought up Greece, I told him about the session with Deana and my life in Greece as Athena. My question was, "Does that mean I was actually Athena?" I was curious about how this all worked.

He said, "You could be either a full reincarnation or just so immersed in her spiritually that she comes through in this lifetime."

I still didn't understand, but I knew this information was another piece of the puzzle.

In early December, Heather flew in for her first visit to Sedona, and we experienced an amazing healing session together. We worked with a healer named Amalia, who led us on a shamanic land journey. We met at Whole Foods and drove out to Rachel's Knoll in the Seven Canyons golf course. Sedona is cold in December, but we found a ledge to sit on after a short climb. Amalia started with a chakra "shit" clearing exercise, where we sent all our emotional crap out of our anal hole and back down to Mother Earth. Then she worked one on

one with Heather while I held space for her. I was honored to watch Heather release what needed to be released at the moment.

My turn. My message was to relax and open myself up to receive. I was too closed. This, of course, tied right into what my massage therapist had said. We worked on my being able to receive. The healer said, "Royals receive. Everybody works for them and brings them things. That is the mindset you need to put yourself into."

There was the word "royal" again. Then she asked me what color I saw. I answered yellow, then white. My back was to the sky, and both Amalia and Heather said that directly over my head was a sun dog with a yellow and white vertical beam of light. They both said the beam appeared when I spoke the colors out loud.

We got up and did a grounding exercise. When I was asked what I saw at the center of the Earth, I replied, "A red glowing ball and lightning." Mama Gaia was full of electricity and life. I harnessed that energy into my body by bringing the energy up through all the layers of the Earth. Heather said she saw the color blue and water. Fascinating how the same experience could be so personal for each individual.

Our session came to a close, and we walked back to the car. We were cold and emotionally drained, as we had done an immense amount of energetic work. On the way home, we stopped to warm up with a glass of red wine and some gluten-free pasta. Time to process and absorb what we had just experienced.

42

QUEEN OF HEARTS

Juice Newton

woke up to a gloomy, rainy morning. Heather was dealing with altitude sickness, so we had a slow morning sipping tea and hanging around in our pajamas. Heather had scheduled in-person sessions later that afternoon for both of us with Debbie Crick, who created Cards of Illumination. This was another new modality for me.

Debbie introduced us to Human Design and gave us the personal charts she made for us. She defined Human Design as follows:

> Human Design is a new system of self-knowledge that differs fundamentally from anything else that exists in the world today. It is not built on belief or faith but is a logical, empirical system which offers the opportunity to experiment with its mechanics and find out for yourself if it works for you. It shows you a concrete map of your own nature and provides you with simple tools for how to be yourself and eliminate resistance in your life. Human Design offers you the opportunity to discover yourself and begin to understand and accept your very nature. The Human Design System is a synthesis of two streams of science, traditional and modern. The traditional sciences—astrology both Eastern and Western, the Hindu-Brahmin Chakra system, the Zohar of Kabbalah, and most importantly of

all, the I Ching, the Book of Changes—these are the traditional elements in the synthesis that is Human Design, and combined with the modern science of reading the genetic code, this offers you profound insight into how you are designed to navigate the material world.

I was a Manifesting Generator. There were a lot of lessons, the biggest being I had to have patience and wait. "Although waiting seems frustrating for a Manifesting Generator, when you notice what is being offered, you will find there is a lot to respond to. You cannot plan your life in advance; it is so important that you remember to use your response mechanism. You will only have a successful and fulfilled life if you follow the strategy of waiting, however passive it may appear."

This was like pouring a bucket of cold water on me. I was used to going after things and getting a lot done quickly. This life lesson would be a difficult one.

"Just because you have the energy doesn't mean the time is right for you. The key is to keep watching and noticing what is going on around you and listen to your body."

Debbie went on to say, "Understanding your sacral response takes time and practice. In adults, the sacral response is deeply repressed and not everyone will get there. Notice whether you are coming from your Sacral Center or your Head Center. Thank your head for its input, but never let your head make the final decision, however much your head will try to. If you allow, the head will always win!" So much new information and such a different perspective on how to approach things. We are all taught from a young age to rely on our minds for our decision-making. I agreed; this was indeed going to take practice.

After this conversation, Debbie explained the Cards of Illumination. "The Cards of Illumination system goes back to ancient times and is the true purpose of a deck of cards. A deck of fifty-two cards elegantly reflects, with mathematical precision, our present-day calendar; the number of weeks in a year, twelve royal cards and months,

the four suits, the four astrological elements (fire, earth, air, and water), and the number of weeks in a month. Everyone in the world is represented by one of the cards in a deck. Through our Birth Card, our lives are revealed: trials and limitations, gifts and opportunities, inclinations, talents, hidden strengths, and much more. All cards have both challenges and blessings, and no one card is superior to any other."

This was all new to me. The information was completely fascinating. I could not wait to get started and see what the cards had to say about me. What Debbie said made so much sense. She said, for example, when we look at the weather forecast before leaving the house, we understand we can't change the weather, but we can certainly choose to dress accordingly and be as prepared as possible. The system helps us chose consciously.

My number turned out to be a ten. Keywords for people with this card included "success, egotism, unity of mankind, and receiving recognition." Ten reduced to one, which had the key words "aspiring to higher levels, leaders, self-serving versus service, able to bring in new points of awareness, ability to surpass obstacles." My knowledge card was a ten of clubs. Keywords for that card were "teacher, a lot of mental activity, successful mind, wisdom."

My challenge: dominant mind (insomnia). Well, that was dead-on. I had struggled to sleep through the night for years. Basic characteristics of my Birth Card include:

- Teacher's card: initiators, mental pioneers, doctors
- Life purpose always a question
- Love to communicate and take in new information
- Fear of limitations; can be skeptical
- Have the ability to change people's lives
- Extremely strong mother influence, for ill or for good; desire strong mate

- Want material world
- Creative
- Strong intuition, but often do not accept or recognize this gift

Then we got really specific and went through my year ahead. The details were on point, in my opinion, though I would not realize just how accurate Debbie was until several months had passed.

Heather and I flew home together a few days before Art's shoulder surgery on December 13th. The rest of the month was a blur as Art recovered from surgery and we celebrated the holidays. Ryan came home, and we all flew up to Buffalo to spend the week between Christmas and New Year's with Art's brother and his family.

As New Year's approached, I realized many of the healers I'd spoken to over the past months had been spot-on with what they said would happen. I did "move." We bought the Sedona house, and I had lived there most of the fall. There were difficulties with Art. His shoulder surgery was unexpected. I could not wait to see how the following year unfolded. Perhaps I would have clients in Sedona and work there!

43

BRAND NEW DAY

Sting

I chose to start 2019 with a more conscious mindset. I decided to stop holding things in at my expense to make others feel comfortable. The time had come to start paying attention to how people affected me and to speak my truth if I felt their energy toward me was toxic.

Andrea had given me counterfeit products as gifts several times. A couple of years ago, she sent a fake Valentino for Christmas. This year, I received a fake Louis Vuitton scarf, which she sent in a real Louis Vuitton box. The only logical conclusion was that she was trying to pass the scarf off as the real deal. I never said anything about the bag, though I had secretly seethed inside.

On my last visit to her home in San Antonio, Andrea had noticed my handbag. She invited me up to her large walk-in closet, filled full of designer things, and showed me her counterfeit version of my bag. She had asked if I wanted one, and I clearly stated I didn't wear or believe in buying fakes. She knew how I felt and had sent a counterfeit item anyway. Even worse, she purposefully tried to pass the item off as authentic.

So I sent her an email on January 1, and I knew it would not be well received. My email stated, "I choose to no longer exchange birthday

or holiday gifts with you. I would rather not put myself in a position where I am repeatedly upset with you. I understand how busy you are with six children and a full-time job, and this is one thing you can take off your list."

She was pissed, as expected, but I felt a huge weight lift as I spoke my truth and did what was best for me instead of always being silently resentful. This was how I now chose to move forward through life. Brave enough to speak my truth and brave enough to accept the consequences that came from my actions.

I went on to take down all the holiday decorations and get the house back to its regular shape and myself back to my regular schedule.

On January 3, with every trace of the holiday season nicely stored away, I sat down for my first real meditation of the year. I felt my crown open as I asked for whatever downloads the Universe had for me that would be in my highest and greatest good. I needed to get back into a clear state of mind. The past few weeks had been rough. Between Art's surgery and the holidays, I hadn't eaten well and had certainly not slept well. I felt like shit. My stomach constantly hurt and had been doing so for a couple of months.

Sofia's family was also going through some serious issues. Sofia had called me while I was in the car coming home from a holiday party with Art and my friend Grace. On speakerphone, she shared earth-shattering information about a family member. Two days later, I reached out to inquire how this person was doing. Her response was, "What are you talking about? Nothing happened."

I reached out to another family member and received the same response. The family had once again closed ranks, and I was on the outside.

I was completely caught off guard by their gaslighting, lies, and deceptions. (The individual's story is not mine to share. Apologies for not being able to elaborate.) I had to untangle myself from these people and this situation. I know the truth does not mind being

questioned, and a lie does not like being challenged. I had asked questions out of real concern, and they had lied to me in response. I energetically cut the umbilical cord with all involved and waited to see how my choice would play out.

The following morning, I dropped Ryan off at the Tampa airport after his three-week visit and started my errands. I looked for a podcast to listen to while driving around. When Oprah's *Super Soul* came on with the author of the book *Wild* as her guest, I almost switched because I didn't think this episode would be interesting. How wrong I was! Cheryl Strayed was amazing. I cried. I felt my mother around when she talked about hers and how angry she had been that her mom died when she was only twenty-two years old. I felt the same way when my mom died, and perhaps still was angry with her for leaving me.

I arrived at Sprouts Gardening, my favorite plant store. I needed to refresh some of the plants in Tampa that hadn't lived through my almost two months in Sedona. Being surrounded by plants always made me happy. I loaded up on succulents and orchids and started my drive home. The podcast continued. As Cheryl talked about feeling a release of her anger toward her mother, I cried again. Not an ugly cry, just soft tears dripping down my cheeks. I listened some more and loved the way she talked about being in the flow. The podcast ended, and another began. I didn't touch my phone. I knew my phone would play what I needed to hear.

The next episode featured author Daniel Goldman. He and Oprah were discussing emotional intelligence and the importance of being in the flow. I knew what being in a flow state was like, and I certainly had not felt in flow for most of the holiday season. I wanted to feel in the flow again.

I got home and unloaded my plants. I started planting and sat on the ground in the rocks by my side garden. I was happy as could be, digging in the dirt, when Art came out and asked if I wanted music.

I had a flashback to what Cheryl said, to go take a walk or be outside without being plugged in, so I said, "No thanks. I am perfectly content the way I am."

About half an hour later, I was deadheading plants and puttering around the patio when the song "Dixie" popped into my head, and I silently started singing, "Oh I wish I was in Dixie ..." I don't even know the words, but the tune kept playing in my head over and over. I recognized this, stopped, and thought to myself how strange this was. Why in the world was this random song playing in my head? Then a voice told me to go with the flow and keep singing. I did, and when I walked inside, the voice told me to look up General Robert E. Lee's favorite song. Part of me thought this was silly and how was anyone even going to know this let alone have the information be available on a quick Google search, but of course, the following came up, from the website *Civil War Talk*, dated June 17, 2014: "He only knew one song and that was Dixie!"

I just can't make this shit up! I am not sure what my ancestor was trying to get through to me. Perhaps he wanted to show me I was once again in a flow state the way I asked to be. I had gone outside, dug in the dirt with my bare hands, was fully present in the moment, and everyday magic happened. Perhaps that was the lesson.

I soon had another opportunity to once again practice speaking my truth. In early January, Sofia and I were on the phone, and she said she would support and be with me when I met Todd and the rest of my biological father's family, but this came with conditions. She would not have any kind of relationship with them outside of me. I didn't expect her to want any relationship with them, but I had to admit I was upset her support came with caveats, considering her actions and her choices were the reason I was in this situation. I was beginning to recognize this family's pattern. They seemed to be able to rewrite history when they didn't like the actual version of events.

A quick refresher: Sofia and her family came looking for *me*. I had had no intention of ever finding or having anything to do with my biological mother. Yet once again, I felt I was only part of "the family" when they wanted me to be or it was convenient for them. They were experts at distancing themselves when anything uncomfortable came up. I tried to remind myself my soul chose to be here. My soul chose my family and circumstances. Still, in all honesty, I was pissed. I hung up the phone with her, then went downstairs to have a glass of wine and vent to Art.

Art tried to get me to see her side of things. My mind understood, but my heart did not. I know Dick's family was unkind and abandoned her when she needed them the most. *Got it.* I had always been gracious and never made her feel bad about giving me away. She said multiple times she wanted to be a mother to me, but each time an opportunity presented itself for her to fill that role, she once again, as with the New York trip, chose to abandon me. Meeting the entire family was a big deal, and she knew I was counting on her and her family's support since this was what they had promised to me from the beginning when they asked if I wanted them to search for my biological father.

Now that the time had come to support me, everyone on Sofia's side of the family was suddenly either unavailable or out of town the entire time I was in Dallas to meet the Williams family. My trip to Dallas had been scheduled for months. Even though we didn't have a strong relationship, ever since Beth's ex-husband passed away, we had continued to have some form of light communication. We would email and text. I had kept Beth and Sofia up to date with all the information the Williams family shared with me. They knew how nervous I was to go to Dallas and meet thirty more new family members, especially since half of them hadn't known I existed until very recently.

There was plenty of time for them to have worked things out if they had wanted to. I even saw a comment Sofia's husband posted

about the weather in Dallas that weekend. I replied to the comment and said, "I thought you suddenly had to go out of town?" He then had to admit he was in town that weekend ... which, of course, led me to wonder if Sofia had been in town the entire time too. It would not be the first time she'd lied to me, nor would it be the last.

I thought about how I would handle things moving forward based on their behavior. I finally decided I would keep the families completely separate. They all lived in Dallas, which is why I thought everyone meeting made sense, but obviously, I was wrong.

They clearly didn't worry about sparing me. I was starting to establish much-needed boundaries with them. I did a grounding meditation and chakra clearing and sat down to write.

I read my oracle card. The card's message was that I was safe to feel the way I felt and this was my time. I was on my way. Only by speaking what I truly felt would I be able to move forward and not feel frustrated and held back anymore.

It was also Beth's birthday. I texted her "Happy Birthday." She responded and asked where things stood with the Williams family meet and greet in Dallas. I responded by saying what I truly felt, which was that, with Art's guidance, my decision was to keep the families permanently separate, so I would no longer have conversations about the Williams family with her or any other family member on Sofia's side.

My text said, "I am only in this situation because of Sofia. It's okay though, I have been dealing with the consequences of Sofia's decisions and actions my entire life. This is just one more thing ..." I had wanted to say these words for so long but had held back to spare Sofia's feelings. I consider myself a kind person, but I would no longer be silent and accept their disrespect and poor behavior. That day, I acknowledged what I needed to say, knowing full well Beth would show her mother the text. I could now move on.

I chose, once again, to speak and not downplay my truth in order to make them feel comfortable.

44

MESSAGE IN A BOTTLE

The Police

January 9th marked the one-year anniversary of my cervical fusion. I couldn't believe how much I had changed physically, mentally, and above all, spiritually in the past twelve months. I was in a lot less pain physically, although my frozen shoulder still gave me problems. I was walking daily, which helped tremendously. As I reflected, I felt such gratitude and honored what I had accomplished. I also realized what a journey I still had ahead of me. The big difference was I was no longer living in a fear-based state; instead, I was looking forward to what lay ahead. Now was the time to get "down to business" and do what I was supposed to do, which was to write this book.

My meditation the following morning was all about having a loving heart and releasing anger and hostility to those you felt had wronged you. Well, wasn't that pretty on point for me at the moment? I was able to wish Sofia's family love and a peaceful heart and, in doing so, set my day moving in the right direction. In the middle of the meditation, I was told I had to move both the Buddha statues in our homes. I thought I had them in the right feng shui areas, so I wasn't sure why ...

While having coffee, I researched and found that Buddha should be at least thirty inches off the ground. Placing Buddha below eye

171

level was considered disrespectful. I was mortified! I immediately made the necessary corrections. Then I decided to read my oracle card for the day out of the Journey of Love set by Alana Fairchild. I picked #58, Beauty.

> *You are in the process of healing past wounds about your appearance. ... This oracle indicates a significant change in self-perception taking place within you, an ability to love and accept yourself more completely than you ever have before quite simply because you have grown and there is more divinity awakened in your heart than ever before.*

I was always amazed at how the synchronization of the Universe worked when I was in a flow state. I had been so miserable the past few months. Aside from the ongoing stomach pains, I had gained ten pounds, my skin was broken out, and I had no energy. I was still not sleeping well, and my shoulder continued to hurt. I knew my hormones were wrong and assumed that was the cause of the breakouts and weight gain.

I finally made time to see the doctor and do the necessary blood-work to correct the hormone replacement therapy dosages. With that accomplished, I turned on classical music and began to write. I decided to listen to a podcast featuring Elizabeth Gilbert. Her words hit me like a bolt of lightning because I had been desperately trying to figure out how to start this book. She said, "You don't need to know why you are interested in something, all will be revealed if you follow your curiosity ..."

I wrote for about five hours and transferred over all the notes I had written about ten years before when Sofia and her family found me. I had stopped writing at the time because things had obviously not gone well, and I wasn't sure what I wanted to do with that information.

The next day, I had my one-year surgical follow-up and was completely unprepared for my surgeon's diagnosis. My neck had not fused, which meant the shoulder pain would most likely continue. My options were to either wait another year and see if my neck fused naturally or undergo a second cervical fusion. I left his office feeling dejected. Heather and I had plans, so I headed to the restaurant to meet her.

As soon as I sat down, she commented on how heavy my energy felt. I told her what the doctor had said.

After lunch, she did a reading for me at her house. I pulled five archangel cards, and all four element cards. She said she had never seen that happen in all the readings she had done. The main messages were consistent with what I had been told all along. I was on my way. I had a story to share that would help people. My life would entail lots of travel, growth, and financial success. Then she cleared me energetically and with crystals. I felt much lighter when the energy work was over, and we set to work on her master bedroom. I was there to help her implement feng shui.

When Art got home, I talked to him about my news, and we decided that undergoing another surgery was not what either of us wanted at the moment, so I would continue to search for natural ways to deal with the shoulder pain.

45

RAINBOW CONNECTION

Jim Henson as Kermit the Frog

had been afraid to do yoga since my fusion and decided to attempt it once more. This time, I decided to approach yoga as a beginner instead of trying to be where I was before the fusion. The class helped a lot, and my neck and shoulder felt the best they had in a long time. Baby steps. I needed to remember to be gentle with myself, and that was hard for me to do.

During meditation the following morning, I was told to go work in the garden. I cut back all the rose bushes and went in to sit and write and then got told to do yoga again. So I did that first and then sat down to start writing. I had incense burning (a combination of mugwort and palo santo to help with psychic work), and the windows were open.

At that moment, Ryan's then-girlfriend, Hannah, texted me with a request. Her grandmother had recently passed away, and she and her dad were having a tough time with her death. Hannah asked if I could help her talk to her grandmother.

I explained I had never done that before. Every visitation I had ever had (except for the little girl in Mexico) was a loved one. I had never initiated a visitation. They just got their message across to me, and that was the end. I told her I would ask to be open if hearing the

message was in all our highest and greatest good, and if I received a message, I would certainly pass the information along to her. I asked for her grandmother's name and a picture so I would know who to expect and not be frightened. In the photograph, her grandmother was wearing a red silk dressing gown with a dragon, which was the sign my Spirit Guide, Rufus, used to tell me he was around. That, to me, was a sign I was safe to open myself up to receive a message.

Around 3:00 a.m. or so the following night, I clearly heard a voice say, "Well done! Well done!" I also saw the words. The voice went on to say, "All is well, and I am happy."

I meditated as soon as I woke up to ask if what I had heard was real. Feeling confident and knowing I needed to trust my instinct, I texted Hannah.

The phrase was not one she had heard her grandmother use, but Hannah was happy with the rest of the information. A few hours later, I walked into my bathroom, and I could smell a heavy perfume. My first thought was that the scent smelled like "old lady perfume," very flowery and powdery. I immediately thought of Hannah's grandmother and went to look for my pendulum. I pulled the crystal out and asked if she was there. I got a large clockwise circle, which was my YES. I asked for confirmation of everything I had heard the night before and received a YES every time. I then asked if there was anything else I needed to tell her family, and the pendulum switched to a NO. I thanked her and told her she could move on. I would make sure to give them the message.

I left the bathroom to put the pendulum away, and when I returned a couple of minutes later, the scent was completely gone. Hannah texted me, and I immediately asked her about the perfume. She confirmed her grandmother wore a heavily flower-smelling perfume. I wasn't sure what to make of this since I had never directly requested to receive a message from anyone, but I was happy I was not frightened and I was able to give people who were grieving some peace.

I received another text from Hannah a few hours later. She had talked to her dad, and he said his mom used the phrase "Well done" with him all the time as a small boy! More validation of my gifts and how to use them.

During my monthly call with Kristin, I discussed these events with her. She confirmed my experience was real and not just my imagination creating ideas to help them feel better. I did have to be more careful as to how I ended things, and I needed to be clear in my phrasing. "Feel free to ask them to disconnect once you are done getting the message. 'I leave this with you' or, 'Thank you—sending love and light and we are disconnecting now.'" Great advice.

Kristin also brought up the word "parasites." She said parasites were leeching off me. I needed to check my diet. She said I needed to go to the doctor as soon as possible. We went inward to release and bring love, light, and healing to my abdominal area.

Ryan and Hannah flew in for a visit a few days later. I was in my bathroom when the strong "old lady perfume" smell came back again. I called out to Hannah and asked her to come upstairs. She walked into the room and asked if I had sprayed something. I told her I had not and didn't have perfume that smelled anything like what we were smelling. She said this smell was her grandmother's perfume. More confirmation. A few minutes before the smell had come back, Hannah had been in the bathroom with me, looking at some of my jewelry. I can only assume her grandmother felt her close and wanted to communicate.

Hannah went back downstairs, and I started to do my makeup. The smell became even stronger, and I felt I was being asked to channel. I called out to her again and asked if she wanted to talk to her grandmother. I wasn't sure, but I had a feeling I might be able to get a message across. Hannah came up and looked a bit freaked out. I assured her there was no pressure. She could think about things, and if she decided she wanted to try and communicate with her

grandmother, we could try. I felt the presence in my bathroom and pulled out my pendulum. She was there. I told her if her granddaughter wanted to, I would communicate, but if not, then she must go. Hannah chose not to. She said she felt at peace with the information I had already given her.

I had mixed feelings. I was honestly kind of excited to try to speak with someone specific on the other side and was, at the same time, nervous. Then again, I had set my intention to only have the communication happen if the outcome was in everyone's highest and greatest good, and I had received my answer.

46

BEAUTIFUL WORLD

Devo

I had begun keeping a journal when I started my feng shui training. My teacher strongly encouraged journaling, saying my learning would transpire in such a short period of time, and journaling would help me remember. I hadn't written my thoughts down since I kept a diary in high school, where I listed all the boys who had kissed me. The list was less than impressive, given the back brace and all!

I opened my first journal, which I started at Miraval, and was shocked at what I read. So much had happened in the last six months. Mother Emilia had told me one of the main activities I would be doing was channeling. I had just channeled for the first time. I had put a star by the note and had completely forgotten about it. I texted Art to share, and his response was, "Neat." I knew he was still having a hard time with my spiritual awakening. I turned the page, and the next entry I read was, "Art is going to hurt my heart. He is going to have a very difficult time accepting my gifts and who I really am and will criticize me for them."

I hadn't read that sentence until after I texted him. People's acceptance of my gifts and who I was becoming would be one of the most difficult parts of my spiritual journey, but their opinions would

bother me less and less over time. I closed the journal and put it back on the shelf in my office.

A few days later, I pulled out my current journal and started writing about my mom's death and asking for guidance to be used by God/Source for the highest and greatest good of all. The temperature outside was a perfect, sunny seventy-five degrees, so I decided to do this on our patio. Our Yorkies Lola and Sofie were lying in the sun and enjoying the peaceful surroundings as well. All of a sudden, the dogs jumped and started barking. I waited a few minutes then reluctantly left my comfy seat to go see what was going on.

Perched on top of our house were two black vultures, just as calm as could be. I yelled at them, and they completely ignored me. I was creeped out. Vultures are not usually a desired animal to be around, and I was journaling about my mom's death. I had a copy of *Animal Speak* in this house as well, so I ran upstairs and grabbed the book.

It included a lot of information on vultures, so I brought the book out to the patio. The vultures had moved, and we were now perfectly in each other's line of vision. I told them I was going to read all about them. I started reading, and as if on cue, realizing I was open to receiving their message, they left.

The book said, "They are seen as a mother symbol because they devour corpses, thus allowing other life to sustain itself." Complete goose bumps all over my body. Ted Andrews went on to talk about a vulture's digestive system. The vulture's message was to pay attention to how I felt physically, emotionally, mentally, and spiritually after I ate certain foods. *Seriously?* These thoughts had been going through my mind daily for weeks now.

Vultures also had a powerful sense of smell. Smell is how I realized Hannah's grandmother was in the room. "The vulture is considered a sign of confirmation of a new relationship between the volatile aspects of life and the fixed, the psychic energies and the cosmic forces.

It is a promise that the suffering of the immediate is temporary and necessary, for a higher purpose is at work, even if not understood at the time." I didn't completely understand my journey, but I was accepting and moving through with as much ease and grace as possible.

I was now a few days away from my trip to Dallas to meet Todd and the rest of the Williams family. During my monthly call with Kristin, I asked for guidance on how to best navigate the upcoming visit so the visit was in everyone's highest and greatest good. I was also open if there was any information my biological father would like me to share with Todd or other family members.

Our session did not disappoint. Kristin channeled Dick, who shook his head and said, "How ironic the visit is finally happening, and I am not there to be a part of the event." She said, "He is placing a crown on your head and saying you are a jewel with the beautiful energy of vibrancy, like a plant, which is something the family needs at the moment. Someone is 'whack a doodle.' Do not let that person pull you into their story."

She also brought up my digestive system again. Had I been to the doctor yet?

47

GET BACK

The Beatles

had to fly back to Sedona before I flew to Dallas. Karen was coming to Sedona to meet with a client and was staying at our house.

She invited me to her consultation, where the client said she was interested in hiring me to implement my design skills with Karen's feng shui recommendations. She wanted to come to my house in a few days to see my design work.

Afterward, Karen and I went out for a quick bite at Mariposa Latin Inspired Grill. I was obsessed with their *pulpo parrilla*, which is grilled Spanish octopus. Karen and I were sitting at the bar, having a cocktail and waiting for our appetizers to arrive, when I felt a strong push on my right shoulder from behind. The push physically made me lean forward into the bar. I turned around and realized no one was anywhere near me. I had not experienced that before, but I felt this was a new way Spirit was using to get my attention and communicate with me.

At dinner, Karen expressed an interest in doing a feng shui retreat with me to, in her words, "show my graduates how it should be done." I felt such gratitude as I realized my hard work and investment had been worth the effort, and I was excited to see where it would lead. During our last session, Kristin had also said she could see a spiritual

retreat taking place at my home here in Sedona. I had chosen to sit out in the meditation garden for that call with Kristin, and as I looked at the lavender bushes and the Buddha under the tree in front of me, I started to see where this idea of a retreat could manifest into reality.

Karen left the following morning, and I sat in the kitchen to journal. The backyard was a virtual wild kingdom at the moment. I counted at least ten different types of birds as well as my favorites, the desert quail. I looked up one bird I had not seen before, because he had made himself very visible to me. He was a towhee, beautiful with a black head, orange and white chest, and black and white wings. I immediately looked up his spiritual meaning. He was here to teach me the balance between knowing when to be forceful and when to be quiet. He was here to show me new ways of looking at things, as I may have been missing part of the puzzle I needed in order to resolve something. I smiled, as the messages were always perfectly on point, and went back to my journaling.

I woke up the following morning to find Sedona was scheduled to receive close to eighteen inches of snow starting at around midnight. The storm was forecast to be the largest in 113 years! Apparently, the town was not prepared for this amount of snow. There were no snowplows, so residents were being warned to get the essentials and plan on staying home for at least three or four days until the snow melted. The flight from Phoenix to Dallas was the next day. If I waited to leave, the roads would become impassable, and I would miss the flight. I sat down with my coffee to read emails. The first one I read was from Todd, with an itinerary for the weekend. I could not jeopardize this trip.

When Karen's client, Martina, arrived a little later, she said she could feel the energy as she walked up the stairs to the front door. I walked her around our home, and she kept repeating that the space not only looked beautiful but felt amazing as well. Once we were done with the tour, we sat down at the kitchen table, had tea and ... Martina hired me!

She wanted to start right away. I told her I would see what I could figure out since I needed to leave town early. We chatted for a bit longer, came up with a tentative game plan for once I returned, and we walked out to her car. As I waved goodbye, I felt chills of excitement, not only because it was cold outside but because I felt all my hard work was about to pay off.

Once back inside, I said a short prayer that if I were meant to do this, the pieces would fall into place.

I also heard from the leasing company that we had renters arriving on March 1. Our intention for this house from the beginning was to lease when we were unable to be here. The leasing company would vet the renters and take care of everything since we were half a country away. To be clear, our leases were always going to be a minimum of thirty days or more. We had no interest in an Airbnb situation. Our leasing agent confirmed the renters had loved the house and its energy when they did the walk-through. So much validation in one day. I was feeling overwhelmed with gratitude, but there were still some logistics that needed to be addressed.

I could fly back to Phoenix instead of Tampa on Sunday, work with the new client through Thursday, and leave in time for the house to be cleaned and turned over to renters on Friday. I called Martina to see if she wanted to work all week, and she did. I had to figure out how to get out of Sedona a day early. All the cancellations, reservations, and changes I needed to make went smoothly, and everything fell into place. I felt so in the flow. I was getting paid my new full rate to do what I really wanted to do—implement my feng shui training with my design background.

I drove to Phoenix and was upgraded to a suite upon arrival at the hotel. I ordered room service and turned in early. Suddenly, I felt I had to check the car reservation for my return to Phoenix. Sure enough, with so many changes to make in such a short time, I had entered the wrong dates. I was off by a month, and that meant I would not have

had a car when I got back to Phoenix. I canceled and rebooked, and the total was almost two hundred dollars less.

These were small things, more everyday magic, but I felt the bigger picture at work. I felt the protection, love, and guidance of being watched over and led in the right direction when I chose to listen to the messages I received. I had really considered staying in Sedona and telling Todd I was sorry when I couldn't get out of town, but missing the trip to Dallas would not have been the right thing to do. Going through the extra two days of travel to make sure I arrived in Dallas on time incurred extra cost and a lot of hassle, but the process also brought a lot of acknowledgment that this was the way to move forward in my life and my journey.

48

HERE I GO AGAIN

Whitesnake

This time when the plane landed in Dallas, I felt calm and at peace. I landed late at night, so I had time to decompress before Todd and Nancy picked me up at the hotel the following morning.

We drove together to the airport to pick up Art and celebrated National Margarita Day at one of their favorite Mexican restaurants. Art had somehow crossed paths with the restaurant manager, who ended up being from Laredo. Art brought him over to the table, and of course, we started talking about how we all went across the river to Nuevo Laredo as teenagers and how we all drank scotch. The manager excused himself and returned with four shots of scotch. This somehow brought where I came from to where I was now. I sensed my parents' presence and felt the blending of my adopted and biological families. I could picture Pepe, Margarita, and Dick hanging around together, cheering Todd, Nancy, Art, and me from beyond.

We took an afternoon break and then met back up with an even larger portion of the family for dinner. By the end of the evening, I was ready to go back to the hotel and decompress. The day had been emotional. Again, all good stuff, but still, a lot to process at one time. We had an easy Saturday morning, and Todd once again picked us up to meet another group of family members for lunch at a Food

Hall. After that, we took a break before the final gathering at Todd and Nancy's house that evening. They ordered old-fashioned Texas barbecue. The smell brought back so many childhood memories. Kay brought a lot of old pictures. I enjoyed seeing pictures of Dick growing up and even got to look at his wedding album.

I tried to make time to have as many one-on-one conversations as possible. Todd's mother Margaret and I chatted in the dining room, and we put together the pieces of a story Sofia had once told me. Sofia said that after she gave birth to me, she went back to Houston and worked in a gift shop at AstroWorld. One day, she looked up to see Dick and a blond girl walk in. "Dick looked directly at me and pretended he didn't recognize me. He immediately turned around and walked out of the store, pulling the girl behind him," she told me.

Margaret told me the story of a day when she and Dick were at AstroWorld, and he abruptly grabbed her and pulled her out of a store. When she asked why they had to leave, he said, "Sofia is here." Strange to hear both sides of the story.

I got up to refill my wine glass and walked by Kay, who was sitting in the living room. Art walked up at that moment, took my empty glass, and said he would bring me a fresh one, so I went over to sit by Kay for a bit. She leaned in and said, "I don't think Dick would have been happy with this gathering."

I did not feel comfortable telling her I already knew he was. I was not ready to share that part of my journey with these people yet. After all, even though we shared DNA, we were, in reality, strangers getting to know each other. Sharing that I was able to communicate with people who had transitioned seemed like a conversation for a later date, especially considering how the information was received the last time I shared it with "family." Instead, I just smiled and said I hoped he was. I was going to ask why she thought that, but right about then, I felt a wave of anxiety.

I had finally hit the wall. I needed to leave in order to rest and process the close to thirty new faces and influx of information. Art and I said our goodbyes, got an Uber, and headed to our hotel. I flew back to Sedona the next morning to work with Martina for the week. Art flew to Tampa.

I drove up to the house and realized there was no way I would make it up the steep driveway with the rental car. Sedona didn't have a town snowplow, so there had been no one to deal with the almost two feet of snow the town had received while I was in Dallas. I parked at the bottom of the driveway and dragged my suitcase up through the snow and into the garage. The walkway to the front door was impassable. Once inside, I took off my wet boots and walked toward the kitchen windows. This was one of my favorite spaces and where most of the animal activity happened. Everything was covered in almost twenty-four inches of snow. In the middle of the blanket of white, a bright red cardinal stood out. The cardinal was alone, and I knew somehow the bird was Dick.

I sat at the kitchen table, sipping tea and trying to get my thoughts about Dallas down on paper, when I saw a chipmunk for the first time. Of course, I pulled out my book on animal symbolism and learned that chipmunks symbolized luck and good fortune. Today was my first day of work with my new client, so I hoped the symbolism was spot-on. I had appointments until four, and then I was scheduled for a massage and a Japanese facial. I knew the importance of self-care after such an emotional weekend.

The following days would be my last in Sedona for a while. I woke up early to watch my bird friends while I drank my coffee. The quiet and stillness of mornings here were my favorite time of day. As I gazed out the window, I saw a white "fog" move across the backyard by the bird feeder. I felt a presence, a spirit. The cardinal was also back and making himself obvious to me. I got up to get the pendulum out of my purse. I protected myself and my space and started asking

questions. I received confirmation I did see a spirit in the backyard, and the cardinal was a physical sign for me that my birth father was around. I was at ease with that information.

49

PARASITE

Kiss

I flew back to Tampa and spent the weekend doing errands, spring planting, and reconnecting with Art. I was still having stomach issues I could not figure out. Then I heard from Sadie, my former friend and client, for the first time after almost a year and a half. She invited me to lunch.

I happened to have a session with Kristin that afternoon, so I brought up Sadie to her. Kristin asked me to consider a few questions before agreeing to lunch. Did I have the capacity to handle this right now? I had been so deeply hurt by her, after all. Could I approach the situation from a healthy point of view?

Kristin knew what had taken place with Sadie. She knew of my "on the bathroom floor" moment and that I had chosen to walk away from our professional and personal relationships because of that situation.

Kristin discerned, "Sadie wants to feel you out. Your work is of a higher consciousness and awareness now, so you work in a higher vibration." Kristin also said, "She will be looking to you as a spiritual coach, but if the situation once again becomes toxic, you need to walk away."

I thought about what Kristin said for a while and realized I truly missed my friendship with Sadie. I would be open but careful this time around. I said yes, and we met for lunch in Hyde Park Village. Our conversation was easy and casual, basic catching up on the kids. Nothing deep. She and her husband had just purchased a new house. I was not sure where this meeting and our friendship would take us this time around, but I was open to the possibilities.

I got home, and my stomach was once again a mess. At first, I thought it was nerves, perhaps from my meeting with Sadie. I ran to the bathroom, and the mystery of the weight gain and the breakouts finally revealed itself. I realized what I was experiencing wasn't nerves. What I was experiencing was parasites. I had contracted parasites from grocery-store sushi I had bought in Sedona. Tapeworms, to be exact. I will spare you the gory details. Suffice to say, I had visual and physical evidence.

I thought back to Kristin telling me I had parasites leeching off me. I had thought she meant energetically, but it turns out they were also literally in my intestines. Debbie Crick, the healer in Sedona whom Heather and I went to see who worked with the Cards of Illumination, had also written the word "parasites" in pen when she and I were going over my report. I ran to my office to pull out the report, and sure enough, she had said they would happen during this exact time period.

I wanted a natural cure, so I used oregano oil. The oil worked, but I did not take into account that the parasites would lay eggs and the cycle would start all over again. I would feel better for a little while, and then my stomach would distend and my face would break out. I was so sick and so frustrated.

I did more research and found a true parasite cleanse. The treatment made me incredibly lethargic, and I was in no mood to write, even though I knew from all the spiritual guidance I had received that I needed to be working on the book.

50

DEAD MAN'S PARTY

Oingo Boingo

Despite feeling no creative inspiration whatsoever, one journal entry had to be made.

It was the middle of the night when I felt my hands being held and shook in order to wake me up. I saw a man at the side of my bed by my left elbow. This was the first time I had "seen" a person since the little girl in Mexico. He had long, dark, wavy hair and ancient Celtic tattoos all over his arms and torso. He was smiling at me. He wasn't scary, but he didn't give off a warm and fuzzy vibe either. I asked out loud, but not loud enough to wake up Art, "Why are you here?" A digital read-out of the numbers 608 appeared on his forehead. He smiled again, and before I could ask what the numbers meant, he was gone. I was now wide awake. The time was 3:36 a.m. I reached for the remote control, turned on the TV, and watched *Cheers* until I fell back asleep. This was the second time I felt physical touch from an unexplained source.

I got up that morning, unable to shake the visitation. What did the numbers mean? The year 608 AD? June 1908, 2008? June 8? I grabbed some coffee and went up to my office to do some online research. The year 608 AD was considered part of the Middle Ages, a time frame I had lived in during a previous lifetime. That year, a king named Fergus Mór (Fergus the Great) was said to have founded Dál Riata,

an area of land that is now Ireland, Scotland, and some of England. Interestingly enough, those were the same areas of my Ancestry DNA results. I was not sure what to make of all this yet.

I spent the next few weeks focusing on my health and resting as much as possible. On March 20th, I was woken up in the middle of the night again. I heard two distinct laughs and felt someone leaning over me. I felt the second presence give me a hug as the spirit held my hands. Again, I was not scared, but the physical touching was still a bit unnerving. When I got up that morning, I could not figure out who my visitors were. I pulled out my pendulum and confirmed they were definitely people I knew at some point in my life.

Over breakfast, I told Art something was going to happen that day, although I didn't know what. I would call him when I knew. I took the dogs for a walk, purposefully leaving my phone at home. I checked messages when I got home, and the first one I saw was from my cousin Maria Elena. Her father, my uncle and my father's best friend, had passed away peacefully in the middle of the night. Our families were extremely close, and now I knew Tío Joaquin and my dad were last night's visitors.

We flew to Laredo for the funeral. On the plane, I prayed for ease and grace during the weekend. I was petrified of traveling with the parasitic infection. I had been on the cleanse for a week, and most days, the symptoms made leaving the house before noon impossible. I had been taking things slow and getting much-needed rest. I knew the medicine was working, as I was completely grossed out at what my body was purging. First, there were several days of tapeworm eggs, followed by tapeworm segments. However, with the gross came the good. My distended stomach flattened back down, and the strange weight I had put on was starting to come off. The face swelling started to recede as well.

Thankfully, I got through both flights without an accident. We landed and met a dear childhood friend, Monica, and her husband for

lunch. I loved the Mexican food in Laredo but was scared to eat much of anything. Monica and I had not seen each other since my father's funeral. I felt comfortable enough to share my spiritual journey with her. I showed her the photo Art took at Bell Rock, and to my surprise, she said, "You are a lightworker." She insisted I follow her to her house after lunch so she could give me a book. She said, "I ordered this book without knowing why, and now it is clear the book is for you." It was a book about the Virgin Mary called *Big Q, Little Q.*

We said our goodbyes, and Art and I headed to Tío Joaquin's house. Though we were there for a sad reason, the house was filled with love and even some laughter as our spouses and children got to hear all about the trouble we got into together as kids. My cousin Marisa brought up how much she missed the chocolate-on-chocolate cake my mom used to make her for her birthday every year. I looked at Art.

"Now do you understand why I was so pissed about the stupid tres leches cake she got for me on my birthday?"

He just smiled. I shared the "tres leches cake" story with the others, and "Ay, but I love it" became everyone's catchphrase for the weekend.

Joaquin Jr. and I had been chosen as eight-year-old children ambassadors to represent the United States in the George Washington Birthday International Bridge Celebration. He brought up throwing up over the side of the bridge right after the ceremony. I had forgotten all about that! Maria Elena, Marisa, and I shared becoming blood sisters during a sleepover by poking ourselves with sewing needles while our parents were at the theater watching *Jaws*. There was no shortage of happy memories to recall. In a "small world" story, Art and Joaquin's wife realized they had gone to high school together! I shared the story of the visitation I had had on the night Tío Joaquin passed. My cousins confirmed he died right around the time of my visitation. They said, "Of course he is with Tío Pepe!"

The funeral was Saturday morning. I knew I would see people I had not seen in over a decade, many of whom I had not seen since

my own parents' funerals. I was usually quite nervous when I traveled to Laredo, as Laredo tended to bring out the best and worst in me. Childhood insecurities and issues got triggered here. My stomach was always in knots when I visited, even without a parasitic infection.

This was the first trip I can remember in which I felt calm. I had no doubt all the meditation I did beforehand helped, but I also perceived I was in Laredo for more than a funeral. I was here to undergo another step in my inner healing. Andrea and I held hands during the ceremony. Hopefully, there would be some healing in our relationship when we went to Miraval in May for a sisters' weekend.

I ran into two old boyfriends, one of which had been serious. I was able to catch up and see that our lives ended up exactly as they should have. Everyone was kind and loving and welcomed me back with open arms. I said I would not go to my parents' grave, but at the funeral, we were parked less than twenty feet from their gravesite, so I went and hated every moment I was there. They were not there, and I didn't like the thought of them in the ground. I understood I could not have changed that situation, as my father insisted on burial when my mother had wanted cremation, and perhaps there was closure there too.

After the cemetery, we went to the house of one of my cousins for the reception. At one point, after a couple of glasses of chardonnay, I felt bold enough to tell two of my older cousins, who were cardiologists, about the "visit." They had not been at their mother's house the day before when I had shared the information with their siblings. One called me a conduit, and the other called me a channel. I loved that even as doctors, they acknowledged and were open to this information. Even through the sadness, what I will remember most is all the laughter and love as everyone shared stories and came together as a family. I don't think I was aware of just how much I missed my original family. My parents had been gone so long, and I had been trying to make all the new families work, but I realized my

true family was in Laredo, and that brought me a new level of inner peace and happiness.

We left the funeral and met another childhood friend, Caryn, and her husband for a late dinner. Andrea joined us. I was a little tipsy by that time. I had hardly been drinking at all, mainly because I didn't feel like drinking anymore and now because of the parasitic infection as well. By the time I got to Caryn, I was feeling quite happy! I once again felt I could be straightforward and share some of what I had been experiencing, and once again, and for the second time in two days, one of my childhood friends called me a lightworker!

She sent me an excerpt from Colossians 1:9–12 the next morning. "Be assured that from the first day we heard of you, we have not stopped praying for you, asking God to give you wise minds and spirits attuned to his will, and so acquire a thorough understanding of the ways in which God works. We pray that you'll live well for the Master, making him proud of you as you work hard in his orchard. As you learn more and more how God works, you will learn how to do your work. We pray that you'll have the strength to stick it out over the long haul—not the grim strength of gritting your teeth but the glory-strength God gives. It is strength that endures the unendurable and spills over into joy, thanking the Father who makes us ..." (MSG translation).

Monica had handed me a book, and Caryn sent me a verse. Both called me a lightworker independently of each other. I do not feel for one moment the specific messages both my childhood friends had for me were in any way random.

SWEET CHILD O' MINE

Guns N' Roses

Art and I met Andrea for brunch before flying out on Sunday morning, and she chatted about our sisters' spa weekend in Austin. There is nothing better than Mexican breakfast tacos and good conversation. Andrea was excited as I told her about my previous experiences at Miraval. This one would be a new experience for both of us since the Austin location had just opened. We had decided to go there because it was easier for Andrea to get to versus the one in Arizona. It didn't matter to me which one we went to; I just wanted one-on-one time with my sister so we could move forward in our relationship. The issues with Sofia and her family had also affected Andrea, and I wanted to make sure she knew I saw her as my "real" sister. As I boarded the flight to Tampa, I was, for the first time in a long time, grateful for my time in Laredo. My time there could not have been any more peaceful and healing.

We landed around midnight, and I spent Monday running around picking up the dogs, groceries, dry cleaning, and doing other outstanding errands. I came home to a lovely sympathy flower arrangement from Sofia.

When I sat down to book Miraval in Austin, I received an unexpected text from Beth with a GIF of two sisters sipping wine. She

asked if I would like to get away for a sisters' weekend over the summer. I found the timing very curious. Then I remembered she had the same gifts I had, except hers were not considered "of the Devil" by her family. I told her I would love to and said, "You can take the lead on this one since I have hosted and planned weekends for us several times." This would be her opportunity to reciprocate.

Spoiler alert: never heard another word about a sisters' weekend.

I finished booking my trip and sat down to meditate. I love to pull oracle cards before meditations, and this time I pulled an Angel card from my Journey of Love deck by Alana Fairchild. Once again, the card for the day was #58, Beauty. The card seemed to fit perfectly with my Laredo weekend. "You are in the process of healing past wounds about your appearance, your body and your sexuality, finding purity in all of yourself, and becoming ready to share that with others in a deeper and more open way, without shame or self-criticism." I was sticking with my Pilates practice and noticing improvement in both my energy and strength as tapeworms were expelled from my body. I felt so grateful to be getting better. I don't think I realized how sick I really was until I felt better and could reflect. I was sick so long I was getting used to feeling like crap every day.

The next morning, as I was working on my frozen shoulder on the reformer, my Pilates instructor told me about her three-year-old boy's room. She said he didn't like to sleep in there and that he wanted her to paint his door green. When I asked what color his room was, she said the room was black. After our session, we walked over so I could take a look.

From a design point of view, the room was adorable. She called it his bear den because she called him her little bear. I looked around and said, "Let me think about the layout and see if anything pops up."

About an hour later, the answer came to me. I remembered what the color green meant to me, not necessarily in feng shui terms,

although green does mean family and life, but in my intuitive terms. Green meant growth, aliveness.

I texted her back. "Okay, the answer came to me. He is asking for something that feels alive in his room. Perhaps he asked for the door because he feels if he can see the door, then he knows there is stuff that is alive on the other side. His room is black, aka, the dead of night. The trees on the wall were all white bark, not big fluffy trees, so they feel dead as well. The round end tables are made out of dead wood and the stuffed animals he didn't want around anymore are also not 'alive.' Think you should consider changing his room even though it's super cute. The subconscious part is not working for him."

She texted back, "Holy shit. You are so right. Every signal he's given me says that. I feel so strange like I'm gonna cry. I don't know how to thank you."

"Good, then we know how to fix things! One more thing: his headboard is not solid, so he is not getting protection in the middle of the night in the dark forest. Don't cry, I'm so happy you asked."

Her response made my day. "Happy tears! I am crying happy tears. I am so happy I finally understand, and this information makes so much sense."

The parasites were finally subsiding, and my health was improving. I had worked so hard to remove a lot of angry energy toward Sofia. However, at my weekly appointment, Dr. Sandi said, "Your entire left side is still lighting up. So is your heart chi." In energy work, the left side of our body harnesses female energy, and the right side harnesses male energy. That meant I was still having issues with a female, aka Sofia. Still, I felt I was making progress and chose to focus on that. She could see my grandmother in the room. My grandmother is always a strong presence, and Dr. Sandi said my adoptive side of the family watches over me much more than any of the biological side.

However, as she left the room, she turned and asked me, "Who is Richard? He is here, and there is a huge blue light all around your

upper right shoulder." I told her that was my biological father's name. She said, "He wants you to know he was not given the whole story. He didn't know everything." I felt he was referring to the story Sofia told me of her calling his house and his mother answering and not letting her talk to him. Maybe he never knew Sofia called …

There was a new moon, so later that day, I wrote a letter to Sofia about the anger and resentment I still felt and burned the letter in a glass bowl outside. It felt good to let that shit go!

I woke up to a Facebook post from my brother Todd the following day. It would have been Richard's seventieth birthday. So that's why he was around! I reached out to Todd and shared my session information with him. I told him this new information helped me soften my feelings toward Dick, and Todd was happy to hear that.

52

6060-842

The B-52's

I saw the number 608 twice on my way down to my weekly appointment the following week with Dr. Sandi. No doubt my angels were trying to get my attention. I arrived a few minutes early, so I reread the spiritual meaning of 608 in the car.

Once inside, I sat opposite an older man, and immediately, my chest constricted and I felt immense pressure. I crossed my legs and turned away from him as much as I could in case I was absorbing his energy.

In the treatment room, I told Dr. Sandi what happened in the waiting room and that I was still feeling a strong tightness in my chest. I was perfectly fine when I arrived. She looked at me and said, "You are dead-on. You are highly empathic. The man's wife is in the middle of battling breast cancer. He is her caretaker and is very depressed about his wife's condition."

You would think I would be getting used to this, but every time something new happened, I caught myself holding my breath and feeling a bit overwhelmed.

"You are a channel," she continued. "We need to work on clearing the anger I am feeling is coming from inside you." I was surprised at this since I had been in a great mood all day. Then she

asked the strangest question. "How old were you when you owned a Swatch watch?"

Who had thought about those watches since the mid-eighties? I had to think for a moment, but I did, of course, own one during my high school years. She said, "That is the anger you have to deal with. The pain goes back to old wounds."

I had hated high school. I didn't have a lot of friends. I was bullied. I was in a back brace. I was not one of the cool kids. My parents were not the wealthiest, even though they were part of society, and I always fell back to a general sense of lack and fear. A lot of pain was definitely to be found during those years. Once Dr. Sandi put the needles in me, I quieted myself and asked for compassion and love to be given to that teenager and to let her know everything would work out great; to hang in there. I felt an immediate sense of peace in the room.

When Dr. Sandi came back into the room, she said, "I see purple all around you, and you are lighting up. Your root chakra is sending Egyptian vibes." Yet another healer who brought up an Egyptian connection.

After my appointment, I ran errands. I walked into the kitchen from the garage with armloads of bags to see four dozen gorgeous multicolored parrot tulips in a large glass vase sitting on the kitchen island. An Easter present from Art. When I opened the mail, there was a $100 gift card from American Express, for absolutely no reason! More everyday magic.

I finally got around to reading the book Monica had given me, *Big Q, Little Q,* over Easter weekend. I was and am still not sure what to make of the publication. The book was about the Virgin Mary and how all these people were coming together to create an army to fight the darkness. Something told me to pay attention to this, but I was still quite confused. The Virgin Mary played a big part in my life. I grew up with a beautiful statue of her in my parents' backyard,

and that statue now lived with us in Tampa. The University of Notre Dame is dedicated to her. I visited the house she ascended from in Ephesus, Turkey. Art's father gave us all a book to read on Fatima, and now Monica gave me this. I knew this was not a coincidence, but I had no clue how to piece together all these details.

We lost the internet the following day, so we spent time out by the pool, played with Lola and Sofie, and lay in the sun. It's amazing how quiet everything gets when the usual distractions are not available. Art and I found ourselves paying close attention to what was happening in the garden around us. We always paid attention to the birds, but today, since there was nothing else to watch, we were very aware. Mockingbirds had made a nest in the bougainvillea by the back gate. We could hear the chirping of baby birds. The adults, especially the male, were flying around, squawking at anything that got even remotely close to the house. In the time we were outside, we saw them fight off a hawk, two crows, and a snake that got near their nest. I ran inside to look up the spiritual meaning of a mockingbird, and of course, the meaning lined up with the exact conversation Art and I were having at the moment.

A mockingbird is courageous, and during breeding season, they are known to fiercely defend their young. This season, spring, corresponded to the development of one's inner abilities, and that is what our chat was about.

We wanted to find a way to work together and make enough for Art to leave his current position. We were considering options like flipping houses and having multiple rental properties in Sedona. We would see how our first investment in Sedona did and go from there.

I decided to share the meaning of the number 608 with Art while we were chatting because it seemed to line up with our conversation. According to angelnumber.org, the number is the combination of the energies of each individual number. "With the blend of these energies, the number 608 symbolizes stability and balance, focusing on

creating material stability and providing for your material needs, as well as your family needs."

"It also symbolizes new beginnings and closures, potential, new opportunities, manifesting abundance and wealth, business, realism, authority, accomplishments, responsibility, the law of karma, spiritual evolvement, change of phases and cycles, family and home, compassion and selflessness."

I loved the synchronicity of the universe when I was paying attention.

53

THERE MUST BE AN ANGEL
(PLAYING WITH MY HEART)

Eurythmics

woke up on Monday morning feeling all sorts of crappy. My chest was tight, I started coughing, and I was hot and sweaty while feeling cold and chilled at the same time. "Shit, I think I've got a cold," I said to Art as he was getting ready to go to work. "Can you please feed the dogs for me? I am not ready to get out of bed."

"Sure, let me know if you need anything," he said. He finished getting dressed and called to the pups, who followed him downstairs.

I lay in bed a while longer and slowly recognized the symptoms. I had not had bronchitis in years, but here it was. I pretty much knew I would not accomplish much that week, as bronchitis has a way of laying me out completely.

I had blocked time to write and work on logos and my website. I finally got up and made myself tea. I sat at my desk, wrapped in a fuzzy robe, even though the temperature outside was warm. I was feeling quite shaky and feverish as I opened the email from my website designer with the first round of logos. I didn't like anything.

Now, I didn't know if that was the fever talking or me, so instead of responding and saying I didn't like anything, I did something I didn't normally do. I did nothing. I put the logos aside and focused only on getting better.

A few days later, I felt good enough to go to my hair appointment, as not much prevented this girl from getting her gray covered! My stylist had cough drops for me and made me a veggie cap full of healing oils. She didn't know I had been sick; she just said she wanted to bring them in for me. I was getting used to strange events happening and accepted them as little gifts from the Universe.

I came home while the window washers were still there. I could hear Karen's voice in my head saying cleaning windows helped if one needed clarity on a situation, as they were a home's eyes. No more than fifteen minutes after the windows were done, I was texting with Heather and showing her the logos. She proceeded to tell me, "I had a vision of your logo during a guided meditation in which I channeled Archangel Metatron and Wayne Dyer."

"Oooh, what did my logo look like?" I asked. "Also, who is Archangel Metatron?"

I had never heard of Archangel Metatron. I looked him up, and of course, he is depicted with a beam of light over his head! He was also known as the Angel of Organization. Seriously?

I walked into the dining room, lit some incense, and asked out loud for Wayne Dyer and Archangel Metatron to help me clearly see, and within minutes, the logo was born. Based on the information Heather gave me, my graphic designer and I created a custom gold mandala. I knew I should be getting used to this, but I was still blown away by the synchronicity of life when I was in alignment. I had chosen to wait and not react when I didn't like something and was given clarity in Divine timing.

I had an amazing call with Kristin a few days later. I loved having my sessions with Kristin in my dining room, as I felt the room had incredible energy. I was sitting in my favorite chair, with a painting of an angel behind me and the guardian angel painting my great-grandmother painted over one hundred years ago in the foyer in front of me. I felt surrounded by angels when I was in this room.

I burned some incense, turned on classical music, and waited for her call. Once on the phone, we worked on starting to understand my interpretation of symbols. In the exercise she had me do, Kristin would say a word and I had to tell her what symbol I saw immediately after she said the word. For example:

Healthy marriage – red heart

Marriage – two people holding hands

Broken marriage – cracked red heart

Anniversary – two interlocking golden bands

Birthday – a lit birthday candle

High achiever – diplomas

Toxic person – poison can

Vibrant person – green apple

After working on symbols for a while and creating my own list, she turned the tables and asked me to do a reading. My first instinct was to say no. I had never done a reading for anyone. I wasn't even sure I knew how. I was completely intimidated, but I also knew this was how I was going to strengthen my gifts.

I closed my eyes, centered myself, and asked for clear guidance that was in everyone's highest and greatest good. Immediately, I saw a tall pine tree, an A-frame house, a baby, and a pink heart. I asked Kristin, "Are you pregnant?" and she said, "Yes! I just found out! I believe the baby was conceived at our mountain home."

"Really? You're not just saying that to make me feel good?"

"Of course not. That was a real reading, and I truly just found out I am pregnant. Trust yourself," Kristin said.

"This is so cool! Thank you for encouraging me to do it," I said.

We said goodbye and hung up. I immediately picked up the phone to call Heather and tell her all about it. She didn't seem surprised. I wasn't sure if I would continue to do readings since I had never considered doing them. I guess I would have to wait to see how this

gift unfolded for me moving forward. I got up, blew a kiss to the angel in the painting behind me, and went into the kitchen to grab a bite to eat.

SHAKE IT OFF

Taylor Swift

Before meeting Andrea for our sisters' weekend at Miraval in Austin, I spent the rest of May in Bavaria, Austria, Prague, and Budapest with Art. While unpacking in our hotel room in Prague, I was suddenly in a horrible mood for no apparent reason. I told Art, "I don't know what's wrong. I am so excited to be here." We were getting dressed to go exploring, which is what I loved to do, but I was stressed for the first time during the trip.

I did my best to shake off the feeling as we left to meet up with our friends. We explored Old Town Square and got a prime outdoor table at El Toro across from the Prague astronomical clock. As we sat to enjoy our first cocktail and wait for the top of the hour to watch the medieval clock perform its hourly show, "The Walk of the Apostles," thousands of people suddenly flooded into the square from all sides. By the time we figured out the people were there for a demonstration against the current prime minister, there were about twenty-five thousand bodies standing shoulder to shoulder, and we were caught in the center of them all.

We sat, unable to leave, and I realized what had caused my uneasiness earlier. I had been feeling the restless energy of what was coming. At first, the protest was disconcerting, but it remained peaceful.

After about two hours, the excitement finally settled down and we were able to move and walk around a bit more. We ended up at an Irish pub for drinks and snacks. Thankfully, the rest of the trip was without incident.

My sisters' weekend with Andrea was the weekend following our return from Europe. Art was, once again, on his yearly multiweek business trip. Andrea and I shared a beautiful room that overlooked the Texas wilderness. As soon as I looked out the window, a hummingbird flew up to welcome me.

We had arrived at different times since I was flying in and Andrea was driving in. I knew she was off getting a facial, so I found a lecture to attend titled "Your Spiritual Connection." The discussion revolved around our soul needing many lifetimes to complete its purpose and journey. As a newcomer to the idea of reincarnation, this information was reassuring and lined up with what multiple healers had already shared with me.

I met Andrea for dinner at 5:30. We chatted and caught up on all the kids. No heavy discussions. I left for my Ultimate Ayurvedic treatment, which was one of the coolest treatments I have ever experienced. The ghee foot massage and hot poultices full of scented herbs and spices like cardamom made me feel that real healing was taking place. I literally floated back to our room and fell asleep almost immediately. Somewhere around 3:30 to 4:00 a.m., I had a dream.

This was a dream and not a visitation. I was in my bed, which was closest to the window, when a beautiful, multicolored tropical bird flew in through the glass. The bird landed on my chest and laid down as a child would lay their head on their mother's chest. I wasn't at all afraid. Somehow, this situation seemed almost natural. Then I felt warm liquid on my chest. When I examined the bird, I saw he had some kind of injury on his left wing. He was bleeding. I could also "feel" other people in the room with me, but I was not able to make out who they were.

I pulled back the duvet, cradled him under one arm, and walked over to the bathroom. I grabbed a towel, wrapped him up, and said, "We have to get you to the vet." One of the "others" in the room said, "Going to the vet is not possible." I walked back to the bed, sat on the edge, and held him as he bled out and died. As he was dying, the bird morphed into a human boy. He stood in front of me and spoke. He said, "Dad says to tell you hi." I seemed to know exactly what he meant.

The name *Ian* suddenly popped into my head. He was wearing a shirt with a crest. A lion was across the top, a horned person on the lower right, and a knight or soldier on the lower left. I asked if this was his family crest, and he replied, "Yes, the crest has been ours through millennia."

I clearly remember asking "Ian" about my stomach. "Do you know how I got sick?"

He said, "The gold balls made you sick." I felt he was referring to the salmon roe on top of the sushi roll I attributed the parasites to. I had been in such a hurry that day and was too tired to cook, so I had stopped at the local grocery store and picked up the first sushi container I saw, and there was indeed salmon roe on top of the roll. "You are much sicker than you even know."

I asked, "How can I get better?"

At that instant, the little boy morphed back into a bird and laid on my heart. The dream ended without receiving an answer to my question. I woke up with real tears in my eyes and felt true sadness at the loss of this being. I was able to fall back asleep a little while later to then be tapped on the right shoulder. I assumed Andrea was up. I had asked her to wake me in time for breakfast. When I turned the duvet down to say good morning, she was nowhere near me. She was in the shower, yet I was definitely tapped, just like at the restaurant in Sedona and in the visitations I had had from the Celtic warrior and my uncle and dad.

I got up to have coffee and watch the sun come up over the hill country. Lake Travis shimmered as the sun hit the water. Today was my twenty-ninth wedding anniversary. All common areas in all Miraval resorts were no-device zones, so I would have to wait to talk to Art until later that day. We had already said the timing would be difficult since he was on the West Coast and I was in Texas. We had celebrated before we each left, so I wasn't too concerned if we didn't connect that day. I wondered what lessons and gifts I would receive. I was also hopeful of having meaningful conversations and spending quality time with Andrea.

We went on a half-hour walk around the property and then had breakfast. We had chosen different activities, so we said we would catch up later. I chose a crystal meditation class, which sounded interesting. As I sat cross-legged on the floor, waiting for other people to arrive, a stone literally jumped off the red fabric that all the stones were lying on in the center of the circle. The stone landed close to me. The instructor came in, and I told her what had happened. Obviously, I needed to work with that stone. Once everyone arrived and had selected their crystals, the instructor handed out cards with the stones' properties. Mine was a blue agate, and the chakras the crystal worked on were the solar plexus and the throat.

I had literally been working on my throat energetically as well as going to physical therapy for the cervical fusion. A lot of the work I had been doing was also directly related to the solar plexus chakra. The solar plexus is your personal power and truth. The throat chakra is associated with being able to speak your truth. This stone was all about speaking my truth. The mantra associated with the stone was: I AM MY TRUTH.

I felt there was no coincidence these two chakras had come into play.

The meditation was quite powerful, and I felt so good afterward I stayed for a vinyasa yoga class. I then met Andrea for lunch and went for my crystal healing session at the spa.

My healer's name was Julia, and I felt an immediate connection. Without knowing anything about me, the crystal she selected to work on me with was a Lemurian quartz! I lay down, and she began the treatment. I could physically feel energy release in a wavelike fashion from the top of my head down through my body as she worked on me.

Andrea and I then went to an Introduction to Tarot Cards session and had some fun. She didn't really get into the oracle cards, but we enjoyed experimenting with them for a while. I kept trying to connect a bit, but honestly, there were no real conversations. Everything reverted to the kids, remodeling, or her maid issues. Since Miraval was a no-device zone, the minute we walked into our room, the phone was pressed up to her ear. She pretty much stayed on her phone the entire time we were in there, even putting the phone on speaker while she got dressed. I was exhausted at trying to initiate any kind of meaningful interaction.

I had been stuffing down my feelings of anger and resentment toward Andrea because I could not get her to engage the way I wanted her to, and now what I learned from my meditation earlier came back to me. Our relationship would never be more than this. I suddenly understood. I couldn't make someone into a person they weren't. I would now accept this reality and work with it instead of always feeling upset our relationship wasn't the relationship I craved.

After dinner, we went on a nice walk around the property and found a building that was considered sacred space. We walked back to our room, and I journaled while she was on the phone, again.

I spent a few minutes online trying to figure out what my dream may have meant. The first thing I found, and I should have known this by now, was that the veil between our world and the spirit world was thinnest between 3:00 and 4:00 a.m. That is why I received most

of my messages during that time. Dreaming of a dying or dead bird signified the end of something. The information said a difficult situation was coming to an end. Well, this made sense. This really was my last attempt at having any kind of a deep relationship with my sister. I saw what I wanted was impossible, and I let go. My imagined version of our relationship no longer served me. I didn't think the dream could be any clearer than that.

We spent our last morning together on a two-mile guided nature walk. The Texas Hill Country was beautiful. The rolling hills and lake made for breathtaking scenery. After the walk, we went to our yoga class. Our instructor asked us to set an intention for the class. As we walked back to our room after class, Andrea said, "I bet you no one else had my intention."

Of course, I said, "What was your intention? Do you want to share?"

"Sure," she replied, "My intention was for all of my children to stop whatever they are doing when I get home this afternoon and paint the garage." I honestly had no reply other than to agree I doubted anyone else had set that as their intention.

We got back to our room and packed. Andrea was heading back to San Antonio before I was scheduled to fly out. We walked down the path from our room to the lobby together, and I gave my luggage to the front desk. We hugged and kissed goodbye as the valet brought her car up. I wished Andrea a safe drive home, and she wished me safe travels as well. There didn't seem to be much more to say.

I had booked a private session with astrologer Lynn Carroll-Rivera. During our session, she suggested I work with someone who did Past Lives deep healing work. She recommended Patricia Walsh, who lived in Sarasota, Florida. The rest of my session focused on speaking my truth. I needed to be who I was. I needed to seek my north node. Scorpio was in my eighth house at the moment, so I was going through a death, rebirth, and major transformation. I needed to look at the underlying meaning of my life. The rest of this and the next

year, 2020, would be a time of focus, followed by a year of great synchronicity in 2021. The parasites I was dealing with were a piece of a much larger health puzzle.

I thanked the astrologer for her time and walked up to the front desk. My driver was there to take me to the airport. I sat in the backseat and stared at the beautiful Texas landscape as we drove away. This weekend was not what I had hoped it would be in terms of sister bonding time, but as usual, I felt my time at Miraval gave me more insight as to where I was headed next. The only question in my head was, *What is the larger health puzzle?* I would have to come back to that later. My driver had arrived at the airport. It was time to go home.

before something with Kundalini, that is, he will be around and will be there for you.” Kristin replied, "Yes, [illegible] sense that he is here, when I [illegible] think [illegible] out loud so he [illegible] can [illegible] away..."

For now, communicate [illegible] with your own Bens, when [illegible] your own reality. Truly, we are [illegible] and movement. You can [illegible] remember I was a [illegible] sense is who has not only lived more [illegible] lifetimes [illegible] and [illegible] in [illegible] part of the galaxy as will it which [illegible] one saw in the [illegible] part of the galaxy and the world CREATION. [illegible] She asked [illegible] today [illegible] conveys a significant rate of [illegible] twelve [illegible]

[illegible] this [illegible] in the [illegible]

[illegible] always Grace [and] humbled by her gift. [illegible] I had no pos-

55

RENEGADE

Styx

When I got back to Tampa, I talked to Kristin about working with Patricia Walsh. She felt the work would be deeply healing for me. I would be retrieving a piece of my soul that got left behind. I would be feeling where I was spiritually and seeing confirmation of the level of my gifts. While we talked, Snake and Egyptian symbolism came through strongly for Kristin. I did remember, from my many years of reading about Egypt as a child, that both Tutankhamen and Cleopatra had snakes on their crowns. The symbolism was about goddess energy and the pharaoh's ability to connect to Universal energies, in other words, a direct connection with the Divine.

I asked if a boy named Ian was around me, by chance. Kristin said, "I see him coming in through a window." (This is how my dream started.) "He is a messenger."

Since she was able to connect with him, I shared my experience with him and asked about the "dad" he referred to. "The dad he is talking about is Pepe." That made sense since both Andrea and I were in the room when Ian had appeared. "The dream is about more than your relationship with Andrea. The dream is also about your transformation and that now is your time to fly. You will be healing your

'broken wing' with Patricia. Ian says he will be around and will be a big helper to you," Kristin explained.

"Please thank Ian and let him know I am very grateful for that information," I told her.

Ian also communicated he would be working with Ryan when Ryan was ready. Kristin saw stars, galaxies, and universes. More confirmation I was a star seed, someone who has not only lived many lifetimes here on Earth but in other parts of the galaxy as well. Kristin then saw a rose suspended in the galaxy and the word CREATION.

She asked, "Did Art buy you a significant piece of jewelry, specifically a bracelet, in Europe?"

I was always amazed and humbled by her gifts. I had not posted or said anything about the gorgeous garnet and gold bracelet Art bought me in Prague. I told her at that point. Kristin said, "This information came through because Art came through. He opened up in Europe. He is very proud of buying you the bracelet because he is your protector and garnets symbolize protection."

When Art got home from work that evening, I shared what Kristin had said to me about the bracelet. He smiled and seemed happy to know the gift had such deep meaning. He didn't seem flustered to hear Kristin say he was opening up, either, which made me happy. Perhaps someday, he would feel comfortable enough to have his own session with her.

On June 13, I woke up around 6:00 a.m. when Art got up to do his Peloton workout. I knew I was in that twilight state, so I asked if there were any downloads for me. I was open to receive as long as they were for my highest and greatest good. I immediately felt a finger push into the middle of my forehead and slowly turn my head from side to side. I asked for healing and was shown the left side of my abdominal area.

I got up, meditated, then put on Tibetan sound bowl music and watered my plants to get into the zone before writing since my stomach

didn't feel good enough to do yoga yet. I pulled an angel card. The card said my inner goddess was awakening, and I needed to find a missing piece of my feminine Divine. I hoped to accomplish that the next week with Patricia. The card also said I needed a lot of travel right now, whether physical or astral. I remembered my last call with Kristin and that she had mentioned stars and astral travel would be coming up a lot for me now.

I drove down to Sarasota to meet with Patricia the following week. I was both anxious and excited and pretty much felt like I had to pee the entire way there. I always felt everything in my stomach. Whether I had to pee or my stomach hurt, that is how I knew I was nervous. As I pulled into her driveway, a black racer garden snake slithered across the concrete right in front of my car. I watched the snake slink away, and I parked. Before going in, I grabbed my phone and looked up a snake's spiritual meaning. What I found talked about healing and shedding old skin to then come out whole. That information seemed pretty much in keeping with what I hoped to accomplish.

Patricia had me lie down on a mattress covered with blankets on the floor. I closed my eyes, and as she guided me into a relaxed state, I saw a blank movie screen. The word "Pompeii" popped onto the screen, like a movie title. I saw a little girl, filthy, around eleven, sitting with her knees pulled up to her chest on the dirt floor of a hut. She had bare feet. I could feel my skin crawl. Everything about the hut seemed dirty, unwelcoming, and energetically dark. An older woman was there, though she was clearly not the little girl's mother. There was a black cauldron in the fireplace to the right of where the girl sat. Whatever was inside the pot was steaming, but I couldn't see clearly enough to know what that was.

The woman was talking at the little girl and giving her instructions. She was to take fruit and vegetables to the market and sell them. The little girl nodded then got up to do as she was told. On her way home from the market, her stomach hurt and was in knots. She

knew she was going to suffer the repercussions of a slow day. All of a sudden, people were yelling and running all around her. She stepped out of the road to see what was happening, and at that instant, the column next to her crumbled and landed on her, crushing her midsection. She lay there trying to catch her breath. A smile slowly spread over her face, and she died.

I could see her bare and dirty feet, which turned out to the sides the way mine did when I lay down. At that moment, I understood. I was the little girl. Tears started streaming down my face.

Patricia slowly brought me back and asked, "How do you feel?"

"My tears are happy tears," I said. "I am really happy for the girl. That was a miserable little life, and I am happy she is no longer there."

Patricia then guided me back to relive the moment the girl died, so any soul fragments left behind could be recovered. She grabbed a body pillow and physically threw herself on top of me to simulate the crushing and told me, "Save yourself." I struggled against her and pushed her off me.

The experience was wild and visceral, to say the least, but I felt an incredible peace take over once I was done. She brought me back again and said, "How are you? We are done."

"I feel good," I replied as I started to get up. I suddenly felt dizzy and said, "Uh-oh. Something is happening. A new movie is starting to play."

Patricia said, "Lie back down and close your eyes again."

This time, there was no title, but the scene was a clearing in a wooded area. Somehow I knew this was England during medieval times. This is the life I had felt would eventually show itself to me. Kristin had mentioned my living during this era the first time we met at Miraval, and several of my visitations involved warriors dressed in medieval attire. I had blond, wavy, waist-long hair (where was that in this lifetime?), and I wore a full-length white gown with a rope belt and leather sandals. A large bonfire was burning behind me as I spoke

to a group of people. My words were passionate, and my hands were animated (I still speak with my hands) as I encouraged them to stand up to the authorities taking our lands and our belief system.

While I spoke, soldiers arrived on horseback and pushed their way through the crowd. They violently grabbed me. The soldiers bound my hands with rope and tied me to a horse, which pulled me into town with my hands over my head and my heels dragging. We arrived at the gallows, and the soldiers forced me to stand on a stool and shoved my head into a noose. The charges were read aloud. I was accused of sorcery.

A crowd had gathered, and I could see my husband and daughter, both with red hair, hiding behind the crowd. My husband's face was familiar to me (in this lifetime). He was Rufus, my Spirit Guide. I could see other people I recognized from this lifetime in the crowd. Thankfully, death was quick. The executioner kicked the stool out from under my feet, and my head tilted to the left as my neck snapped.

Patricia slowly brought me back and once again asked, "How are you?"

"This was very different," I said. "I didn't want to die. I felt very guilty that using my voice and speaking my truth left my daughter without a mother and my husband without a wife."

Patricia once again had me reenact the death scene. She literally tied ropes to my wrists and pulled my bound wrists over my head. She put another rope around my neck and had me fight her choking me. At first, I felt panic, then anger took over. Thinking of my motherless daughter made me fight back. I removed the rope from my neck, and the ensuing emotion was one of incredible peace.

Patricia said, "Very important soul fragments were recovered here today. You reclaimed your voice by fighting back. The fusion scar on your neck is the reminder of that life in this present one."

Kristin had said the same thing when we first met. I thanked Patricia for her time and healing and drove back to Tampa.

The session was about four hours long and was life-changing, to say the least. Patricia said she usually did one past life regression per session. Of course, I ended up with two!

56

STRANGLEHOLD

Ted Nugent

When Art got home, he said he wanted to hear about the session. He popped open some champagne for me (one of my favorite sounds in the world is to hear a champagne cork pop) and poured himself a beer. We sat on our bed and talked. I don't know why we chose to sit there with so many other easier areas to chat in. He listened intently. He even correlated the poor, filthy little girl to my compulsive habit of washing my feet anytime they were even the slightest bit dirty.

Then, he said, "You need to be extremely careful who you share this story with."

"What?" I said. "I just told you I reclaimed my voice, and the first thing you ask me to do is suppress it?" I understood he was coming from the space of being my protector, but his reaction truly exemplified the daily struggle of my spiritual journey. No one encouraged me to shout my truth from the rooftops. I felt like my voice and my gifts were to be locked up in a room where only I could play with them.

Art knew I was a bit disappointed at his reaction, and over the weekend, he suggested I create a meditation and yoga space for myself. Perhaps this was his way of apologizing or his way of giving me a space to quietly use my gifts without anyone else knowing about them. I don't know what was truly in his heart, but I chose to accept

the suggestion as coming from a place of love. I took over an extra guest bedroom that we rarely used and created a beautiful sanctuary filled with crystals, a Buddha, a sofa, artwork, plants, meditation cushions, candles, singing bowls, and fresh flowers.

On Monday, I went to my usual 9:00 a.m. Pilates class. We had been continuing to work on rehabbing my frozen right shoulder. Without thinking, I reached for the strap, and to both our surprise, my right shoulder lay flat on the mat for the first time, and I had absolutely no pain. My teacher said, "How did this happen? What in the world did you do this weekend?"

I just smiled and asked if she *really* wanted to know because my experience was pretty out there! She said, "Um, of course!"

So, I shared my past life session with her. She had already shown an interest in all things spiritual, and it was hard to deny a change had obviously happened since my shoulder was now completely fine. She kept repeating, "That's amazing, that's amazing."

To this day, my shoulder has never bothered me again.

57

GIRLS JUST WANT TO HAVE FUN

Cyndi Lauper

I knew this trip would be totally different, if for no other reason than I wasn't alone. Three of us—Sadie, another friend, Crystal, who lived in Sarasota, and I—were going to Miraval together. Sadie and I had been working on our friendship since she had reached out and we had lunch. She and Crystal were also good friends, which made traveling together easy. Sadie and I were now in a place of mutual respect and were looking forward to our first girls' trip.

I had my itinerary planned but wanted to be flexible and have some fun, too, so what was to be yoga and meditation turned into cocktails in the kitchen with Miraval's chef. This was an interactive experience that invited the guest to learn to prepare a creative cocktail with a bartender and chef. We learned how to mix and pour correctly, all while laughing the entire time! At the end, the chef brought out little appetizers, and we got to enjoy our libation. We had a great time making the recipe, and we named the drink the "Smokey Bees" cocktail:

- Smoked strawberries
- Mint
- 2 oz. Silver tequila
- 1 lime

- 1 oz. agave
- Brut champagne
- Muddle the strawberries, then mint — add the rest – stir and top off with champagne!

The next morning, the three of us were up early for the sunrise desert hike, followed by morning meditation and a barre class with Sadie. After lunch with the girls, I had a Spirit Flight with Dr. Tim Frank. Spirit Flight is a ceremony of purification, liberation, and rebirth. The ceremony started with me lying down on a table. He began channeling messages for me. Dr. Tim's metaphor was that of the butterfly. I thought back to my first conversation with Kristin when she called the metamorphosis of the caterpillar in the chrysalis a challenge with a purpose. So much seemed to come back to the butterfly for me. He said, "You are to ask for consciousness, clarity, ease, and grace to move forward."

Immediately following the healing session on the table, we sat down across from each other as we had the last time I worked with him. He invited me to take out my journal, as he would have information coming through for me, and I should write it down.

"There will be TV, stage, and movie opportunities. Perhaps your own channel or network," Dr. Tim said. My head was spinning as he spoke. There was so much to process, and I wrote as fast as I could. "You are to be the bridge to Latin America. That will be your audience. You will be interviewing people like Deepak Chopra in Spanish, and you need to start practicing being on camera. Start practicing now."

He continued, "SPIRITUAL AWAKENING equals FINANCIAL PROSPERITY for you." He told me to capitalize those words.

When a person channels, the messages don't always come as complete thoughts or sentences. I want to share the messages with you the way Dr. Tim shared them with me.

Star. Big. Big.

You have to stay humble.

Humility. Humility. Humility.

When in doubt, ask myself, Showmanship or Shamanship?

Make sure your motives were always pure. You must be light/love/
service.

BE EGOLESS!

You are a lightworker, and all this will be happening very fast.

The book will be self-published, then bought by a larger company.

After the flurry of quick messages, he said, "Your mother and father
are very present. Are they deceased?"

"Yes," I replied.

A song came on in the hut as we sat. Dr. Tim said that song only
came on when the other side was trying to get a message across. The
song was "A Mother's Blessing" in Spanish. He said, "Your mother
would like to start coming through more, and she will do so with
music. Their message to you is that them being here is their gift to
you. They now understand."

Tears rolled down my cheeks as I wrote the words down.

During the shamanic ceremony part of the session, I saw angels
and Jesus's face. Dr. Tim said, "You are a conduit to the Divine. You al-
most made me pass out twice because you were healing and releasing
so much old energy and trauma." Dr. Tim also said, "The Hollywood
part will be fun, but you must work hard to stay grounded. You will
continue to release relationships that no longer serve you."

He said, "You are never alone, beloved, you are never alone. You
are Divinely protected and there are many with you always. You are
the first in generations to see the reality beyond the illusion. You are
the first in many blood line generations to be AWAKE."

Our session was coming to an end. Dr. Tim wanted me to know a
few things as I gathered my Miraval tote bag and journal. "You need

rest and time to take in all the healing that took place today," he said. "I want you to completely submerge yourself in the saltwater pool at the spa."

I said I would, of course, do what he suggested, and we walked back to the spa lobby together and said goodbye. I went into the locker room, changed into my swimsuit, and headed for the main spa pool. I found an empty lounge chair, tossed my towel and bag on it, and headed for the water. I did exactly as instructed. I completely submerged myself and then floated in the water for about an hour.

Once my fingers and toes were good and pruney, I went back to the locker room, rinsed off, and wandered over to the Bird Ramada. The Ramada was my favorite spot when I needed to process and reflect. There were three benches under the structure overlooking the mountains, and there were always birds flying around.

I sat and watched a cardinal, two doves, and finches. A yellow and black butterfly floated close by. I realized, as an empath, I took in others' energy, and now I was finally healing from garbage that wasn't even mine. Thankfully, with the help of the amazing healers I was working with, I was now releasing what no longer served me.

A roadrunner walked up to me. I resisted the impulse to say, "Beep, beep!" I felt completely at peace and thanked my angels and guides for showing themselves to me.

Dr. Tim suggested taking things easy after such powerful work, so I met Crystal and Sadie for an early dinner. We had one more session for the day. We had signed up for a creative workshop called Creating Your Sacred Space led by Kristin Reece. I loved working with Kristin and always looked forward to seeing her in person.

This class combined the history of smudging and smoke cleansing with a little DIY. An herb is burned to clear, cleanse, and restore native balance to a person, place, space, or thing. Wise men were called sages because they burned sage. The act itself is called smudging when

used in ritual, and smoke cleansing when used to clear a space. Using plants native to the area is best. Examples of herbs and intentions include rosemary for uplifting and psychic connection, creosote for earth-based grounding, palo santo for travel, and cedar for dream world "travel in sleep."

The next step is to set intentions and hold the energy. My intentions for this session were to restore, enlighten, and uplift. Now the time had come to learn how to make our own smoke cleansing stick. Our instructions:

- Gather herbs
- Trim off ends
- String hemp (14 inches)
- Ladder tie
- Double knot at top
- Add crystal
- Add feather

How to smoke cleanse:

- 1st pass: CLEANSE
- Open windows and doors
- Work all around the room in a vertical circle
- For a person: start at the crown, move to the bottom of the feet and back up, then go in a horizontal circle
- 2nd pass: RESTORE AND RECEIVE

My intention was, "May all that comes through me be only and always of light and love and in my highest and greatest good."

The proper way to smoke cleanse is to start at the bottom of a corner and work all the way around the room. Different intentions need to be set for inside and outside the home. The intention for outside the home is protection. To achieve this, one has to go around

the threshold in a complete circle. Kristin suggested placing a purchased smoke cleansing stick outside for a complete moon/sun cycle before using.

The workshop ended, and the three of us set off to Celestial Yoga under the full moon with our new smoke cleansing sticks in hand.

58

GOOD DAY SUNSHINE
The Beatles

I woke up early but decided to skip the hike with the girls to enjoy coffee on my patio and check in with Art since I could only use my cellphone in my room. I watched the sunrise over the Catalina Mountains as I held the steaming cup in my hands and set my intentions for the day. The beautiful stillness that enveloped the desert right before the sun came out was pure bliss.

The stiller I became, the more I recognized just how much was happening in that moment. A hummingbird was flying by the mesquite tree on the other side of my fire pit. As I sat and observed, I saw roadrunners, jackrabbits, finches, ravens, and a cactus wren. The words "you are the bridge" came back to me. I had a flashback to a black-and-white photo of me when I was around eight, dressed in colonial attire and representing the United States. I was standing on the International Bridge as my father hosted the International Bridge Ceremony, emphasizing the unity and friendship of the United States and Mexico.

It was soon time to get ready and meet Sadie for meditation and yoga before my private session with Kristin. Crystal had a spa appointment.

Kristin and I once again sat outside by the bubbling creek in the center of Miraval. We sat facing each other, and she placed her hands on my knees. She said, "Your mom and dad are here." Having them be so present during this trip made me very happy. Mom came through with a gondola and water. Kristin asked about this.

I explained, "Mom and I rode on a gondola together in Venice on the last day of our last trip together."

Kristin reiterated what Dr. Tim Frank had said: "Your mom wants to come through more and will do so through music." She continued to channel messages for me. "Royal. You will be crowned in this lifetime as you have been in lifetimes before. You have also been in chains in previous lifetimes, so you know both sides."

She saw Spanish flowing freely from my mouth, which reinforced Dr. Tim's message that I would be doing a lot of speaking in Spanish. She saw a carnival of sorts and people saying, "Come on up." Kristin said, "The message from this is to be discerning because many people will be trying to get into your space. You are to hold tight to those who truly uplift and value you and your thoughts."

Art showed up, said, "Thank you for the bedroom," and blew me a kiss! This was for the effort I had been making to dress "more appropriately" in our private time. I had not felt very sexy in the past year. The weight gain, parasites, stomachaches, and constant fear of an accident had certainly made me withdraw in the intimacy department. I was happy to hear he was happy.

We closed our session as we always did by spending a few moments catching up, and then Kristin and I said our goodbyes and I went back to the Bird Ramada to process. I kept hearing the song "McCavity" from the musical *Cats*, which to me meant my grandmother was around. She had given me the album when I was a child, and I had memorized the words to every song. The Ramada was surrounded by quails, doves, finches, and a black-chinned hummingbird. I was meeting the girls for lunch, so I turned over my phone to check

the time, popped it back into my tote bag, closed my journal, and headed over to the main restaurant.

We sat at the outdoor patio under an umbrella, and Crystal, Sadie, and I compared notes over prickly pear iced tea and salads. We each had different itineraries. Everyone was in a lively mood and happy with their experiences so far. The issues Sadie and I had had seemed like a lifetime ago. We finished lunch, walked over to the main boutique, and enjoyed a little retail therapy! With our new body lotions, potions, and coordinating silk ensembles in Miraval gift bags in hand, we made our dinner plans and then headed off to our next individual sessions.

Mine was a Tibetan Chakra Sound Bowl Ceremony with Pam Lancaster. She told me I needed the flower essences golden yarrow and larch. I would ask Heather to make something for me. During our vision quest, I saw a fox and the warrior with 608 on his forehead. Pam saw an eagle soaring high above and Archangels Michael and Gabriel. The words that came up were *water – flow – transformation*. She said I would be doing ancestral integration remapping—she was not sure if I would channel it, as it had not been invented yet, or if I would learn it and then do the work myself. I needed to be patient and watch how it unfolds.

This was the first time I experienced gongs. I loved them. I could feel them breaking up stagnant energy in my body. Pam took off her scarf and light sweater because she said I had so much energy running through me and created so much heat that I made her hot!

She helped me shape my morning prayer, which I was to do after meditation. I was to ask, "Please show me clearly all the talents and teachings of previous lifetimes that I may incorporate into this lifetime in my and the world's greatest good, so that I can be of service and heal."

When our session ended, I once again headed over to the saltwater pool to immerse myself. I was drawn right back to the Bird Ramada.

My friends this afternoon included a jackrabbit, yellow-bellied finch, hummingbird, and doves. As I sat there in the warm desert breeze with the filtered sun coming through the trees, I turned to see three feathers next to me.

The next morning was our last. I sat on the patio and watched the sunrise. After a mindful meditation, I recited the morning prayer Pam taught me the day before as I stood in mountain pose facing the desert.

59

MAGIC CARPET RIDE

Steppenwolf (John Kay)

Next stop, Sedona. The Miraval shuttle dropped all three of us off at the Tucson airport. We hugged and kissed Crystal goodbye, wishing her safe travels to Tampa. She had a prior commitment and was not able to join us in Sedona. Sadie and I headed to the car rental area. I picked up our car, and we set off on a girls' road trip, or "magic carpet ride," as I like to call it, across the desert. Our four-hour drive flew by as Sadie had the brilliant idea to research the mascots from each other's schools. She found articles and read them aloud. First up was the origin of the Florida Gator, which was her school mascot. This was followed by the history of my Notre Dame Leprechaun. I honestly felt like there had never been a rift; we were back!

This would be Sadie's first time in Sedona, and she was spending several days with me at the house. As we drove in and the red rocks started to show themselves, she said, "This place is magical."

"This is just the beginning!" I said.

We drove by Bell Rock, my favorite hiking spot, and I told her we would be going there the following morning for a sunrise hike. We got home, unpacked, and headed out for a quick dinner.

The next day started as promised, with a sunrise hike on Bell Rock. The rock formation was named for its shape, which, of course,

looks like a giant bell, with spires that tower over five hundred feet in the air. Like all the other major rock formations in the area, the rocks are red and brown, with green prickly pear cactus and juniper trees mixed in. There are canyon trails around the base, and whether you are climbing to the top or walking along the canyon floor, the views are always amazing. This is one of Sedona's most famous energy vortices, and I have to say, I always feel incredible, magical, mystical energy here.

Sadie took pictures of me that clearly showed orbs and a pillar of light over my head. She had doubted some of the photos I had shown her until she took pictures with her own camera. She built her first cairn, which is basically a mound of stones. They are usually built by walkers to commemorate their visit. We also did two beautiful meditations in different locations as we moved around the mountain.

After our hike, we shopped, bought crystals, and ate Mexican food. Dinner was charcuterie, champagne, wine, and an old episode of *Below Deck Mediterranean*, which featured people she had just traveled with! The perfect Sedona day.

The following morning, we headed out to hike Buddha Beach and Cathedral Rock. This was another favorite trail and hike. The trail starts out parallel to Oak Creek, and in order to cross over to another major Sedona landmark, Cathedral Rock, you have to get across the creek. How wet you get depends on the time of year. During the summer monsoon season, you can be in up to your waist or higher. The dry season will get you wet up to your thighs. Once you cross, you can follow the trail around the back of Cathedral and then make your way to the front, where you can climb all the way to the top if you are brave enough! I have only made it about three-fourths of the way up.

You never know what you will see. A lot of weddings take place at the trailhead. There are usually people sunbathing, chanting, or meditating in and out of the water, and that is what we were planning on doing.

On our way to the spot where I wanted to sit, we happened upon a butterfly garden. We stopped to take pictures. Sadie took some amazing photographs. I took a video and caught some magical energy orbs as I walked. We got back on the trail and suddenly felt every inch of our bodies vibrating with energy. We had hit an energy vortex, one of the most powerful energy vortices in Sedona.

I saw the spot I was looking for, and Sadie and I then took off our shoes and walked into the warm water of Oak Creek. I pointed out a couple of rocks in the middle of the creek, so we climbed up, meditated, and had conversations I would have loved to have had with Andrea. I told her my landscape designer was the one who showed me this place. We had been working on the meditation garden at my house one afternoon, when he asked if I had been to Oak Creek. I was still new to Sedona at the time, so I told him I didn't know where this trail was, and he hopped in my car and showed me.

After our wonderful afternoon, Sadie and I came home to an email that the very same landscape designer had passed away from a brain tumor while we were hiking. I was so saddened and shaken up by the news that we ended up staying home that evening.

The following morning, I took Sadie to the Boynton Canyon vortex. We hiked up, and I was told during meditation to go sit in a certain spot and have her take my picture. When I inspected the photo, I saw a blue orb right at my feet. I was always amazed and grateful for those signs.

From there, we went by the Amitabha Stupa and Peace Park. This little gem is located about five minutes from my house. The energy there is different from the vortex energy of the Red Rocks. This is a softer, sweeter energy that makes you feel like you are wrapped up in a cozy blanket, even if it is one hundred degrees outside. Aside from walking around the actual Stupa, one can walk over to the gorgeous large wooden Buddha and around the medicine wheel. We chose to meditate by the medicine wheel. Again, I was told to stand in a

specific spot and have her take a picture. I told Sadie I felt like I was being felt up! There was a strange energy around my breast area, unlike anything I had felt before. The picture showed an energy, a light blue orb of some kind, from my neck down to below my breasts. I laughed and said what I always did: "I just can't make this shit up."

The next morning, Sadie's car service arrived promptly at 9:30, and she headed to Phoenix for her flight back to Tampa, as there is no commercial airport in Sedona. I finished tidying up after breakfast and headed out for my appointment with Shekina Rose.

I honestly don't even remember how I found her, but I was now used to being led to the healers I needed to work with. Shekina is an angel medium and sound healer, among many other gifts. I had an angel healing session. She said I was surrounded by many, including the Angel of mercy (which she said she had never worked with before), pink angels, flower faeries, and Archangels Michael, Gabriel, and Adriel.

Shekina said, "There is a need for what you are going to offer." She kept repeating this, which was one of the things I struggled with most, as I was not sure what service I could provide that was not already out there. "Things will unfold. Water is going to play an important part," she said. Pam Lancaster, Tim Frank, and Kristin Reece had also brought up water while I was at Miraval. Water would be big going forward. This was interesting since I didn't particularly love the water or being in the water. Shekina recognized I was an empath and a Blue Ray Starseed. Yet another new term. What the hell was a Blue Ray Starseed?

Shekina could see the perplexed look on my scrunched-up face.

"You are wondering what a Blue Ray Starseed is, are you not?" she asked.

"Um, yes, please," I replied. "I have never heard that term before."

She explained a starseed was an old soul who had spiritual wisdom from many incarnations on other planets and solar systems and is who

is now choosing to incarnate on Earth. This incarnation may be the first or one of many, and the purpose of their incarnation (their life's mission) is to share their wisdom, light, and knowledge with others to help bring about positive change for the planet. A Blue Ray Starseed is said to be a true empath (I had already been told that many times), sometimes called the original lightworker (checked that box too).

Blue Rays were intergalactic travelers (Kristin had brought this up) and could be a mix of many starseed types. There was so much more, but I started to go into information overload. I am pretty sure she saw my eyes glaze over, and at this point, she stopped and encouraged me to do more research when I was ready to do so. I thanked her for her time, and we said our goodbyes.

So much to process from the last few days. I was looking forward to going home to an empty house. Being alone would allow me the time I needed to go inward and unpack all of these messages and information.

60

BIRDS

Imagine Dragons

I always woke up early in Sedona and had my coffee at the kitchen table as the sun came up. I was surrounded by quail and their babies, bluebirds, finches, cardinals, cactus wren, and cottontail rabbits this morning. For the third time in twenty-four hours, a hummingbird came right up to the deck and made sure I saw him.

I have felt connected to animals since I was a child, but my connection had definitely been strengthened since my spiritual awakening. As a child, I vividly remember getting up and running out of the movie theater while watching *Benji* because the dog was being kicked. This connection to animals was another reason I always felt out of place in Laredo. Hunting was part of the way of life there. I never understood hunting as a sport. I understand hunting to feed your family, but not to stuff an animal and hang it on your wall. I wanted no part of going to ranches on weekends and stalking animals. I now recalled Shekina mentioning one characteristic of a Blue Ray is their incredibly strong connection to animals and that animals of all kinds, including wild ones, would be attracted to my energy, and vice versa. This did, indeed, ring true to me.

I got up and went to get my Ted Andrews book. As I looked up these creatures, a theme arose: the Faerie Kingdom. Shekina had been

the first to bring this to my attention the day before. I had heard of Faeries but had not given them much thought, yet every animal I looked up was somehow a representative of this kingdom. I laughed out loud and, of course, got goose bumps all over my body, which for me confirmed that what I was reading, doing, or seeing was true.

I had also been struggling with whether or not to kill two spiders with large webs on the patio. They were up high and not bothering me, but still, I was not a big fan of spiders in general. I had left them alone for the past three days while I decided what to do. Since I had the book out, I looked them up. Spiders represented a link to the past and the future. To Native Americans, they represented the grandmother. Ted Andrews went on to say, "Do you need to write? Are you inspired to write or draw but are not following through? Spider can teach how to use the written language with power and creativity so that your words weave a web around those who would read them."

Obviously, I left the spiders alone.

This writing thing, ugh; I was just so conflicted. I knew a lot of what was keeping me from fully embracing my "task," for lack of a better word, were feelings of self-doubt and judgment. If I were truly honest with myself, I was afraid to put myself out there. I was afraid all the insecurities I had had as a child would rear their ugly heads. I had worked so hard at overcoming so many of them, and I wasn't ready to feel that old, deep-seated pain again any time soon. I still didn't completely feel I had anything to say that hadn't already been said by writers much more prolific and further along their spiritual path than me.

I did more research on star seeds. Perhaps if I changed my perspective and looked at my writing a book as more of a way of fulfilling a mission versus a task. Maybe that was the key. I certainly loved helping people and had been doing so for years through my design and feng shui work. I felt it was imperative for me to align, embody, and manifest my true purpose—that much I knew. Anything less

would feel inauthentic. I just never thought the manifestation would be a book!

I would ponder all of this information for a bit and see where I landed. In the meantime, I would continue to journal, even if what I wrote never ended up seeing the light of day.

61

BAD DAY

Daniel Powter

The next few days were a flurry of travel, both expected and unexpected. I flew to Tampa to prepare for my birthday trip to The Bahamas, but the trip subsequently got canceled due to a hurricane in the Caribbean. So we pivoted and flew back to Sedona for a week, where Ryan and Hannah met us. My birthday week started out quite well. I wasn't going to swim with pigs as planned, but I would get to see one of the main places I wanted to experience here in Arizona.

I booked a private, all-day tour for the four of us to go to Horseshoe Bend and Antelope Canyon on the thirteenth. I had seen so many photographs of this Native American slot canyon on Instagram, and I really wanted to see it in person. You needed a guide, so booking in advance was a must. Getting to drive through the Painted Desert and then to experience Antelope Canyon's magic in real life was awe-inspiring. The canyon, made of beautiful sandstone walls, was truly a natural wonder.

However, by my second day in Sedona, my actual birthday, my stomach symptoms once again worsened, and I spent most of the day in bed. I texted with friends and with Sofia, Beth, Kyle, and Andrea, who all wished me a happy birthday. I didn't have much of

241

an appetite but knew I needed to put a little food in my stomach. Hannah brought me tea and toast. We canceled our plans for dinner down by Oak Creek at one of the best restaurants in Sedona, and Art ordered pizza for everyone. I watched television and assumed I was still having leftover issues from the parasite infection, but I could not figure out why I was not getting better.

The following afternoon, we hired the guide we had for Antelope Canyon to be our driver and guide to the wineries in the area. Page Springs, which is about a twenty-minute drive from Sedona, has several well-known wineries where you can visit, have lunch, and do tastings. Art, Ryan, and Hannah were excited about going. My stomach was still pretty sensitive, and the pizza the night before had not helped matters, but I didn't want to spoil the day, so I went. I did the tastings at the first winery, where we also had lunch, but I couldn't even think of tasting any more as we continued on. At the final stop, and sorry if this is too much, I barely made it to the bathroom stall before I had a horrible accident. I felt so sick, embarrassed, and defeated and had no clue as to what to do.

Upon returning to Tampa, I decided the time had come to really figure out my health issues. After many tests and specialists, I got my diagnosis. I was relieved to finally have an answer; I just didn't like the answer. I knew part of my journey was to accept things as they were and not as I wanted them to be. This was hard for me. My guess is this is probably hard for everyone. Who wants things to just be? The week would leave me reeling, and it was only Monday.

My diagnosis is lymphocytic colitis. This form of microscopic colitis is difficult to diagnose, which is why it took so long. Lymphocytic colitis is the sister disease to celiac disease. The bottom line is that for the rest of my life, I have to remove dairy, gluten, sugar, spicy and fried foods, soft drinks, alcohol, and worst of all, caffeine! The last time I had gone without caffeine, I was pregnant with Ryan, and that was twenty-five years ago.

My initial reaction again reverted to "Why me?" I had already been through so many physical challenges. *How will I go out to eat? How will these dietary restrictions impact my ability to travel? To go to dinner parties? How am I going to cook for Art?* All the changes had to be implemented immediately, so the process felt extremely overwhelming. I took a day or two to be pissed off and feel sorry for myself and then set about cleaning out our pantry, refrigerator, and freezer of all items I could no longer consume. Art, supportive as always, agreed to adopt this new lifestyle when eating at home so I would not have to cook two different meals.

The rest of the week didn't get any better. Our beloved friend and neighbor of twenty-five years unexpectedly passed away. And we "rehomed" our Yorkie Sofie on Tuesday.

We had known for a while that we needed to take measures to deal with Lola and Sofie's fighting. We had hired specialized trainers, and the dogs would stop fighting for a few days. This time was different. When we had come back from Sedona a week earlier, our dogsitter asked if I had time to talk, which was unusual.

I said, "Sure. Is everything okay? Did they behave badly?"

We sat down at the kitchen table, and I listened to information I absolutely did not want to hear. "Lola and Sofie need separate homes," she said.

"What?" I replied. "Why?"

We had had them for six years, and the fighting had gone on for two of those. I was in tears as I heard this, and I called Art and conferenced in Ryan as soon as she left. The three of us discussed the situation at length while both dogs lay in my lap. That was the hardest part to make sense of. Ninety-five percent of the time, things were great, but the five percent that were not were going to leave one of them dead or badly injured. We could not let that happen. We loved them too much. I talked to Sofia about the situation, as well, and she also agreed the dogs' safety was the number-one priority. In the end,

we chose to do what was best for Lola and Sofie, regardless of how we felt. The couple who adopted Sofie was lovely but knowing that didn't diminish our pain at losing her.

That morning, as I counted down my time with Sofie (yes, literally looking at the clock every hour and saying to myself, three hours left with her, two hours left with her, etc.), my carpet cleaner yelled out from the patio where he was working that there was a small white dog in our backyard. Our entire yard was fenced in, but he had left a gate open, and this little guy somehow got in. His name tag said Carlos. I picked him up and started walking down our street with him in my arms. Halfway down our street, a woman ran toward me, frantically waving her arms. She was distraught. She said Carlos had dug a hole in their backyard and escaped. She looked at me through her tear-filled eyes and said, "Thank you! Thank you! You have no idea how upset I have been. I thought I was never going to see him again!" I told her all was well, and as I turned around to walk back to my house, the countdown continued—one more hour until I would never see Sofie again.

Art and I had gone over and over this decision when we first decided to rehome. I would sit at the kitchen table and break down each time we talked about who stayed and who went. I couldn't choose between them, and the final decision was to rehome both. I don't know if my decision was a cop-out or not, but I just couldn't say that one could stay and one could not. This decision meant we would have to go through this pain all over again, as Lola's adoption was scheduled for the eighteenth. I hoped I could stay strong. The only thing that mattered to us was what was best for them. I understood part of my awakening was to give up what no longer served me. So far, the people and things that had fallen away had been pretty easy to deal with. Friendships I didn't really want to continue, habits I wanted to change ... but this next phase was harder. I was being asked to accept and make so many life-altering adjustments in such a short period.

In the two-week interim between rehoming placements, Lola's temperament completely changed. All the anxiety she had shown around Sofie was gone. She was happy, playful, and extremely good-natured. You could literally feel a change in her energy, and her little spirit was light and bright. We knew the couple that was going to take her, as they had been her previous dogsitters. They were lovely, and we knew she would be loved. The night before they were scheduled to pick Lola up, she was sitting on my lap in the family room, and I just looked at Art and said, "I can't go through with the rehoming."

He was sitting across from me and said, "I was just thinking the same thing."

We could not give her up. We just couldn't do it. I picked up the phone and called my current sitter, who was facilitating the rehoming. She understood and said she would let them know. I have carried a twinge of guilt around with me since then. In the end, I did choose, a task I had said I couldn't do, and I hoped Sofie would understand.

62

YOUR WILDEST DREAMS

The Moody Blues

I had been trying my hand at automatic writing. Kristin had mentioned this technique in a previous phone session when I once again brought up the question of what I was supposed to write about. The idea is to ease into a deep state of relaxation and allow your mind to answer questions. The technique is meant to help us connect with a higher source of inspiration, creativity, and insight. I wanted to use it to help loosen mental blocks and find answers.

I sat in my favorite chair, in my favorite room, my dining room, and began. I felt the questions I had were endless ... "What is my soul's purpose? Do I actually have a mission, or am I making all this up? If I do have a mission, how am I being prepared to serve? What the hell will this book be about? How do all these bits and pieces of information I have received over the last year fit together?"

Now that I was embracing the idea of having previous lifetimes, I asked for my talents and teachings from those previous lives to be made available to me in this life so I could share the information and use my knowledge to help and heal people. I did find I encountered someone every day whom I was able to share something with.

To be honest, I hadn't been writing about my own story. I didn't want to re-feel the feelings. Revisiting a hurtful or traumatic

experience, then moving on to the next thing, like cooking dinner, as if nothing happened, was incredibly hard for me. I learned from healers that our body experiences events as if they are happening, even if you are just thinking about a past or future situation. This made writing difficult for me. My mind didn't want to relive a lot of this stuff. This was probably why I took on more feng shui work and created projects that "absolutely" had to be done at home. They were placeholders that allowed me to create legitimate excuses for not having time to write. Aha, so I answered my own question. This automatic writing really works!

I needed a schedule. There had to be at least one day a week when I did not work with clients. That day would be dedicated to writing and furthering my real mission here on Earth, ah, so I did have one. When I came to this point in my automatic writing, I felt better. I put down the pen and started reading the book my Pilates teacher gave me. Ted Andrews had written a new book called *Enchantment of the Faerie Realm*, in which he teaches how to communicate with Nature Spirits. The book certainly seemed to tie together with all the other information I had been given about animals and nature, and I couldn't wait to see what I learned from it. The funny part is she didn't remember ordering the book but knew the book was some-how for me when she received the package. Again, just like the book Monica gave me in Laredo, the synchronization always amazed me.

My monthly phone session with Kristin was happening that same day, and I was excited to share what the automatic writing had yielded. I decided to change locations since I had been sitting in the dining room for a while. I went upstairs to my meditation room, sat on my cushion, did some deep breathing, and centered myself. Next, I lit incense and chose a phantom quartz crystal to work with. The first message that came through Kristin for me was: "You are not to veer at all from your new dietary plan, as this way of eating is a huge part of your soul evolution. You have your very own Round Table.

They are your guardians. 'You are to know we are always here. Your best interest is always the topic of our discussions. Information is the beam of light, and we are the orb. Don't be disappointed if you don't physically see them. We are always here.'"

Art's dad came through. His first message was for Art. "I am speaking directly to Art in his sleep. He is hearing it from the horse's mouth." His message to me was, "Dream big. Dream big. Nurse yourself right now." His last message to both of us was the phrase "March of Dimes." He would start sending dimes for Art and me to find in completely random places. We both found dimes on the street and in our pockets, and one time we found one in our hotel bed when we checked in. A few months later, Art, his brother Pat, Pat's wife, and I were in Salem, Massachusetts, for a wedding. On our walk from the hotel to a restaurant, which was six blocks away, I found three. One on the street, one on the stairs in the restaurant, and one under the table where we were seated. He was definitely hanging out with us on that trip!

The last message that came through was, "You have done the work on your solar plexus chakra and are safe now. You are healing from within"—as I had been told I would be on the yellow sticky note my facialist had given me months before. "You need to allow that to come into your entire being. The time has come for you to fully understand what a safe and solid foundation feels like."

As always, we chatted for a few moments at the end of the session, and then Kristin asked me if I had ever connected with a woman named Lauren who was also at Miraval.

"Oh no, I completely forgot all about that conversation!" I said and explained what had taken place.

On the day Sadie and I left Miraval to go to Sedona, Sadie had had a strange encounter. She told me about the conversation on our drive. She said a beautiful, tall blond woman had walked up to her in the main courtyard and asked her if she was Alejandra Brady. Surprised,

Sadie said no, she wasn't, but that she happened to be traveling with me. Over the years, when Sadie and I were together, people have often mistaken us for sisters, but it seemed so wild for a random person to happen to find someone I was with and think it was me. The woman said her name was Lauren, and Kristin had told her to seek me out. Kristin felt we should meet. Lauren gave Sadie her number and asked her to relay the message to me.

Kristin said she felt we would be a good fit and suggested I reach out if and when I felt compelled to. I told Kristin I would reach out when we hung up.

Life had been so busy that I had forgotten to reach out, but I had entered Lauren's number into my contacts.

I hung up with Kristin and reached out by text to Lauren. I apologized for my delay in getting back to her. Lauren Douglass was a CEO Coach at Vistage, a company that helped coach people on becoming better leaders. We chatted for a while, and I felt comfortable with her, so I scheduled the first of several Zoom calls for the following week. We saw each other for the first time and she was as beautiful as Sadie described. Lauren was empathic as well, and during one of our sessions, she picked up on a lot of grief. I wasn't surprised, as I was grieving all the massive alterations taking place.

She said, "You need to be kind to yourself at this time." We talked about the fact that I had the right to be angry about all these modifications, even though I knew, in the end, they were for my highest and greatest good. Knowing they were for my betterment still didn't make them any easier to deal with.

Somehow the topic of me at the age of eleven came up. She asked me, "If you could pick anywhere in your wildest dreams, where did you want to live when you were young?" Spoiler alert: not Laredo. My mind immediately went to New York City. My uncle and aunt lived there, and my grandmother and I went to visit for two weeks when I was eleven. I thought New York was the most magical and elegant

place on the planet. She asked me, "What else happened at the age of eleven?"

The back brace. I had to wear clothes that were several sizes too big to fit over the brace, and I felt the brace defined me. I suffered in silence.

Funny enough, as I write this, I am reminded of a conversation with a childhood friend who came to town a few weeks ago. He texted me when he found out he would be in Tampa, and we picked a time to meet up for dinner. We were sitting at the table, catching up over dirty martinis, and he asked why I needed so many spinal surgeries. I reminded him of the many years I spent in my back brace.

He looked at me incredulously and said, "What brace? You never wore a brace!"

We had had most of our classes together throughout junior high and high school since we went to a school with fifty-two graduating seniors. Was he going senile? A few days later, he even texted me a photograph of a group of us in high school, and he asked the same "What brace?" question. Of course, I was wearing the brace under my baggy clothes. The huge lesson he taught me that day was to realize what was in my head was not necessarily what was really happening. I always thought the only thing people saw when they saw me *was* the brace.

I had to apply this same lesson to the autoimmune diagnosis. Although the colitis was an issue, I would adapt and find what I needed when traveling or going out. Once I accepted that I would be okay, the solutions showed themselves. I was always able to find something I could eat when I went out or traveled, and that solved one of my biggest fears. The diagnosis would not define me.

63

SUSSUDIO

Phil Collins

I hadn't seen Dr. Sandi in months. When I did, she asked if we were moving and said she saw the numbers "7842." Could these numbers be referring to an address? A zip code? Someone named Jean came through very strongly to say she was around me a lot. Dr. Sandi said, "Jean is someone on your biological mother's side of the family."

I didn't know who Jean was, so on my forty-five-minute drive home, I called Sofia. She answered right away, as she usually did when I called. We had a few minutes of catch-up time, and then I told her I wanted to ask her a question. "Do you know a Jean on your side of the family?"

I respected her beliefs, so I didn't dive deep into how the name came up. After all, she had stood there while her husband had called my gifts "of the Devil," so I assumed she would not want to hear anything of this nature. I just told her, "My doctor felt a person with this name in the room with me."

She responded, "Jean is my mother."

My entire body got goose bumps. I wasn't sure what to say next. I was stopped at a light, drinking water while I figured out my next sentence, when Sofia said something I never, ever expected to hear.

Her question caught me so off guard, I almost spit out my water. She asked, "Have you ever had any interaction with Matt?"

Her son Matt had died before the family found me, so she obviously meant spiritual mediumship interaction. He had not come to me that I was aware of, and the thought of reaching out to him had never even crossed my mind. I took another sip and listened.

Sofia told me, "Matt was actually the one who started the search for you. We found the name of a company he was using to locate you on one of his credit card receipts while going through his belongings after the accident."

I took a deep breath and asked, "Would you like me to try?"

"Yes, I would."

Wow, okay. This was big. My mouth was suddenly really dry, and my palms got clammy. I took another sip of water. "Would you want to know what transpires if I receive messages from him?"

Again, she said, "Yes."

The thought of losing a child was one I could not begin to comprehend, and if this could help bring her some peace, I was more than happy to try, even with everything we had been through. She was obviously making herself vulnerable and open to possibilities, and I wanted to honor her. This was, after all, the entire point of my gifts. I was here to help others who were in pain and who needed to hear the messages I received.

I promised Sofia, "I will ask, and if communicating with Matt is in everyone's highest and greatest good, I feel strongly I will get a response and share any information I receive with you."

A few days later, I smudged my meditation room to allow clear energy to come through. I pulled crystals and meditated. Then, I prayed and asked, "May I connect and communicate with Matt if again, communicating with him is in everyone's highest and greatest good?" I quieted my mind and opened my heart, and the first message came through. I saw and heard the words "blueberry ice cream." I

didn't understand. The voice then instructed me to reach out to Beth with this information.

I texted her. I knew hearing about her brother touched a deep wound for her, and I hoped the information would bring comfort to Beth as well as Sofia. "Sofia asked me if I had ever communicated with Matt. I said I had honestly never thought about it or tried. I asked if I reached out, would she want to know? I would only get a message if it was to be in everyone's highest and greatest good and only of the light of course. The reason I am sharing this with you is that I did ask today, but I was told to tell you first. I honestly don't know why—maybe what I was told is something you know that Sofia doesn't. I immediately started hearing the song "Sussudio" by Phil Collins (which I truly dislike, so I would never stick that in my head!!!). Then I heard the words 'blueberry ice cream'—something I didn't know existed! I just looked up what the song means and it is about having a crush on someone when you are young. So, I am doing what I am told—I feel this is from Matt and perhaps the song and words will make sense to you? I know it can be jarring to get told something like this out of the blue. I was going to wait a few days, but I keep getting told to tell you and I need that insane song out of my head! I would love to know if it does, so perhaps then we can share it with Sofia. Thank you for listening ..."

She replied right away. "Hey there! No, the song and the ice cream don't mean anything to me regarding Matt. I'm like you—I didn't even know they had blueberry ice cream!!!"

"Okay, thanks," I responded, feeling quite confused.

I went back into meditation and asked for further clarification. This time, I saw a cow with a girl in a bonnet. That was the logo for Blue Bell Ice Cream (and the confusion with blueberry). Then the words "butter pecan and/or with caramel" showed up for me.

The song kept playing in my head. *Ugh.* I knew I had a call with Kristin in a few days and decided to talk to her before I reached out

to Sofia with the information I had. My gifts were still pretty new, and I wanted to give Sofia as much true information as possible. I would use my session with Kristin to possibly further communicate. I really wanted to give Sofia this present. I would see what Kristin had to say.

Kristin was instantly able to connect with Matt and almost immediately saw pizza and a bike. "Was there a bicyclist around the accident?" I didn't know. That was a question for Sofia when we spoke. "Lights on, lights off." I knew that meant a quick death. "Now there is light everywhere." Heaven or a good place, depending on your beliefs. "He is very much at ease even though the event was tragic and there was another family involved. It was good that the family went together as a unit," she said. The accident had been a head-on collision, and all members of the other family died. Sofia and her husband had shared that much with me early on. Kristin continued, "They are all in the hands of God and were lifted together. Looked like there was a girl. The other family was also not paying attention on the road. Was there a girl in the car with him or in the other car?" Again, I didn't know the answer but would ask. Matt had a lot he wanted to share, and I furiously kept scribbling down everything Kristin was channeling.

"He doesn't want his family carrying this burden and guilt. He was the one under the influence," Kristin said. She shared Matt's words: "Mom, I'm happy my picture is back up." "Beth has always been difficult and two-faced." "I have come to my mother many times, so when she feels or sees me, she is right, I am there." Sofia's face showed up, and Kristin said there was a rose around her. "What she did for Dad was amazing, incredible. She held space and lifted him up. She felt alone in a lot of this." "Mom needs a big hug. She has put herself in a very protective box. Mom, I am hugging you," Matt said.

Now he was showing Kristin a dove. He wanted Sofia to feel and have peace. "Tell her to look for doves." He showed Kristin an open

book with handwriting. He said, "I was very creative and had a lot of big ideas. A lot of times I felt on top of the world but could and would sway from this to the other extreme dramatically." He was very stylish, cool, and sweet-natured. He continued, "Someone else in the family also has the same problems and doesn't know how to reel them in. I loved music. 'Sussudio' is one of the songs I liked. I had a lot of good rock tracks and would have been a good musician or drummer. That dream was shut down, but I am with Jean."

Our session ended with him thanking us for communicating with him. He really appreciated being able to do so.

I was overwhelmed with happiness and beyond excited to share Matt's messages with Sofia. I called her immediately. When she did not pick up, I left a message to call me back. I also sent a text, saying, "Can you chat?"

Three hours later, she responded. "I just saw this text. I was getting a facial and my phone was off."

I replied, "No worries, I am home if you want to talk." To my amazement, I didn't hear back from her for several days. Up to this point, she had always taken every opportunity to talk with me.

I texted her again four days later. "So, I never heard back from you. I wanted to reach out again and let you know I have had three interactions with Matt. If you would still like to hear about them, give me a call. I am out of town on a work project tomorrow and Tuesday and will not be available. Have a wonderful day."

Her response once again changed the course of our relationship. Three hours later, she texted me back, saying, "I'm sorry. I forgot to call. I have a friend who's been very ill and it's been hard. I'm probably better off not hearing about Matt. I know where he is and Who he is with and I'm at peace with that knowledge. Have a good work trip. Love you."

"As you wish. Yes, he is with God and he is at peace. That much is confirmed," I responded. She texted back, "Thank you honey."

I felt I had to give Sofia one more try since Matt had been so excited to have someone communicate with him and be there to give his family the messages he wanted to share. "If you ever change your mind, I wrote everything down—it was a lot, and he had some specific messages for you. I will keep it for you. I hope your friend gets better soon."

"Thanks. She has lung cancer and something on her brain. Biopsy this week. Don't know the prognosis yet," she replied.

Not one word about anything I had said …

I had spent my time, talent, and treasure getting the answers Sofia asked for, only to have her make me feel, once again, like I had done something wrong. Thanksgiving was the following week. I was always the one who sent cards and reached out. Given what had taken place and the fact that I was honestly quite offended by her response, I decided to sit back and wait to see if she or any other family member would reach out first this year.

Not one single person did. As the saying goes, "No response is a response." Their silence spoke volumes and again let me know where I really stood with this family.

As of now, they don't know any of this information. I guess if one or all of them decide to read this book, they will finally know what Matt wanted his family to know for years.

I felt a small pit in my stomach as I wrote this because I was forced to revisit this incident. I now understand she was probably preoccupied with her friend's illness. I really do. I understand we all cope with situations differently. Sofia's and my journey has been muddy for some time now. Our relationship may never be clear, but I can now see a small level of clarity I could not see then. At that point, I could only see that she, once again, didn't choose me.

Even though I was hurt on Thanksgiving, I had so much to be thankful for. Ryan and Hannah had flown in from Chicago to spend the holiday with us, and we had a new family member.

Two days before Thanksgiving, our petsitter who helped rehome Sofie had reached out to us, pleading for help. She was part of a dog and cat rescue operation and needed emergency foster parents for a dog in dire shape. My first instinct was to say no. We had just gotten Lola adjusted to being without Sofie, and bringing in an unknown, abused dog could really mess with her. I told my sitter I would talk to Art and get back to her.

Art and I talked and realized we had to help. After all, someone had helped us with Sofie. I picked up my cell, called back, and said yes, we would foster the dog through the holidays so she had time to find a forever home. I said a little prayer that Lola would be okay, and we waited for the dog to be dropped off.

What showed up was the saddest little thing I had ever seen. When I asked what his name was, the sitter spelled it out instead of saying it. I asked why, and she said not to say the name out loud because he would associate that name with the severe abuse he had been subjected to. She said we had to come up with a new name on the spot.

I looked at Art, and he looked at me, and we both said "Angus" almost on cue. We were in the middle of binge-watching *Outlander* and had been for a few weeks. A scrappy little soldier whose name was Angus really stood out to me. I remember saying to Art, "That would be the cutest boy dog name ever!" Who knew "ever" meant three weeks later?

Art took Angus into our pool bath and washed his emaciated, eight-pound body until at least a hundred fleas came off him. He had scratched and chewed raw the parts of his body he could reach. He was missing large clumps of hair and instead had bright red skin. The owner's solution, instead of dealing with the fleas, was to keep him permanently in a cone. The backstory was that the owner was the girlfriend of a meth head, so you can only imagine the conditions they lived in, and she was at the vet insisting the dog be euthanized. The vet said he could not in good faith do that because all the dog

needed was food and, obviously, care. She said she would throw him out into traffic from her car on the way home if he didn't put the dog down. The vet tech who was in the room, and also part of this rescue organization, offered to take him. Thankfully, the woman had enough humanity in her to turn him over.

Our sitter called the next day to check on things, and by that time, we knew what a special little boy he was. We told her we were foster fails and instead wanted to adopt him. We nursed him back to health, and he is a happy little guy. I did research and found out he is a Chorkie, which means he is half Chihuahua and half Yorkie. He and Lola get along great, and Angus has been a joyous addition to our little family. He is a happy, chunky ten pounds now!

Sofia and I texted a few times during the Christmas holidays. There was no substance to the texts. They were only to let each other know gifts had arrived. Again, I was the one who reached out to her on Christmas morning with a text and a couple of family photos. I received short replies. "Great pic, where are you?" "So cute." No one else in the family reached out at all. I decided the time had come to reevaluate if I truly wanted to remain in this passive-aggressive family dynamic or simply allow them to become genetic history.

64

FEELING GOOD

Nina Simone

I woke up at our friend's beach house on January 1, 2020, with a wonderful sense of peace and a positive outlook for the year ahead. Little did any of us know what lay ahead for the entire world and that the worldwide coronavirus shutdown was only three months away. Life, as we knew it, would never be the same.

I stood on the balcony, faced the ocean, and did a twenty-minute meditation as I set my intentions for the year.

My intentions were:

To take all steps necessary to control my health.
To have a clearer vision for my true soul mission.
To take concrete steps towards that vision.
To support Art in his next chapter.
To take steps to move.

I didn't know where the perfect next home for us would be, but I had complete trust in the Universe that the perfect house would show up at the perfect time. In the meantime, I would do my homework so we were ready to make the decisions at the appropriate time. We had been in our current home for twenty-five years, and although I had worked hard to energetically shift our home's vibes, I was ready

for a life outside the suburbs and for Art's and my next chapter. We wanted the more urban environment South Tampa offered, where we could walk on Bayshore Boulevard, to restaurants, and to Hyde Park.

> To figure out where I wanted my relationship with Sofia and her family to go.

Did I want a superficial one or none at all? Did I need to set up clearer boundaries?

> To watch less TV and to read more.

This last one went out the door with the pandemic!

During our January call, I told Kristin what had taken place with Sofia over the holidays. Kristin was less surprised than I was by Sofia and her family's reaction. She said, "I see you on one side and Sofia and her family on the other side of a big opening, a divide." The messages coming through for me were that there was no longer a need to continue to try and build a bridge with them. "They do this to other people too. You can let them go. The time has come to release them to their highest good," she said as she channeled my guides. "You are to let go to let things flow and release in order to receive. You are already included in the bigger realm of what really is and have given them too much power." My answer to one of my 2020 intentions seemed pretty clear.

Kristin also asked how my relationship with Sadie was going. "Great!" I said. "I am working on projects for her again and having a lot of fun doing so. We have also made more time for our personal relationship, and we go out as couples every couple of months. In fact, we are going out later this evening."

"Wonderful," she said. We said goodbye, and I went to get ready for our double date.

In February, I started having crazy dreams about giving birth, multiple nights in a row. I asked Heather to come over. We were

putting our Tampa home on the market, and I wanted another set of eyes before the photoshoot for the house took place. "I want you to pull cards before we walk the house," she said. She had a new deck she loved, the Starseed oracle deck by Rebecca Campbell. I pulled three cards, and of course, they were all about birthing something new, with the words "book" and "home" clearly spelled out.

Shortly thereafter, the photo shoot was done and the papers were signed. The house was officially on the market on the first new moon of 2020. Listing the house was the first step toward a new chapter. January 24 was also Art's last day at work. Two major steps toward ending old chapters and birthing new ones.

I was so excited for our next adventure yet tried not to obsess over Zillow on a daily basis. I sensed old patterns creeping in. I felt the need to control everything and know how and when everything would happen. I was getting frustrated that I was not finding another house right away. I talked a good game, though. I told Art and Ryan things would happen the way they were meant to in Divine timing, and I did believe that, but of course, I was trying to control the "meant to" part of things. Being able to step back as an observer of my life and simply watch where I was allowing these old patterns to creep in, then correct them, felt like immense growth.

The following morning, my Pilates instructor canceled on me at the last minute due to a sick child, so I indulged in the luxury of a slow morning, decaf coffee, some Bravo, and then an extra-long meditation connecting with Akashic Records, during which time I was told to do another meditation, an Archangel Michael meditation, to be specific. So I did. The meditation was about releasing fear and allowing love in. I pulled cards from some of the decks I had, and of course, my overall takeaway message was to release, trust, be soft, allow love, and be of service. I still struggled as to why anyone would give a rat's ass about what I have to say, but over and over, I was told I was here to help the world. The definition of my name is "helper of

humankind," after all! So I kept writing, and I hoped by sharing my struggles and vulnerabilities, others would feel safe to share theirs and that a better world would emerge.

My writing began to feel a bit more natural. I honestly never had a clear vision of what the book was supposed to be. I had just started writing what was taking place and hoped, at some point, the larger picture would show itself to me. The thought of creating a tool that would impact and help millions, as many of the healers indicated, frankly left me paralyzed with fear as to where to start and what to say. The meditation helped me realize I wasn't supposed to write for everyone. I relaxed, and the words came.

I had a second Zoom session with Lauren Douglass a few days later, and she helped me see I would help just by being me, and the people who needed to hear and benefit from my story would be the ones who resonated with the book. I didn't need to worry about the "worldwide" scale I had been getting swept away in.

A few days after our session, I was at a party at Sadie's house when a woman I didn't know walked up to me and said, "I want to rub up all over you and have your light come off on me." I thought her comment was a bit odd, but her words helped me see what Lauren meant. I just had to be me. This girl didn't want someone else's light; she wanted mine. That was my gift. I was me. I would shine *my* light in hopes of helping as many people as I could. All of us called to do this work would each shine and eventually flood the earth with the golden light we were all here to bring.

The other issue that still took up an enormous amount of my time and energy was how to eat. My most recent round of bloodwork came back strong, which was great. I was making progress and getting a little better every day. I had eliminated everything on the list of "what not to eat" but still dealt with diarrhea daily. I went to the bathroom at least five times every morning. This condition made leaving the

house quite difficult. I was having a hard time leading any kind of normal life and figuring out why I still had that particular symptom.

The Snow full moon fell on February 8. First, I did a powerful meditation from the Downloads of Divine Consciousness course I had been working on. Next, I wrote a letter. The letter was to release and cut cords to what no longer served me. I wanted to continue healing from within. Finally, I burned the letter. My entire body was vibrating by the time I was done, and I felt a huge emotional release.

My letter:

> *I choose to release all those who no longer serve me or who make me feel less than for sharing who I really am.*
>
> *I choose to release them to their highest and greatest good. I ask that they easefully and gracefully be removed from my life.*
>
> *I choose to release my hold on this house. I choose to release this home so the house may connect with the next occupants and so our new space may connect with us in our/Universe's most perfect and Divine timing.*
>
> *I choose to send love to people I find difficult.*
>
> *I choose to release my negativity and instead show compassion and understanding since everyone is walking in and through their own journey.*
>
> *I choose to be open to opportunities even if the timing seems tough.*
>
> *I choose to put out into the Universe that I would love to go to Machu Picchu with the group Heather is going with if going is in my highest and greatest good.*
>
> *I choose to let go of old patterns, resentments, and envy, and bathe myself in gratitude for all of the blessings the Universe/God has bestowed on me.*
>
> *I release to receive so that I may continue my true mission here on this planet at this time.*

Thank you
Thank you
Thank you
... and so it is. I choose love.

65

AROUND THE WORLD

Red Hot Chili Peppers

The following day marked fourteen years since my mom's death. I was getting ready to attend Heather's birthday luncheon at Bazille, the restaurant inside Nordstrom's. They had the absolute most delicious skinny french fries served with black olive aioli, and they were my favorite. As I was getting dressed and dreaming of tasting a couple of french fries (I had to be careful because of my dietary restrictions), I pulled out my mom's charm bracelet. I didn't wear the bracelet often because the charms caught on almost everything, but I clearly remember my mom wearing the bracelet all the time. My dad had given her the bracelet on their honeymoon. He was able to combine a work trip to Central and South America with their honeymoon, so they spent their first three months of married life traveling to countless countries. She collected charms from each stop and created this bracelet.

I remember her talking about visiting Peru, and I was looking for the charm but could not figure out exactly which was the Machu Picchu charm. Regardless, I felt a strong pull to wear the bracelet. Tears rolled down my face in the car on my way to the luncheon as I felt both her and my grandmother's presence with me.

Heather and I were the first to arrive. Then Kathy joined us. She was a powerful energy healer who was legally blind. I shared the story

of my bracelet with her and reached out my right wrist so she could touch and feel the piece. She said, "I can see both your mother and grandmother right behind you." I knew she was right since I had noticed them with me in the car. I was grateful for her confirmation.

The other ladies arrived. They all knew each other, so the focus was on me. They asked questions, and I told them about our home in Sedona. They immediately said, "Well, you are one of us!" They followed this up by inviting me to the retreat in Peru. I, of course, said yes immediately! I was quickly moving forward with my new year's intentions.

I came home and talked with Art, who said yes without hesitation. "I know going to Machu Picchu means a lot to you. Peru has been a bucket list item for quite some time now."

I was beyond grateful! I called the directors of the retreat to sign up, and they said, "The last spot is now yours." Everything flowed seamlessly. I was not sure what was waiting for me, but I was ready.

My mind bounced back to what Dr. Tim Frank had told me last August. He said I would eventually be a bridge between the United States and Latin America. The Universe was taking me back to Miraval in March, then Peru, and two weeks later, Costa Rica. Art and I had also been talking about going to Europe for our thirtieth wedding anniversary in June. The doors were opening, and I felt the shift and was excited! Little did I know what the Universe really had in store for me and pretty much every other human on the planet.

The next few weeks were insanely busy as I prepared for all my upcoming trips. I took time out to have a session with Kathy, the energy healer I had met at Heather's luncheon. She used Jin Shin Jyutsu, a form of massage, to connect and then reveal what Spirit and guides were wanting the person on the table to know.

The next ninety minutes were amazing. As soon as she touched me, she said, "You have a man and woman over your right shoulder, a man above your head, a woman over your left shoulder, and you—the real you, soul you, by your left elbow. The room is full of guides and

beings, but the ones mentioned are the ones who most want to make themselves known."

A few minutes later, I asked if I could guess who was there and if she would know. She responded, "Yes, they light up if you name them correctly." They were as follows: Mom and Dad, Dick, my grandmother, and ME.

ME got a name today. I shared the story of my two names with Kathy and said, "I think she may be called Cassandra," and Kathy said she (ME) nodded and was very happy with that name.

Kathy began channeling, and the lifetime coming in for her to "see" was a barbaric time, although she was not able to decipher a specific place or time frame. "You are encrusted in jewels." She must have repeated this at least twenty times. "Your chest and privates are covered with cloth, and jewels cover the cloth. Basically, you can't see any skin because of the amount of jewels you have all over your body." I freaking loved that! She continued, "You are a lead Priestess/Goddess during this life, and even though you are covered, you wear the jewels with power. The jewels do not wear you. You use them to help people and freely give them away, knowing there are always more."

She said, "You help empower women and children. You work with boys who have been beaten and girls who have been raped or made to have sexual relations with those in power in order to stay alive, even if they are married or love another. You heal them and help them learn to clear themselves so they do not carry the victim mentality with them. You shape-shift and are able to go to people who are tied up or otherwise unable to leave their space. You ride a large white stallion, and those who need to find you, do. You have a home because of your position, but you only go there to procure more jewels."

She continued, "There is gold light all around you. You use the light as a cloak to cover the white light over your head so you can get in and out of places undetected. The abusive people in power also have seers, and they can also see you if you do not cloak your light."

I asked about a connection I felt toward my assistant in Sedona, who gave me the Lemurian quartz necklace. Kathy explained, "You intervened in the middle of a ritual because you knew something was going to happen to this little girl (in a different lifetime than our present one). There was an elder woman who bathed her and tied her up for a man who was going to come and have sexual relations with her. She was six years old, so obviously, this was not okay. You shape-shifted through a wall and pulled her close to your heart and were able to go back through the wall with her attached to you. She was so young and innocent that she didn't understand what was happening. The man hunted you for many years because of this. You kept her safe, and she became your little apprentice. She was not as powerful as you were, but she was able to help you run things to people when you could not get to them. In this lifetime, she is there to help you when you need assistance, and her help is her way of showing her eternal gratitude for saving her."

Woah ... that was a lot.

Kathy got quiet for a little while and asked about my health. I told her about the lymphocytic colitis diagnosis. She said, "Cassandra is working on you and bringing in sacred geometry codes through your elbow. This will be a power you can call upon to help as you get stronger." Blue and green patterns were placed over my stomach area with bright white light to help the healing process. I was healing from within, just like in the note David handed me after my facial. Then she said, "There is a dragon at your feet. He protects you and literally moves things out of the way if you are in any danger."

I replied, "I know I am very protected. I feel the protection." I didn't tell her I wasn't too sure about all the sacred geometry stuff, though. There was still so much I didn't know and understand.

Kathy said, "Yes, yes you are."

She got quiet, and again I asked if I could ask a question. I was still getting "bumped" out of nowhere at the most random times.

I told her about the incident at the restaurant in Sedona with my teacher, Karen, and about the incident at Miraval in Austin when I went with Andrea.

"I got bumped on the left side of my bed last night. Who was that?" I asked.

Kathy said Cassandra raised her hand. I asked, "Why did she decide to wake me up from a sound sleep?"

"You are starting to integrate more and more and coming into your real power," was the answer.

I asked if I would regain my clairvoyance and shared the experience in Mexico with her. "I am pretty sure that is when I closed down since I have not had a clear visitation or vision since then," I said.

I went on to say I accepted the situation, but if getting my "sight" back was an option, I felt prepared to handle the visions now. Kathy got really quiet. So did I. Then I finally spoke up and said, "There is a lot of pressure on my third eye."

She said, "Cassandra and everyone else is working to give you your sight back. You are ready. You asked."

We continued quietly for a while longer. She went to the pressure points on my feet.

"Reclaiming your clairvoyance will take several days, perhaps three or more. They are working on you slowly and in a way that will protect you, not frighten you, and also not allow lesser beings to enter," she said. Cassandra also said to NOTICE her when I looked for houses on Zillow. She would give me three signs when the right house came up for us.

When Kathy was at my feet, she said, "You are very closely connected to and performed many rituals with the sun, moon, and the stars, and there was one star that was there for a reason, but I don't know why."

The word that popped into my head was "Venus," but I was not sure why either, so I didn't say the word out loud.

Kathy gently let me know she had finished the massage and would give me a few moments to gather myself. She would meet me in the waiting area when I was ready. I stretched my arms and legs out, rolled over onto my left side, and gently sat up. I put my shoes back on, reached for my purse and sweater, and headed to meet her. I thanked Kathy for her time and her insights, and we talked about our upcoming Peru trip for a few minutes before I headed home.

Once home, I went upstairs, stopped in Art's office to give him a quick kiss and say hello, and then went directly to my meditation room. I sat cross-legged on the floor and started scribbling notes in my journal from my experience with Kathy. I didn't want to forget what she had told me, and I knew if I got sidetracked and started doing something else, chances were I would forget something.

I heard Art get up from his desk and softly close his office door. He was about to get on his first phone call with Kristin. I had been talking about Kristin with him for months now and always offered to schedule a session with him if he wanted one. He had finally said he did, and today was the day! I had smudged his office that morning, so his energy field and that of the room would be clear for this conversation. I knew he was still skeptical of so much of what I was going through, and on any given day, so was I! I was grateful he was opening up to energy work and the possibilities that came from embracing an open heart and an open mind. Even if he didn't feel inclined to schedule another one, this call would bring him a step closer to his own awakening.

So much had taken place during my session with Kathy, and I hoped I had not forgotten anything as I wrote notes down. If I did, perhaps what I forgot was not as important as what I remembered. She and I both felt a lot would change quickly after my upcoming trip to Miraval, but no one knew just how much.

66

TRUTH

Gwen Stefani

The following morning, I checked texts while sitting in my car after Pilates. I had one from Heather, who was dying to know how my session with Kathy went. One from Sadie, letting me know the artwork I ordered for her had arrived. And one from Sofia, which caught me by surprise. I had not had any texts, conversations, phone calls, or interactions of any kind with her since I reached out on Christmas Day.

Her text said, "How are you? Are you feeling better?" Another text followed, "This was for Ali" (which she never calls me). "My phone is messed up. Are you well?"

My chest tightened. Over three months had gone by with basically no communication, and then this text shows up as if we chatted yesterday. I took a deep breath and decided to respond by speaking my truth, regardless of the consequences. What consequences could there possibly be at this point, anyway? I would continue to be ignored and rejected? Check. I would continue to be gaslighted and made to feel less than the other family members? Check. I would no longer have any communication from them? Check. Check.

At one point, Sofia's husband had told Art he had set up a trust fund and alluded Ryan and I were included, although he never said

the words outright, and we never received any paperwork to confirm his implications. Okay, so left out of the will? Who cares! He used money as a means of control, and that did not work on me, even though this tactic seemed to work on all other members of his family. I did not want or need anything at all from him, which took away his ability to control me. I had a feeling this was a huge part of his issue with me and why he, along with Beth, tried to undermine me any time the opportunity presented itself. I could do what others perhaps couldn't or wouldn't do. I could walk away.

From my perspective, I no longer had a relationship with either Sofia or her family at this point. My response was harsh and intended to discourage any further communication. I now knew having her and her family in my life no longer served me. Time had shown me that much.

"I am stronger than ever and can see people/situations more clearly for what they really are. My family and I are doing better than ever. Thank you for asking. Take care," I texted back.

I hoped she would take the hint. I thought I had accomplished what I needed to when I did not receive a response the rest of the day. However, the following morning, I heard from Sofia again. "I am happy to hear that you are all doing well. I am here if you need me. Love you."

I saw red. There is no other way to describe what I felt. She had been anything but "here for me," and to tell me she loved me when she hadn't reached out since before the holidays was beyond hypocritical. Her words were absurd. Her response showed me she did not live in the same reality I lived in. She and her family felt they could reject, insult, gaslight, and toss me aside, and then pick me up whenever they started feeling guilty or simply had the impulse.

I took a moment to center myself and view the situation from an outsider's perspective. Doing so made me realize their treatment of me was on *me*. I had allowed them to behave this way with me. I had

not set clear boundaries early on. I felt they certainly took advantage by making me feel like one of them when they never truly considered me as part of the family. Their actions showed this loud and clear. I had simply chosen not to pay attention. When my parents had just died, the thought of having a family again seemed like a blessing. Well, I would no longer allow her and her family to make me feel the way I was feeling. I went up to my office, sat at my desk, and took several deep breaths. I asked Cassandra (since Sofia gave me that name) and my angels and guides to step in and write the response that Sofia needed to hear from me.

"No, Sofia, you are actually not there at all. I have not heard from you in months. Specifically, since you asked me to contact Matt and I was able to do so. I thought I was doing a wonderful thing for you and instead I was met with silence and then an admonition that you already knew and didn't want to hear what I had to share with you. Your words brought back the day your husband felt the need to hand me a printout and tell me my gifts were evil. From that day forward, I have not had a text from you with anything meaningful. You have not tried to connect in any way. Feel free to look at the thread above. I decided to sit back and see if you or anyone in your family would reach out for once, since I am usually the one that initiates contact and of course, no one has. Like I said, I have a very clear picture of the situation.

"I don't feel you are capable of more. I understand that, but I am in a really good place and wonderful things are happening. I choose at this point not to put myself in a situation where you can once again, for at least the third time since we met, reject me until you feel like reaching back out. Take care of yourself, I truly wish you and your family nothing but the best, but I also need to take care of me and even as I write this, the wonderful mood I was in this morning has dissipated. That confirms to me that hearing from you now does not bring me joy anymore and I choose joy."

I hit send, and when I went to reread my text, I didn't remember writing any of the words.

Sofia texted back almost immediately. "I understand. I never meant to hurt you. I am sorry."

"Thank you," was all I replied.

I wanted to keep spewing all the frustrations that had built up in me in the last few months. To remind her she had said those words to me multiple times, yet her actions were completely contradictory. But I decided to stop the text thread and just end things. The emotional catharsis I desperately needed had taken place. I didn't need to keep pounding on her. I had spoken my truth and released her and her family to their highest and greatest good, as my teachers had taught me to do. I was so grateful for all the teachings and all the healing that had taken place. All the muddy, messy inner work and healing I had been willing to put myself through had led me here, to this point, the most important point of all: I had released myself.

67

MEMORY

Barbra Streisand

As our Peru trip approached, I scheduled a private session with one of the trip leaders, Ina Lukas. I sat in my meditation room to center myself and wrote down my intention for the session in my journal:

To continue to release what needed to be released so I could receive what I was meant to receive in Miraval, Peru, Costa Rica, Sedona, and Europe.

I called at 4:30 p.m. on the dot as instructed, and this beautiful voice greeted me on the other end of the line. Ina sounded warm and happy, and we made an immediate connection. We chatted briefly about our upcoming Peru trip and how magical and powerful it was surely going to be. Then she started asking my intentions, and I shared what I had written down. Ina had a few questions about the autoimmune condition and my wish to have my sight back. I had experienced a few small things but not in the way that I had my sight before the Mexico trip. Then we began.

I asked if I should sit or lie down, and she told me, "I never know where the session will go, so perhaps best to lie down."

I lay down on my sheepskin rug with Angus and Lola on either side of me and covered up with a soft blanket. Ina began by saying, "Take deep breaths to soften and relax your body." She started

speaking in light language. Light language, according to jamyeprice. com, is "multidimensional language that is understood by all on a soul level. Light language adjusts to the resonance of each person's vibrational needs in the moment: initiating, clearing, balancing, activating, and aligning a new vibration of well-being. Light language is a powerful healing tool for lightworkers on a path of ascension and empowerment ... and speaks directly to your DNA, activating and recoding your personal vibrational signature as your higher self activates the Light language."

"What is coming up for you as you breathe, dear one?"

"Nothing yet," I replied. Then I felt pressure, like fingers touching my stomach.

"Breathe into the physical symptoms of your body's reactions which are causing your bloating, diarrhea. What is coming up for you as you breathe there, dear one? Start connecting into your older soul. Start summoning in the parts of you that want to come home. Is this coming from little Alejandra in this life or from a past life?"

"I feel this is coming from this life. I feel like this is little Alejandra." As I connected with my inner child, the word five came up, as in five years of age.

Ina said, "Connect into the consciousness of five-year-old Alejandra. What is she doing?"

"All I see is an old photograph. She is smiling," I said. "I remember working on this before, but maybe I didn't clear all the way, so that's why she is coming up again." I went on to share the story of my grandfather dropping dead of a heart attack and the effect his death had on my mother. The black balloon in my stomach showed up again. I had worked with a healer at Miraval named Brett Baum on my first visit, where a black balloon showed up when we scanned my energetic body. I had subconsciously taken on my mother's grief over her father's death. I was five when he died. As an empath, I had absorbed all her sorrow.

"This feels like there is a deeper fear, terror there, beyond your mother's grief," Ina said.

"I think the fear actually goes back to the adoption then," I said. Perhaps my grandfather's death triggered the fear of abandonment that was buried so deep in my subconscious.

Ina had me connect to three-day-old Alejandra (still Cassandra, at that point) and summon in her consciousness where she was alone. I had to breathe into the void of being taken away from a biological mother and handed between people until adoptive parents came for me. She was moved a lot and through a lot of hands with no safe place to land. She then had me pick up three-day-old Cassandra, hold her close, and let her know her parents were on their way. I started crying and felt such sadness for her. I needed to let my body feel the sadness of the moment I didn't understand as a newborn. I could now feel the emotion and move on to heal.

68

DESERT WOMAN

The Vandals

As I checked in to my happy place, Miraval, for another visit with Sadie, I was told the session I had booked with the astrologer was canceled. *Hmmm, strange.*

I asked if he had another time available during my stay. He did, but they needed my birth time in order to book me. For the life of me, I could not remember my exact birth time. I asked if they could look it up, as I had already given them the information over the phone when I first made the appointment.

They couldn't locate the information, either, and it was mandatory for the session to be successful. They suggested I work with Alexandra Nicol instead. I asked what she did, as I was not familiar with her work.

"She is a world-renowned psychic," the lady behind the desk said. I told them I was not interested, as I already had a personal session booked with Kristin. I set off to get settled in my room, certain the right healer would eventually pop up for that time slot.

Sadie and I woke up to a cold, rainy morning. The desert hike was out, and we opted for morning meditation. During the silent portion of the forty-five-minute meditation, there was a word loop going off in my head. "Alexandra, Alexandra, Alexandra." Sadie and I

chatted about this over steaming hot coffee and delicious scrambled eggs with avocado toast.

"I think I need to go to the front desk and see if I can get in with her," I said. Alexandra Nicol obviously had a message for me. As I always tried to do when I felt guided, I listened.

I went to the front desk and gave them the time frame I had open, and yes, there had been a cancellation, and I could get in. I smiled, as this was the way things worked for me at Miraval. I couldn't wait to see what would be unearthed during my session.

There was no more time to think about that at the moment, as I was off to the main event of the day, my private session with Tejpal. I sat down, and she asked in her heavy French accent, "Why are you here?"

I said, "I am open and ready to receive whatever information the Universe feels I am ready for."

"Okay, let us begin," she said as we sat cross-legged on chairs across from each other. She began to channel and told me, "You are a dancer and have been in many of your lifetimes. Dancing is the way you connect to everything."

That made perfect sense to me. I always got chills and started crying at every musical or live performance I attended. I had never been able to explain why I felt such overwhelming emotions when I was in a theater.

Tejpal went on to say, "You need to bring dance back as a daily practice. Your meditation should not strictly be stillness practice, but one of movement. This can include any type of yoga, Pilates, Qigong, etc. You have been a dancing goddess who performed many rituals. Your most powerful time is the transition from night to day. You are very in tune with nature and that is and will be where your power comes from. You will be leading and helping people connect with nature. You will be holding retreats. You connect more to nature because you are not from this planet, and this is why you find connecting with

humans more difficult. However, the experiences you have help you empathize with the human condition."

I have always felt a difficulty in connecting with other people, so her comment made me think.

"You need to give yourself permission to fall apart, as you feel the need to be perfect." *Ugh.* That word, "perfect." She was right. Yes, I did. I was raised that way and continued to hold myself to very high standards.

Falling apart and giving myself permission to do so continued to come up through the session, and I started to become a bit concerned. I asked, "What has to happen for me to fall apart?" The thought petrified me. My mind wandered into all sorts of terrible scenarios.

Tejpal responded, "What if nothing has to happen? You only have to surrender completely." She said, "You are very, very strong, and when you decide to do something, it is done. What this also means is you don't give yourself permission not to do something or again, fall apart. You have to realize how much fragility is in you as well."

She asked me to connect to my spine. I told her my two fusions made that difficult. She had me move over to her massage table and lie down. She asked me, "What is your grandmother's name on your mother's side?"

She looked confused when I answered, "Mercedes." Then I remembered and said, "What about Jean?"

She said, "Yes, that is who is here."

Jean liked to show up a lot lately! Her message was for me to write a book.

Tejpal and I had not discussed the possibility of a book at all. I brought her up to speed and said, "I am giving the book my all. I am putting words on paper and moving forward as best I know how."

She asked me what the title was. I told her I had a couple of working titles. She was insistent and again said, "What is the title of the book?"

I told her, "I love *I Just Can't Make This Shit Up.*" She said Jean smiled and acknowledged that was the right title for my book.

The other option, *How I Healed From the Inside*, went back to the yellow sticky note, and Tejpal said, "No, the first one is the title, the second one is the theme. The first title connects with everyone." I had felt the same connection from the beginning. Those were the words I actually used every time I had an experience, so the title felt authentic.

Tejpal told me, "You will be teaching, which means you will be getting the book's message out. You have information to share. You have to remember you are here to help humanity move forward. Do not allow people to be groupies or consider you a 'guru.' The bright white light you have over your head is very, very strong and is a good thing."

A thought occurred to me. The autoimmune disease I was diagnosed with had a lot to do with shit, literally. I was releasing all that no longer served my physical body (food that was toxic for me) in order to heal, in much the same way I was releasing subconscious trauma and people who no longer served me in order to mentally, spiritually, and energetically heal at a soul level. I was pretty certain this was no coincidence. I had to continue excavating and healing before the book could be birthed.

I thanked Tejpal for all her insights and headed straight for the Bird Ramada to write everything down. When I was done writing, I went to my room, changed outfits, and headed out to meet Sadie for dinner, where we caught up with each other on the day's sessions and insights. She had worked with a beekeeper that day, and the session sounded so unique and cool. I made a mental note to add it to my itinerary on a future trip.

When I woke up the next morning, I decided to give myself the gift of a slow morning. I walked over to the restaurant and had breakfast by myself before heading back to my favorite spot, the Bird Ramada, to write. The sun's warmth was on my face, and a cool breeze blew

around me. The temperature was about fifty-seven degrees, much warmer than the last few mornings. I had a steaming cup of coffee in my hands, and I could hear the water from the stream that ran through the property as I looked out onto the mountain range. People walked by. This felt more sacred to me than any church ever had. I felt at home, content to just sit, be, and write.

My first appointment was with the psychic Alexandra Nicol. She met me in the lobby, and I could hear her Scottish accent as soon as she said hello. I liked her immediately.

The moment we sat down in her office, she asked me, "Who is Joseph?"

"My dad," I replied.

She told me, "He and your mother are present." We had just met, and I had not said anything, especially that my parents were deceased.

My mom's message to me was, "Do not lose track of who you are and where you are going. You are on your path to fulfillment. Please know I am proud of you." She showed Alexandra she was rocking my daughter Catherine in her arms.

Alexandra then saw lots of flowers and asked, "Is a big celebration coming up?"

"Yes," I told her. "Our thirtieth wedding anniversary is a few months away."

She had me pull oracle cards. One card had a photo of a woman with a white beam over her head, just like many of my own photographs did. She said, "You have many people surrounding you at all times." Alexandra then asked, "Do you have a living son?" When I said yes, she said, "I see him playing with a stick he is holding out to his side, but the stick is not a golf club." She was confused. I laughed and told her what she saw was a lacrosse stick. She said, "Ryan is in love and will be very successful in his own right. He has the gifts and has time to use them."

Alexandra told me, "You have two people very close to you with *M*'s in their names, and you carry them around on you daily." These were Margarita (my mother) and Mercedes (my grandmother). I realized I did have two *M*'s I carried around with me daily, in another form, as well. I showed her my palms, which each had an *M* on them. She actually looked a bit taken aback by that.

Her next question was, "Who is the male who died in the car accident?" I told her that was my high school boyfriend. He asked for forgiveness and blew me a kiss. She asked what name he called me because he was not saying Alejandra. She was right; he called me "Ale."

"Who is the male who died from drugs and alcohol?" was her next question.

"That would be my ex-brother-in-law, Timothy." He was the one who showed up in my closet.

Alexandra explained, "He is at peace but not happy. You need to pray for him, and that will help him move on with his transition."

Dad (Brady) made an appearance. He was the one sending the dimes Art and I kept finding. To be clear, he never gave us dimes when he was alive. This started after he passed and I was able to communicate with him, so we understood who they came from. He wanted me to tell Art he loves him. Mother Mary was with Art, too. That was amazing to hear but not entirely surprising. Art's dad was as devoted as my father to the Virgin Mary. He had given us all books to read about Our Lady of Fatima a few years before his death.

She asked if my husband had bought a new car; she was getting information about a car from Art's father. I burst into laughter. "Yes, Art has his father's beloved BMW, and the convertible is now his baby." Art takes incredible care of that car, as it serves as a special connection to his father for him.

Alexandra said, "You need to use and open your gifts more. You have the ability and gift of reading people, and now I want you to read me."

As you can imagine, I was suddenly self-conscious about being asked to read a world-renowned psychic. I told her what I had told Kristin when she asked me to do a reading, which was, "I will do my best."

Alexandra explained how to do a reading step by step, and I followed her instructions. The first step was to ask for protection, so I did not take on anything from the other person. Then I was to close my eyes and take a deep breath. Focus on my pineal gland (third eye) and take the focus up to the crown of my head and down the back of my spine. I was to take another deep breath and trust what I saw. I did as I was told, and I saw a sun setting over the ocean, which made no sense since we were in the middle of the desert. I told her, "I'm sorry. I guess I need to practice more."

She showed me the goose bumps on her arms and said, "I don't have any vices. The sunset over the ocean is my only hook. My husband and I are headed out to San Diego next week so that I can sit and look at sunsets for five days in a row." Woah, now I was covered in goose bumps, too!

She laughed and asked if I wanted to switch seats and give her a full reading! I accepted the compliment graciously, but of course, we were almost out of time at this point. We talked a bit more about what to do and not do in a reading and how to help people with this gift. She said a wonderful way to end a session and not take on anyone else's stuff was to say, "Blessings. I leave that with you for now."

As we wrapped up, she reached into her bag and was talking but not to me. "Oh, okay, so not the quartz heart? The elephant? Okay." She pulled out a little soapstone elephant and presented it to me. I was to read about the elephant as a spirit animal. I had been to the gift shop before my session and had a cute elephant tank top wrapped up in the bag sitting next to me. Obviously, Elephant was working hard to get my attention! Later, when I took her advice and looked up this animal, I saw that the elephant brought good fortune.

She asked if I had any questions. I had one. I wanted more clarity on the visitation from the Celtic warrior the previous year. Alexandra was from Scotland, so I hoped perhaps there might be a connection there. I told her about the visitation and the digital "608" on his forehead.

She added up the numbers, which totaled five. Today was the fifth of March, and I was working with someone from Scotland, and somehow that felt like a connection to me. She brought up that I needed to take action. "On what?" I asked.

"Your brilliant idea, the book," she said.

We had not discussed the fact that I was attempting to write a book. My guides were nothing if not consistent!

We said our goodbyes, and I went to my room to process and write down notes before my floating meditation class. This was a class I had been afraid to try because of my cervical fusion. I was ready to release that fear and give the class a go. As I sat on the patio, writing, a hummingbird flew up less than three feet away from my chair and looked directly at me. A few minutes later, about thirty quail flew into the tree with limbs that stretched onto my private patio. I could feel a lot of animal Spirit Guides around.

After meditation on our last morning, I had my final private session for this trip with Mother Emilia. I had had three private sessions with her the first time we met, as there was so much healing work to be done due to the adoption. She asked how my relationship with my birth mother was going and said my laugh gave her all the information she needed.

She started with Reiki energy healing and received messages from God as she worked. The message to me was, "You were not rejected. You were loved. Sofia gave you life, and now is the time for you to move on. You need to send her love but you do not need to have the negativity from her and her family in your life any longer."

Mother Emilia made me repeat these words: "I am happy. I am healthy. I am wealthy." She worked on my stomach and intestines for

the majority of the session. She cleared the anger she said I was holding in them. Then she took my upper body in her arms and rocked me like an infant and again repeated I was loved.

After the session, I went back to my room to finish packing. I was able to spend a few moments on the patio, processing what I had just experienced. As I sat there in stillness, I felt overwhelming gratitude as I realized my body, soul, and mind felt balanced and perfectly at ease. I had not felt that way in as long as I could honestly remember. I felt whole.

69

I MELT WITH YOU

Modern English

March 16, 2020, happened to be Ryan's twenty-fifth birthday. There had been news stories about COVID-19 for weeks, but in my wildest imagination, I could not fathom the pandemic, which basically shut down the planet. Our Peru retreat leaders assured us the trip was still on, and Ina actually left for Peru with her two kids a week before we, as participants, were scheduled to arrive. Our Tampa crew was starting to question if we should cancel. Fear was creeping in at all levels. We had a WhatsApp Peru chat going, and I was still brazen at that point. I even typed in something to the effect that I would not miss this retreat unless the government kept me out of the country. Well, of course, we all know what came next. The Peruvian government, along with many other countries, closed their borders and didn't allow any international flights into their country. Game over.

The way our entire world operated changed overnight. The United States basically shut down, and everyone was told to quarantine at home. I ran out to the grocery store amid rumors of a toilet paper shortage, only to find shelves actually bare. Seeing those bare shelves was the strangest feeling. We didn't really need any toilet paper or paper towels, as I always keep the house stocked, but the fact that

I could not purchase any was quite unsettling. I have never lived in a place or time where things I needed were suddenly unavailable to me. This was a surreal experience. In addition to the water bottle aisles being empty, the aisles with rice/beans/soups were also empty. Same thing in the produce, dairy, and meat aisles as I drove from Whole Foods to Target and finally to Publix, only to come home empty-handed.

I had left to run errands in a calm state of mind, but after being in the stores and feeling other people's fear energy, fear crept into me as well. Living in Florida for as long as we had, we were pretty used to hurricane prep, but this was a different feeling, and it unnerved me. Art called me as I drove home to let me know he was coming home indefinitely. His office building downtown had just closed down.

I sat around, trying to comprehend how much was suddenly out of my control. I thought back to my session with Tejpal and the lesson I was told I needed to learn about falling apart and surrendering. Well, hello! I had meticulously planned out the upcoming three months of my life to the very last detail, and all my hard work was about to be undone. I had the spiritual retreat to Machu Picchu, Easter in Sedona, Sadie's fiftieth birthday girls' trip to Costa Rica, and finally, our three-week thirtieth anniversary trip and cruise to Europe. I stepped back, took a deep breath, and stopped the negative spiral I was headed headfirst into.

I became the observer of my thoughts and refocused my attention on something positive. I was able to get my hair done the day before my hairdresser closed down, so I decided that was a win. Then I started hearing from friends. Many were having to cancel weddings, high school and college graduations, and sports seasons. That shook me out of my "pity party" attitude almost immediately.

Art and I took the dogs for a long walk through our neighborhood that evening. I tried hard to focus on what was around me. We saw a hawk, a butterfly, and a dragonfly on our way to the dog park. We

talked about how we were going to handle the uncertainty of the situation. We decided on one day at a time.

I woke up the following morning and chose to be productive. After meditating, I pulled the Earth School card from my Starseed oracle deck. The interpretation for this card read, "If you pulled this card while you're going through a difficult time, you're being prompted to remember that you came here to grow and learn. Try not to look at difficult times as 'getting it wrong,' and instead see them as opportunities for soul growth. If you can find a way to soften your heart through the highs and lows, your soul is most definitely growing, which is the whole point!"

70

I STILL HAVEN'T FOUND
WHAT I'M LOOKING FOR

U2

I spent my early days of quarantine meditating, doing yoga, cooking, gardening, and making smudge sticks.

Every crystal I could carry got cleared under running water then set out in the sun to recharge. That felt great. Thankfully, Tampa was having a stretch of perfect weather.

Art and I slowly got used to all the "togetherness." He operated out of his home office while I worked on what I could. I normally spent my time in people's homes or out shopping for them, all of which I was unable to do at the moment. My clients canceled upcoming appointments as expected, so I chose to concentrate on self-improvement.

I also spent an enormous amount of time unraveling all the trips. Even though airlines had canceled flights, speaking to a representative in order to obtain a refund was impossible. Our flight to London on April 28 was canceled, but the cruise line had not canceled, so again, nothing could be resolved. The time had come, as Tejpal had said, to surrender and be patient. But surrendering was a concept I found much easier to say than do.

I did my best to find things that made me happy each day. The "thing" could be simple, like listening to the birds as soon as I woke

290

up, or more involved, like the day I did the Spring Equinox activation with Ina Lukas and Janet Raftis (our retreat leaders) in my meditation room. An activation is meant to be a deep healing session where each participant calls in their own Spirit Guides for removal of negative or toxic energy and to invite in deep healing and growth. Our teachers merely serve as support. I was supposed to be doing the activation in person with them in Peru, but at least we found a way to honor the day.

I also decided to be of service each day, or at least as often as I could. I would post "how to's" and feng shui information on Instagram. I wrote scripts for sixteen Instagram videos. I decided this was the best way for me to help as many people as I could at this time. The videos were each a few minutes long and meant to teach people how to make small feng shui changes in their homes during quarantine. Being of service helped shift me from a "look at what I lost" to a "how can I be helpful to someone today" mentality, and that shift made life much easier.

I did Melanie Beckler's Equinox activation. During the activation, she said to pay attention to the dreams we had, especially in the days following such big lightwork. On March 25th, I woke up from a dream in which I was working with Gwyneth Paltrow at Goop. I listened to the Goop podcast all the time and used several of their products. So I wrote about the dream in my journal, printed out a picture of the Goop logo, and tacked the printout to the career area of my vision board. I would certainly love to manifest that dream!

I was doing my best to follow the guidance I asked for and was given, but I still found the task of writing the book incredibly difficult. Sometimes I found myself guided while I was in my garden, where I went when I needed to ground and connect to Mother Earth. When I was angry, I pulled weeds or chopped back plants. When I was happy, I watered and planted flowers. I was cutting back knock out roses one afternoon before sitting down to write, and I "heard" I

needed to come back and elaborate on a part of the story where I had written that Sofia and I did not speak for six months. I guess I needed to see on paper how upset and unwanted she really made me feel. I needed to sit with the pain a bit longer before moving on. This would help me take a step toward true forgiveness.

On this day, I watched one of Melanie Beckler's Ask Angels videos where you picked a number corresponding to a deck of cards, and she did an angel reading. I picked the number three. Of course, a feather popped up in that reading, and Melanie went on to say the message was for writers: "It's time to write!" Just can't make this shit up, people! I was taking an Epsom salt bath at the time, and Art walked into the bathroom to check on me because I laughed so hard he thought I was on the phone. The reading also said to believe in myself and the time was now to do what I was here to do, so I recommitted myself to my writing.

On March 27, I woke up in much better spirits. The fog of self-pity was gone, and now I just felt grateful to have a beautiful, comfortable home to be in during this uncertain time and a spouse who could support me while I was unable to work. I went into my meditation room and after meditating, decided to do a five-card spread from my now beloved Starseed oracle deck.

I sat cross-legged on the floor, placed my Himalayan singing bowls on the ground next to me, played them for a bit, and worked with the oracle cards.

I found such peace and clarity following my energy work that I immediately moved over to the couch, tucked fluffy pillows behind me for support, laid my yummy cashmere throw blanket over my thighs and got my thoughts down on paper. After writing for a while, I decided to perform a feng shui ritual to help us detach from our home and, with that done, attract the right buyers in Divine timing. I set a specific intention of attracting the perfect buyers at the perfect time and went outside to sprinkle chili powder from the street up

into our property and through our front door. This ritual is a cure to invite positive energy into your home. The cure also works well as a way to attract new business since the Career Gua usually lines up with the front door.

DOES ANYBODY REALLY KNOW
WHAT TIME IT IS?

Chicago

By April 1, we had quarantined a little over two weeks. We had followed all the rules and had gone out only for essentials. Every closet and drawer in the house had been reorganized. The pantry had been rearranged at least twice. Feng shui cures were fine-tuned. Ribbons, wrapping paper, and tissue paper were all now organized by color. Our home was on the market, but we could not have showings, so I was not able to move forward with packing or searching for a new home. I was running out of house projects and looking forward to the two-week quarantine being done.

I was in the kitchen making my gluten- and dairy-free meatballs when President Trump came on to give his daily briefing. We were now all to stay home until at least the end of April. *Wow.* I had hoped life would start normalizing around Easter and had held out a little hope Art and I could drive to South Carolina to spend the holiday with Ryan since he and Lydia were quarantining there. Originally, we were all planning to spend Easter in Sedona.

Ryan and Hannah had parted ways right after Thanksgiving. He and Lydia had recently rekindled a friendship and relationship that had started six years before, during their time at Washington and Lee University. We had not met her yet and were so excited to do so.

There went that. Of course, I completely understood, but the news was disappointing, nonetheless. Art was able to work from home, as many were, so his day was still pretty structured and "normal," filled with Zoom meetings and Peloton workouts. I turned on my phone and opened the calendar app on my iPad. There was literally nothing on the calendar for the entire month. When had that ever happened before? My life had been quite scheduled since I was a child, and now I had nothing to do and nowhere to go.

So the question was, what would I do with this gift of time I had just been given? I didn't have children at home as so many did, so my days were my own. I hadn't chosen this, but I was determined to use my downtime wisely. As my Starseed oracle deck cards kept showing me, I needed to birth what needed to be birthed. For me, that was my book. The next step was to create a reasonable schedule but also allow myself the flexibility of tossing the schedule out the door if I woke up and decided I wanted to do different activities that day. I needed to surrender and allow my intuition to lead me through my day.

My general structure starting April 1 would be as follows:

- Coffee and a half-hour of whatever Bravo show I had on DVR
- Meditation
- Walk dogs / hug a tree / yoga
- Check emails / pay bills / office stuff
- Lunch
- Write all afternoon
- Make dinner
- Eat clean
- Time with Art

How April 1 actually went:

- Coffee and two Bravo shows
- Walked dogs / hugged a tree

- Meditation
- Whole Foods
- Lunch and watched an episode of *Little Fires Everywhere*
- Took an orchid to a new neighbor (after wiping the pot down with disinfectant wipes, of course, and standing six feet from the front door)
- Tried out three new recipes from the *Medical Medium* cookbook, plus made my go-to Mexican rice and the dog's food
- Diet Coke & potato chips
- Binge-watched *Tiger King* with Art

So, my first day went slightly different than what I had planned, and guess what? I felt no guilt whatsoever! My soul was calling me to cook. I listened, followed my intuition, and cooked my little heart out!

The following morning was another picture-perfect day. I opened every window and door in the house. Opening windows and doors is a wonderful way to release stagnant energy and invite fresh chi into your home. This enhancement is one of my go-to feng shui cures. I was well aware we were incredibly fortunate to be able to quarantine where we could be outdoors and commune with nature daily. I heard the awful stories of frustration from friends across the country who were stuck in small city apartments or in feet of snow. Just having the ability to go outside was enough to feel an overwhelming sense of gratitude. I pretty much kept my schedule on April 2, and as I wrote on my patio, the birds chirped, the dogs barked at squirrels, and I could hear the fountain gurgling behind me.

On my morning walk, I came across a baby opossum. He hissed at the dogs. I didn't see a mother nearby. I said a little prayer in hopes that by the time we walked back, his mother would have found him. He definitely came as a spirit animal to me, as I had not seen one before on my walks. When I got home, I looked up the opossum's spiritual meaning. An opossum's gift to us, according to Ted Andrews, is

that "it can teach us how to adjust our behaviors and appearances for the greatest benefit. Opossum teaches us how to use appearances."

The next animal we encountered was a red-headed woodpecker. I had seen them before, but there were three this time. The woodpecker's message to us, according to *Animal Speak*, "indicates that the foundation is there. It is now safe to follow your own rhythms." That seemed to be a recurring theme. I was ready. I needed to trust myself and be who I really was. IT WAS TIME.

Now that I was serious about completing the book, I had to take logistical factors into consideration. I reached out to my Aunt Kay to ask permission to use her story since hers was directly linked with mine. She responded that I could and asked about the deterioration of my relationship with Sofia. I told her everything, including that I had been able to see people and receive messages from people who had passed since I was a teenager. Kay and her family were also Evangelical Christians, so I knew by sharing this information and speaking my truth, I was once again choosing to put myself in a vulnerable position. But, as the messages from the animals on my walk reflected, I was ready and could now beat to my own drum.

To my happy surprise, Kay was supportive. So interesting how situations sometimes play out, isn't it? The person I expected to be supportive, Sofia, wasn't, and the person I originally thought might be even more judgmental, was instead supportive! I guess my lesson here was to give people a chance to speak for themselves. As before, I had certain assumptions of how I thought each would react, and wouldn't you know it, I was wrong both times!

72

FEELINGS

Morris Albert

The beginning of the fourth week of quarantine was immediately followed by a full moon, which meant the next three days would bring heightened emotions, activity, and energy. I woke up in a shitty mood. I tried, honestly I did, but I did not walk, do yoga, or even get out of my pajamas until 4:30 in the afternoon. I felt guilty for not accomplishing anything meaningful, and then I remembered I had promised to listen to my intuition and my gut, and to respect myself and what I was feeling at the moment. I realized this was also a time of just being, not doing. The world had basically come to a halt, and I was being asked to do the same. I had time in spades at the moment to just BE. To let whatever I felt rise up, be there, then lovingly work itself out of me. Again, this process was so much easier said than done, and I struggled the entire day.

I had attempted, with little success, to continue to unravel our trips, which certainly did not help my mood. The cruise line had still not canceled our cruise, set to embark in Lisbon, Portugal, on May 1st. There were seven ports of call in Spain, and we were to disembark in Barcelona. Of course, Spain was on total lockdown, so we would not be disembarking anywhere. If I canceled, I would not be eligible for a refund, only a future cruise credit, and that was not what I

wanted. After over an hour online and on the phone, nothing was accomplished. Next up was the airline. They had canceled our flight from JFK to London, and the website said I was eligible for a refund, but I had to call a certain number. So I called. The message said they were sorry, but they had so many callers they could not answer. Please call back at another time. *Ugh …*

On to American Express. We had one segment on a different airline from London to Lisbon. I explained that since the flight to London had been canceled and the chances of the cruise happening were next to zero, I needed to cancel this segment and request a refund. I was informed this airline had suspended all refunds, and I had to book and *fly* by July 4 of 2020 to not lose my two business class tickets. Most borders were not even going to be open by then, which meant that was obviously not a viable option.

After two hours of phone calls and online work, I had made absolutely no progress. I decided to veg in front of the television until our scheduled FaceTime with Ryan and Lydia. This was the first time we would "meet" her since our Easter trip to Sedona was canceled. Art made me a dirty martini and poured himself a beer from his outdoor keg as I set up my iPad on our coffee table in front of the sofa and waited for their call. We were on the call for almost two hours and had so much fun catching up with Ryan and finally getting to see and talk with Lydia.

The following day, I woke up in exactly the opposite mood. Full moon energy brought out the best and worst, that was for sure! I had a great night of sleep and woke up ready to take on the day. I again chose to respect what I was feeling. I walked the dogs, hugged a tree, practiced yoga, and took a salt bath. I planned on writing all afternoon and doing a full moon ceremony later that evening.

To set up for the ceremony, I created an altar on the patio just as the moon was rising. A light breeze was blowing. My altar included fresh flowers, crystals, candles, water to be charged by the

moon, the Starseed oracle card deck, and one of my Tibetan singing bowls.

I focused on the areas of my life I wanted to transform. My intention was to amplify success and abundance in my life. I didn't want to print out a picture of a specific house or a specific area because I wanted to leave room for the Universe to guide me and to bring me what was supposed to come to me. Who knew—I could be thinking too small. My teacher Karen Rauch Carter said, "People always tend to think too small," so I was going to leave wiggle room and focus on the perfect next home for us. Part of this was also to bring the right buyers for our house, as we needed to sell our home in order to make the move smoother both financially and physically. I also needed the right people to come into my life to guide me in the book creation process. I had no idea how to get from putting my thoughts down on paper to having a book for sale on Amazon.

I performed an opening invocation and did a full moon meditation. I had such a feeling of peace and release when I finished. Next, I wrote down all the things I felt were holding me back from creating the future I envisioned. Then I tore up the papers, put them in a glass, fireproof bowl, lit a match, and watched them burn! I surrendered and allowed everything holding me back to go up to the Divine.

Once the release took place, I wrote down all the things I was grateful for at this moment. I was grateful for my family, Ryan's happiness, our health, my brains, beauty, my strong body, our current home that served as a haven during quarantine, our dogs, our friends, the fact that our finances had not been as greatly impacted as they had for many others at the present moment, the ability to take time to do this ritual, the ability to co-create with the Universe, the moon, our Sedona home, the beautiful night, the people who will buy our home, and the people whose home we will buy.

I pulled out my oracle cards and asked, "What additional messages are my team in Spirit trying to convey to me now?" The answer

came through in the Earth Pulsing card. Slow down and spend time in Nature. Rest. Take care of the body. I felt the overall message was one of release and surrender since the next card I selected was the Void card, which spoke of surrendering to the unknown. There was nothing more on point than that card since we truly didn't know what would happen with this pandemic from one day to the next. We didn't know if we had jobs, when we could travel, when we would feel safe … all we could do was rest and have faith that the Universe was working on our behalf.

I chose to begin to check my daily habits and adjust as needed. I chose to start my days with intention and meditation before I allowed the outside world in so I was fully prepared to deal with whatever challenges arose. I closed out the ceremony and basked in the moonlight for a few extra minutes. I had been outside for around an hour and a half and knew Art was inside watching television, waiting for me. I went in and asked if he wanted to make love to a witch. He looked a little surprised, as I had never used that word to describe myself, but he didn't say no!

A WILD BEING FROM BIRTH

Lou Reed

had some good days and some very bad days. Honestly, I was finding being productive a difficult task as quarantine dragged on. I had been sliding back into doing meditation later in the day. I knew I needed to meditate before I dealt with the rest of the world so that I was spiritually equipped to do so. I had been told this many times, but as always, old habits proved hard to break, and the endless days made sticking to a schedule difficult. I was getting lazy about writing, as well. I knew messages needed to come out, to be said, but since I didn't know exactly what they were or how to get them out of me … I once again procrastinated. I wanted to reconnect with all the ancient wisdom inside of me so I could be of service and fulfill what I was here to do, but I still struggled to figure out how.

I joined an online group our Peru teachers created. I chose to do the Stabilizing the Pillars activation that Ina and Janet did on 4-4-4 (April 4, 2020). An activation is a bit different than a meditation. A lot of people did the activation live, but since I lived in Florida, the broadcast would not start until around 10:45 p.m., and that was way too late for me. I created the space for this sacred ceremony by lighting candles and incense, getting comfy on the floor, and popping on my earbuds, which was how Ina recommended we listen to

the activations. I felt so much energy flow through my body over and over again. At one point, I saw the world as if I were in space, looking at a small ball in front of me, and then saw myself as part of a grid of light with my arms and legs outstretched, circling the Earth with other lightworkers. By the time the activation was over, I was both energized and exhausted, as if I had done a hard cardio workout.

Ina and Janet's activation focused on teaching us that our knowledge is already within us. We created the façade, which we felt brought us safety, but the façade was false. We were now to slough that away and let who we really were shine through. We didn't need to be afraid anymore or worry about what the outside world thought. We, as lightworkers, were here to help create the New Earth, and we would do so by birthing something of value into this new reality.

This made me think of a butterfly. Quarantine is the womb, the chrysalis. The book is already inside me, resting and growing strong enough to come out. In order to give birth, we have to endure birthing pains. Anyone who has had a child knows you don't get a baby without feeling some level of pain. Writing, for me, is the long, very slow and painful part of labor—in other words, the birthing pains. The caterpillar goes through the same struggle to break out of its cocoon. Once the struggle is over, the book, like the butterfly, is free to spread its wings, fly, and create beauty in the world.

The word *birth* came up a lot for me. I used to automatically assume "birth" referred to my actual birth and adoption, but I now felt the word had a much deeper meaning. I felt "birthing" meant allowing myself to co-create with Source, to give life to something that would be of service to all of humanity. This is said with the utmost humility, as the task seemed monumental and not one I consciously asked for. Yet I had done enough work on myself to know this task *was* what I asked for. This task of birthing something into creation to help humanity was what I was here to do.

I took an Epsom salt bath after the activation, as Ina and Janet recommended, then I sat and wrote down my thoughts. In this quiet space, Angus jumped up onto the dining room table and started barking. I looked out the window and saw the Amazon courier dropping off a package containing our face masks. Our current reality was a new Earth, indeed.

The following Sunday morning, I woke up in tears. I had received a text from Beth the day before. I had not heard from her in almost five months, except for her response of "thank you very much" to a birthday text I sent in early January. I had hoped when I told Sofia that hearing from her and her family no longer brought me joy that the message would be shared with everybody. I knew for a fact, since I had seen the texts firsthand multiple times, that she and Beth texted nonstop all day, every day. There was no way Sofia had not shared and discussed our last interaction with her family.

Beth's text read: "Hi there! I just saw a few of your videos. Love them!!! You look great!"

Honestly, the text shook me and gave me a pit in my stomach all over again. I was raised to be polite and to respond to people, but every instinct in my body told me not to respond. I could see (through Instagram analytics) that she was looking at everything I posted. My guess was that curiosity got the best of her, and she wanted to know what I was up to. I also assumed they were scared shitless of what I would write in this book. I had just mentioned writing the book again on Instagram, and although I never spoke directly about it with any of them, I am certain she knew. They knew I had emails and evidence like the sheet of paper Sofia's husband had printed out, calling my gifts evil, which proved everything I said was true.

I chose not to respond, and that was probably a part of why I was upset. Art was amazing. Instead of some clever response, he just let me cry on his shoulder and set about trying to make me feel better. We decided we needed to leave the house. We had been in quarantine

for six full weeks, and I was positive this was also a huge factor in my sudden meltdown. We packed up the dogs in the Jeep and headed to Armature Works, a new and very cool indoor/outdoor mixed-use building that used to be an armory. Armature Works itself was closed, but you could park and walk along Tampa's riverwalk. Since the beaches were all closed, the Tampa River was the largest body of water we could get to. The walk did wonders, and I went home in a much better mood. We had a FaceTime call with Ryan and Lydia, and they shared the news they were moving in together!

After the text from Beth and subsequent cry-fest, I did a salt burn and smudged myself with one of the sage sticks I had made. I meditated and practiced yoga. We once again opened all the windows and doors and let the house get filled with fresh spring air. I swear I could feel both my and the house's vibration elevate. The last thing I did was the traditional feng shui cure of moving twenty-seven things around to shift energy. This is a simple yet powerful cure. You set an intention of inviting in vibrant, fresh energy, and then you set about moving twenty-seven things in your home. I liked to do this quarterly.

Within an hour of doing all the energy work, my manicurist texted me and asked if I would like her to come over. Yes, a thousand times yes! My spinal fusions made giving myself a pedicure almost impossible. She came over and worked on me (both of us wore our masks) outside with the birds singing and the butterflies fluttering around. I could not have asked for a nicer day. I felt such gratitude.

Then, we received a house showing request. Funny enough, I felt the fear creep in again. The house was on the market, and I wanted to move, but I felt the old stories starting to replay. If this house sold, would we have the money to buy a house I really wanted? And why did I really want a new home? To impress friends and family or because the new house would serve me? Were we being smart to sell right now when our world was so volatile? Our house was affordable since we had lived there for twenty-five years. We would be jumping

into a much bigger financial commitment again. Prices had drastically changed since the last time we bought a house, so to get what we already had in the area where I wanted to live would be at least twice as expensive. Should I take a leap the way I did with Sedona? Ugh ... here came the pit again.

I had pulled a card from my Starseed deck the day before that said, "trust the timing." I shared that with Ryan and Lydia, who were also stressing about their apartment, but perhaps the message was meant for me as well. That was a constant battle for me to rein myself in from negative thought processes and to realign myself.

STUCK IN THE MIDDLE WITH YOU

Stealers Wheel

The start of our eighth week of quarantine, stores were slowly re-opening and restaurants were allowing people to dine in at 25 percent capacity. However, leaving the house now felt strange. I could barely get out of bed. I didn't want to. I didn't see the point. I had had another Sunday morning meltdown. I was having a decent weekend and doing what I felt was important: daily meditation and exercise of some form. I didn't know why the weekends were harder, but they were. Sundays seemed to be the day I broke down. I had woken up crying again, for seemingly no reason. As we got ready to go on an outdoor bike ride, the tears kept coming.

I tried to dig deep and sit with the feeling as the tears rolled down my face. What was this?

We were supposed to embark on our cruise on May 1, and I had the itinerary memorized. We were scheduled to tour an island off the coast of Portugal. We should have been on our amazing thirtieth-anniversary cruise, not stuck here with absolutely nothing to do again. The walls of my beautiful home started to cave in on me. I allowed my thoughts to spiral, and all the frustrations at all the things I was supposed to be doing and could be doing and was not able to do came to a head. So that was it! What I was feeling was frustration, lack,

stuck. That's what this was. *I felt stuck.* I was someone who liked to make progress on a daily basis, and I couldn't. I tried to focus on what I could do, like creating the IGTV videos and writing, but even that had certain limitations.

We went on our bike ride, hoping it would make me feel better. It didn't. I tried to put on a happier face for Art (it wasn't his fault I was acting cray-cray), but I don't think I did a very good job. We came home, and I asked to go for a drive with the dogs. I didn't care where. I tried to find ways to refocus my attention but wasn't successful. I finally gave in to feeling all the feels and binge-watched *The White Princess* while I sipped a Diet Coke and crunched on my favorite Cape Cod waffle potato chips. I encouraged Art repeatedly to go do something on his own since I was being such a wet blanket and was actually craving alone time, but he quietly stayed by my side and hung out. He had been really great at not making me feel bad about going through all my "feels." He seemed to process differently. Perhaps he got all his anxiety out on the Peloton because his mood didn't seem to waver much, and I, on the other hand, was all over the map! I knew accepting I could not always be in a good mood was a sign of growth. I had to be able to ride the waves, but on certain days, the waves were way over my head, and I struggled to stay afloat.

I eventually pulled myself out of bed, had coffee, and watched Bravo. I dragged myself up to my meditation room, meditated, and had a great yoga workout. While I by no means felt blissful, I felt balanced enough to sit and write for a while. I knew I needed to trust in Divine timing and surrender to the Universe. My card pull that morning confirmed what I was thinking. Another card from my Starseed deck, called Breath of The Cosmos—My Will to Thy Will. Micromanaging the Universe.

How perfect was that? As much as I liked to believe I was surrendering, I was really attempting to micromanage. I honestly didn't know how to exist in any other way. I was trying, though. The second

card I pulled was Cracked Open. Yup, that certainly summed up how I felt.

Over time, I had learned to look for signs from my angels and Spirit Guides. Repeating numbers are a big one for me, and I kept seeing the number "914." At least two to three times a day, every day. The spiritual meaning of the number summed up everything I was going through. I needed to be patient (a daily struggle), and I needed to remember that what was happening was happening for my spiritual development. I needed to accept those changes and know they were helping me further along my path. I just needed to feel my "feels" and know the Universe had my back.

I kept writing but had been focusing on transcribing my journals from 2018, and reliving certain events took a lot out of me emotionally. I was also back at work. Sadie had reached out and asked if I would come back, and honestly, doing so did wonders for my mental health. For me, the risks of COVID-19 exposure (I did follow all the safety guidelines) were outweighed by the benefits of feeling a bit more "normal." Having your temperature checked before being seated at a restaurant, and having your servers wait on you with masks and gloves, took a bit of getting used to, but baby steps were still steps, and I was willing to take them to re-enter society at this point.

Art and I continued our outdoor bike rides, and on the last two weekends, we were joined by dear friends. We rode for twenty-five miles and made pit stops at coffee shops. Amazing to think a year ago I didn't know how to ride a bike. I had come a long way from my first ride on Father's Day the year before. To be honest, I never thought I would learn. As a child, when I asked for a bike, my parents said they would buy me one, but I would only be allowed to ride it inside our walled and gated yard. They would not allow me out on the sidewalk or the street.

As an adult, I now get where they were coming from. Laredo was a border city, and their worries came from a place of love for me.

They said they were scared I would be kidnapped and taken across the border to Mexico. If that actually did happen, it would be pretty difficult to track me down. Not being able to do what most kids did surely didn't help my insecurities, but given the rules under which I would be allowed to get a bike, it was me who said no because I was not willing to abide by their conditions.

Then I was in the back brace, and I never really thought about riding again. Fast forward to Father's Day weekend in 2019, when I asked Art what he wanted to do, and he said, "I want to teach you to ride a bike so we can go on rides together."

"Ugh, anything else you would like to do? Anything at all? Seriously, anything?" I responded.

"Nope."

"Okay, I will give riding a try, but you have to promise to be patient with me," I said, and he loaded his two bikes in the Jeep bike rack and set off to find as deserted a trail as possible.

The first ride was not pretty. I lost track of how many times I fell. I had a few scratches on me by the time I was done because I would jump off instead of trying to stop. I also didn't realize I had to lift my butt up when going over rocks and other items in the road, so again, I fell off. Regardless, we "rode" (and I use the term loosely here) for about an hour. We got back into the Jeep and were headed home when he asked if I would go for a ride again.

"Yes, I will, with one condition," I told him. "I want a girl's bike, and I want a pretty one with a basket."

"Whatever you want," he said, laughing, and we stopped at the bike shop on our way home, where I lived out my childhood dream of getting a spearmint-colored bicycle, basket and all!

I was learning to be okay with not knowing what was coming next. I was doing my best to not micromanage (not easy for a Type A Virgo), and I was trying to listen to what my inner voice was saying. I pulled cards from my deck after meditation. My request was guidance

on any/all of the decisions we had in front of us. The first card I pulled said, "Jump In—Andromeda's energy. Adventure. Say yes to change."

The second card was "The Seven Star Sisters—birthing creations. Tapestry of life. Expression." I needed to create, to give birth to something. I had been slowly working on the book for almost two years, but perhaps the card also referred to another home. I had given birth and created all that I could create in both the Tampa and the Sedona homes. I felt the time had come to birth a new space for Art and me to start our next chapter.

Once people started to move about a bit, we received a lot of requests for house showings and soon had an offer on our home. We scheduled the closing for August 14, Art's mother's birthday. We had not found another home that worked for us in Tampa, and somehow, I was not stressed about not having a house to move into. We decided to move to Sedona until we found a house, thinking we would be there through the end of the year.

75

WILD, WILD WEST

The Escape Club

In Sedona, we had been so in the flow that even Art acknowledged we had a "team" looking out for us. We weren't sure how long we would be living out West, but for now, our situation was great! Things just seemed easy. We had work to do at the house, and workers showed up on time and did the job correctly the first time. A far cry from my experience when I was first installing the house.

I was finally able to get an appointment with Anahata Ananda, a Shamangelic healer in Sedona. I had been unsuccessful in getting a private session the last three times I had been in town. This was my time because she had one private session on the one afternoon I had open. Our session was incredible and opened the door to a much higher level of energy work for me.

I arrived at her home and took off my shoes as she welcomed me in. Her beautiful blue eyes were warm, and her smile instantly made me feel at ease. She was wearing a flowing white top and white pants and had the most absolutely gorgeous long blond hair. We sat down in her living room. Anahata asked, "Why are you here, and what do you want to work on?"

I told her, "I am open to all messages my angels and Spirit Guides have for me, which are in my highest and greatest good." My house

situation was first and foremost on my mind, but somehow the con-
versation turned to Sofia and Beth.

I told Anahata there had been no contact since we texted in Febru-
ary. I had chosen not to respond to Beth's "happy anniversary" text on
June 1 because I felt the text had been completely passive-aggressive.
Her text read, "I know you don't want to respond and I respect that.
No need to. Just sending a happy anniversary to you and Art! Take
care!!" There she was, clearly stating she knew I did not want to com-
municate with her, so sending me a text was a way of making herself
look altruistic while making me look misanthropic!

I don't know how Anahata turned me around, but she was able to
get me to see the family dynamic from a different perspective and to
understand that my silence was as petty as their behavior was toward
me. The big difference was I knew better. They resorted to passive-
aggressiveness and shutting me out because those were the only tools
they had in their toolbox. I had more. I was able to see the bigger
picture, and with that gift came the responsibility of responding with
love. Not at all what I wanted to hear.

Of course, my first question was, "Does that mean I have to let
them back into my life? They repeatedly hurt me, and I honestly
thought by no longer communicating with them, I had established
much-needed healthy boundaries." I knew enough at this point to
understand that by setting clear boundaries, I was honestly trying to
stop the pattern of self-abandonment and of trying to get their love.

Anahata explained, "You could and should have clear boundaries,
but only if they come from a place of love and not from a place of
spite. Your withdrawal, silence, defensiveness, and stubbornness fall
under the category of spite at the moment. As you described Beth's
text, your voice and arm gestures mimicked those of a thirteen-year-
old girl with an attitude." *Well, shit.*

Anahata handed me a piece of paper and a pen and asked me to
write what I would like to say to Sofia. I wrote, "I wish you would

grow a pair and stick up for me." I guess that was my core wound issue with her. She had never chosen me. I inherently understood she was incapable, but I found being okay with her perceived limitations difficult to deal with. She didn't seem to have a problem choosing her other children over me time and time again. I thought all the healing work I had done up until now had cleared up this issue, but Anahata helped me understand I still had work to do.

She asked, "What perspective is your writing coming from?" Of course, even though I was writing down the facts, the book was obviously from my point of view. She reminded me, "Make sure you are writing from an integrated place. The entire purpose of your book is to have your work be an offering and even perhaps medicine for those who choose to read the book. You need to allow the reader to see the pain Sofia and her family also carry, and you need to be careful to not make anyone a villain."

I told her, "My intention has never been to make them villains. Sofia gave me life. I would not be sitting here without her. Her husband spent a lot of time and money hiring people to find me. Beth obviously has a lot of pain in her life. I find the situation incredibly complicated. How can I be empathetic to what they may be going through if they choose to never share what is really going on with me and instead make me feel like I am the one doing something wrong?"

Anahata listened to what I was saying and said, "If you approach the book and your life from this perspective, you will achieve what you want out of life: Healing – Freedom – Joy."

As we discussed this, a hummingbird flew up to the window. Hummingbirds represented joy, and I had seen one every single day so far since we had been here. They were a beautiful reminder of my true goal. When I sat back down to write the following day, I went back and re-wrote much of what I had written about Sofia and her family and did my best to come from the perspective Anahata advised while staying true to the facts.

Anahata said, "You have to have realistic expectations. You know what they are not capable of, but what are they here to show you? What is the lesson you have to learn from them? They are here to be teachers for you. Perhaps to teach you accountability, honesty, integrity. If you view them from this perspective, you will grow, and that is what your soul is here to do—to grow. You need to remember to consciously practice these things with everyone else in your life as well."

We moved on to the healing part of the session. She had me lie down on a bio mat, and she placed the stones I had chosen (HEALING – FREEDOM – JOY) underneath. I closed my eyes, and she went to work. Throughout the session, Anahata asked me questions. She said, "The High Priestess has a message for you—what is the message?" My answer was, "You are ready."

I was to work with lavender essential oil. The herb would help me come from a place of love. Our session went way over the allotted time. I offered to pay for the extra time, but Anahata said the length of the session was what I needed and would not accept any extra money. As we said our goodbyes, she told me she was thinking of doing a women's retreat locally since no one was traveling. I remembered what I had been told several times about having the Sedona house host a retreat, so I offered my home. We scheduled a time for her to come over and see if the space worked for her.

Ryan and Lydia arrived the day after my appointment with Anahata, and we spent the next several days hiking, cooking, and getting to know each other. They were so well-matched, and I was so grateful and happy to see them together. We took them to my favorite crystal shop in Uptown, and Lydia said she got "chills" as she held a meteorite in her hand. She had gifts, too, I could see them, but she had to do some healing before they would show themselves to her. They were having such a wonderful time that they changed their flights and stayed an extra three days.

At the end of my month-long stay, I flew back to Tampa to prepare for our move. July and August were a blur of activity. I purged the house of anything I felt no longer served us. Decluttering had always brought me so much joy. This time was different. I found myself in deep funks as I went through items and decided to keep or to let go. We had been there for twenty-five years, and the finality of moving away was hitting me harder than I would have thought. I was always so hard on clients when they were going through that same funk, and now I understood why. I actually called and apologized to a few of them.

We closed as scheduled on August 14, without finding another home in Tampa. We had the movers put our belongings in storage, shipped the Jeep to Sedona, and hit the road in my car with Lola and Angus.

Since the coronavirus was still raging, we chose to drive to Arizona instead of getting on a commercial flight. We started our cross-country road trip by spending ten days in Watercolor, Florida. Art's sister and her husband owned a beautiful vacation home there. They met us, along with our niece and nephew. Ryan and Lydia joined as well, and we spent a wonderful and relaxing ten days by the ocean. Then we set off to cross Alabama, Mississippi, Louisiana, Texas, New Mexico, and eventually arrived in Telluride, Colorado. We spent a week there, relaxing and hiking, before the final drive to Sedona.

Moving in was a completely different experience than going to visit, so the first few weeks were quite hectic. Eventually, though, we settled in, just in time for Ryan and Lydia to visit again. The hidden blessing of the pandemic for us was that now everyone worked remotely, so we were able to spend extended periods of time with each other. By the end of 2020, we had spent almost three months together. We had an incredible opportunity to not only meet and get to know Lydia, but to get to know our son as an adult. As the MasterCard commercials say, it was priceless.

76

VENUS

Bananarama

I dedicated my birthday month, September, to inner work. I was ready to release any lingering issues and wounds and start fresh. I worked with several major healers locally. I had a birthday session with Debbie Crick. I learned Oracle Mastery from Amanda Romania.

In late August, Anahata had reached out to me, saying she would like to use our home for her retreat at the end of September. Several Tampa friends signed up, and most stayed at my house. There were seven of us in total (remember the Seven Star Sisters card).

The theme for the retreat was "the Goddess in all of us." The retreat began with a poem.

> The Goddess is that all-knowing part of us, regardless of gender.
> *She is far more than outward physical beauty.*
> *She is the essence that springs forth from the depths of creativity*
> *That encompass the innocence of the child, playfulness of the youth*
> *And the wisdom of the Great Mother.*
> *She is the place where all possibility lies, birthing forth into light in*
> *the appropriate time in*
> *Accordance with nature and the natural rhythms of life.*

It is the feminine, the soft, the nurturing, patient and supportive
essence, as well as,
The dynamic strength and passionate vitality of the spirit that is
The core to the creation of life as we know it.
That is the Goddess, the all-encompassing power of the feminine
divine.

Anonymous

There were tears, laughter, major aha moments, and deep, deep healing workshops. During a breathwork ceremony, I channeled light language from the Hathors for the first time. Hathor is the Egyptian goddess who fed the Pharaohs (another connection to Egypt and royalty). As I channeled, I felt my arms vibrating so strongly that I placed them on my "womb" and asked for my womb to be rooted down to the Earth and healed so that I could birth what needed to be birthed. I felt heat and vibration coming through my hands as if I had a heating pad on a high setting on my stomach. A message from my soul came through and said, "All of your pieces are here now, you (we) are whole. Move forward, for the time has come to do the work."

After the four-day Goddess Retreat with Anahata, I was ready for a day to completely decompress and relax. I was sure nothing was left to work out at this point, as I felt I had been wrung dry.

There's a great little day spa, Sedona New Day Spa, about five minutes from our home. I scheduled a two-hour bodywork session called the Cedarwood Citrus Wild Chaparral high desert purification, regeneration, and balancing treatment. The treatment sounded like the perfect way to ground and integrate all the work I had completed. I arrived and was told my therapist would be Mary. I did not know her, nor had I requested anyone in particular.

I went to the locker room and changed into my robe and slippers, then returned to the lobby to wait. Mary introduced herself as I

was sipping hot tea. We walked back to the treatment room, and she described the service, which consisted of a full-body massage with warm riverbed stones. After the massage, I would be wrapped in a soft cocoon while receiving a facial massage with a specialized serum to help bring my skin back to its normal state. I had cried and released so much in the past month that it had taken quite a toll on my complexion.

Spirit, as always, had other plans.

Mary started working on me, and within five minutes, she asked, "Do you mind if I share messages Spirit has for you?" Well, I guess my healing wasn't quite done after all.

"Of course not," I replied.

She then asked, "Does the name Catherine mean anything to you?"

Again, we had never met. I smiled (facedown in the face cradle) and said, "Yes."

I told her who Catherine was, and Mary said, "Catherine loves when you dance. You need to dance more." Those were almost the exact words Tejpal had said to me during our session at Miraval.

The next communication came from my Ascension team. They were waiting to help and give me guidance as to how to "truly" forgive my biological mother and her family. I was a bit taken aback by this message. I had just spent an entire month and most of the past three years working on this, but the truth of the matter was that I hadn't really forgiven them yet. Not fully. Not from the heart. I would say I did and honestly felt like I did, but I obviously had some residual anger and blame I had not let go of, or this topic wouldn't have come up again. I acknowledged my resistance and started crying on the table.

Spirit instructed Mary to teach me how to do heart-centered breathing so I could finally forgive from the heart if I honestly wanted to do so. There was always a choice. We all have free will. My guides were there to help if I chose to show up. A person can want to change, wish for change, pray for change, but until that person is

willing to do the ugly, deep, messy, muddy, hard work involved, no change will occur.

I wanted to show up. More than anything. My greatest desire was to navigate from a place (subconscious or not) of "I am not wanted. I am not loved. I am not enough. I am not chosen" to a better, more peaceful place. I wanted to be able to say, with certainty, "What I know now is that I am wanted, I am loved, I am enough, and I have been chosen, if by no one else, then by me." I was ready to reclaim my value and worth, and to do that, I had to fully forgive.

The energy work took up most of the session time, so in the end, there was no facial. I came out with blotchy skin, bleary eyes, and an amazing sense of happiness and liberation. I had chosen to forgive them. I had truly, from my heart, forgiven them. My forgiveness didn't mean I would automatically allow them back into my life. That situation remained uncertain. In order for me to lower my boundaries, our relationship would have to be reciprocal in respect. I didn't know if they were capable of that kind of relationship or if they even wanted a relationship with me at this point. By forgiving them, though, I was now free.

I let go of the need to feel right versus them being wrong, or feeling I was the victim and they were the villains. I wasn't. They weren't. I was loved, guided, and protected by forces much stronger and more powerful than one could imagine. This family was placed in my life to be one of my greatest teachers. What did I learn from them? The lessons certainly included accountability, integrity, and honesty, but the real lesson was *forgiveness*. They taught me how to forgive, and for that, I would be eternally grateful. A quote from Najwa Zebian came to mind: "Today I decided to forgive you. Not because you apologized or because you acknowledged the pain that you caused me, but because my soul deserves peace."

I changed back into my black maxi dress and sandals and walked over to the reception desk to pay. The spa owner, Jill, came up and

introduced herself and handed me a pretty orange bag with ribbons and tissue paper. I asked, "What is this for?" She responded, "I just wanted to. I put some rosemary and mint bath salts and body butter in there as a gift for you."

Some of rosemary's amazing properties are its power of protection and its ability to remove negative energy. I smiled and thanked her. I knew the gift's meaning went much deeper than spa products in the bag. This was a gift from *all* who guided, surrounded, and protected me. They were acknowledging what I had just chosen to do. They were there. They had always been there, and they would always be there. That is the real gift for those of us who choose not only to listen, but to do the hard, dark, messy work necessary to bring about true change.

EPILOGUE

All the inner work I have done for the past three years with so many amazing teachers has finally allowed me to let go of all the fear of abandonment and the need to be perfect. I can move forward the way I want to, not in the way I am expected to, unless that way also works for me. I am safe to open my heart. Those who truly care about me and are important will not leave or reject me.

I learned how to heal my inner child. I am not Sofia's mistake, and her actions and fears are not mine to carry any longer. I did not need to forgive her for her choices. I forgave her for the way that her choices affected my life.

I learned how to ask, "What do I need today?" If I don't ask that question regularly, then my life becomes more about, "What does everyone else need?" We all know we cannot give from an empty cup, so we need to find what fills us up in order to be better partners, parents, and people.

I learned if you are with a person who won't change or won't meet your needs, then your response to that person has to change. That is where the clear and loving boundaries come into play. If your choice is coming from a place of truth, then it is okay to set those boundaries. It is solely up to you to stop the pattern of self-abandonment by always trying to get someone else's love.

I learned my names Alejandra and Cassandra were also no coincidence. As my mother said when I was a child, "Your name has great power. Never give it away." I will never give my power away again. My

name also means "helper of humankind," and my sincerest hopes and dreams are that this book does, in some small way, help humankind.

The most important lesson I learned is that I am and always have been whole and enough. I wanted me! I am not here by accident. I am cherished by me, and my soul mission brought me here at this time in history.

HEALING RESOURCES

Alexandra Nicol, Psychic Medium / AlexandraNicol.com

Amanda Romania / AmandaRomania.com / AtlantisSedona.com

Amber Prida / SpaJardin.com

Anahata Ananda Shamangelic Healing / ShamangelicHealing.com

Debbie Crick / CardsOfIllumination.com / Rustic Heart Farm

Dr. Sandi Carter / NirvanaAcupuncture.com

Heather Radke Holistics / HeatherRadkeHolistics.com

Ina Lukas, Ina and the Alchemists / InaLukas.com

Karen Rauch Carter, Modern Feng Shui for Life Mastery / KarenRauchCarter.com

Kristin Reece / KristinReece.com

Lauren Douglass / LaurenDouglass.com

Rev. Marcella Zinner, Intuitive Counselor & Clairvoyant / MarcellaZ.com

Patricia L. Walsh / HealThePast.com / KairosAstrology.com / SoulwiseAstrologySchool.com

Shekina Rose, Priestess of Light / ShekinaRose.com

Dr. Tim Frank & Pam Lancaster / Awake108.com

ACKNOWLEDGMENTS

want to acknowledge and thank, first and foremost, my amazing husband of thirty-one years (and counting), Art, without whose support I would not be here. I never thought I would write this book. The thought of writing a book hadn't even crossed my mind. I was Divinely guided during a meditation to do so by Archangel Michael. I now know this book was meant to be part of my life's mission.

When I told Art I was supposed to write because I was told to do so during an incredibly powerful meditation, he just said, "Great. Let me know what you need."

Thank you to our son, Ryan, who now considers me "woke!" His support during my spiritual awakening and journey has been unwavering, which has made my journey all the more special. He also makes himself available anytime I need tech advice!

I want to thank my parents, grandmother, and in-laws, for even though they are no longer on this Earth, I feel their presence, love, and encouragement every day.

It is with deep gratitude that I thank my dear friend Heather Radke, who is the first one to tell me I had "gifts," who explained the concept of Energy to me, and who was with me when I bought my first crystal. Heather introduced me to Karen Rauch Carter, who became not only my amazing feng shui teacher and mentor but a wonderful friend as well.

Within the first ten minutes of meeting me, Karen told me I would become a feng shui consultant. I am so grateful to her for all her wisdom and teaching.

To our home in Tampa, Florida; implementing feng shui principles in my own home is how I created the energetic space I needed to write this book. Feng shui was the first step in my spiritual awakening, and I don't know if I would be here without it.

So many helpful spiritual teachers and mentors have joined me along the way. I want to thank Kristin Reece, whom I met on my first visit to Miraval in Tucson, Arizona. Her coaching and guidance have been invaluable these past three years.

To Gregg Gonzales, founder of Joyful Living, LLC, who helped me open up and get to the heart of the story and then introduced me to Susie Schaefer.

To Susie Schaefer, who guided me through this book-writing process. The thought of writing a book was overwhelming enough. The thought of actually seeing my manuscript come to life seemed insurmountable. Susie and her team at Finish the Book Publishing walked me through each step with love and a lot of patience!

To Alexandra O'Connell, owner of Your Resident Wordsmith, LLC, for her patience with a first-time writer.

To my amazing friends and family, thank you to all who supported me on my spiritual journey. I am forever grateful!

ABOUT THE AUTHOR

*A*fter fifteen years designing the interiors of beautiful homes and offices, Alejandra found herself missing something. She took a break from work and focused on her most important client – herself. Her *mental and emotional* interior needed a reboot. She found that in Feng Shui.

Working with and studying under a Feng Shui master practitioner helped Alejandra unlock a new and wonderful set of principles to combine with years of high-end design success. With these combined experiences, Alejandra delivers beautifully designed spaces that improve the lives of her clients, their employees, and their families.

Born in Austin, Texas, Alejandra was adopted at just five weeks old and raised in a Mexican-American family culture in Laredo. She is fluent in both English and Spanish, graduating from the University of Notre Dame with a Bachelor of Arts Degree. Notre Dame was where Alejandra met her future husband, Art Brady. She and Art married and gave birth to their son Ryan.

At age 50, Alejandra began her spiritual journey. Coupled with the training she experienced in Feng Shui, her awakening brought

her new insight into the mystical world of infinite possibilities and abundance. This book is the result of that journey.

Alejandra experiences true inner joy when she sees the impact of her service on the lives of her clients. Her mission is to enhance far more than the appearance of their home or office, but to improve their well-being and lifestyle in a way they had not imagined.

Alejandra holds the following accreditations:
- Certification in the BTB style of Feng Shui and Bau-Biology under Karen Rauch Carter and the Academy of Exquisite Living
- Professional Member of the International Feng Shui Guild (IFSG)
- Certified Crystal Healer

After 30 years of living in Tampa, Florida, Alejandra and Art moved to their home in beautiful, magical Sedona, Arizona during the pandemic, with their two dogs, Lola and Angus. During their time in Sedona, they rescued a third fur baby, who they named Pepe after Alejandra's father.

Alejandra and Art recently moved back to sunny Tampa. When not working with her clients on inspired interior design and the art of Feng Shui, Alejandra enjoys crystals and gardening. Alejandra and Art love spending time with family and friends and can be found traveling to see their son and his fiance whenever possible. To connect with Alejandra, visit alejandrabrady.com.

CPSIA information can be obtained
at www.ICGtesting.com
Printed in the USA
LVHW091500270422
717377LV00021B/297/J

9 781736 685631